S0-AIJ-059

Sexual Predators_

How to recognize them on the Internet and on the Street_
How to Keep Your Kids Away_

Stephen Dean_

SILVER LAKE PUBLISHING

LOS ANGELES, CA ◆ ABERDEEN, WA

Sexual Predators
How to recognize them on the Internet and on the street
How to keep your kids away

First edition, 2007
Copyright © 2007 by Stephen Dean

Silver Lake Publishing
111 East Wishkah Street
Aberdeen, WA 98520

For a list of other publications or for more information, please call
1.360.532.5758. Find our Web site at **www.silverlakepub.com**.

All rights reserved. No part of this book may be reproduced, stored in
a retrieval system or transcribed in any form or by any means (elec-
tronic, mechanical, photocopy, recording or otherwise) without the
prior written permission of Silver Lake Publishing.

Library of Congress Catalogue Number: Pending

Dean, Stephen
Sexual Predators
How to recognize them on the Internet and on the street
How to keep your kids away
Includes index.
Pages: 252

ISBN: 1-56343-794-5
Printed in the United States of America.

Contents

...They're Flooding the Internet

Every minute of every day, they're flooding the Internet. While others are sleeping, shaving, eating or working, sexual predators are prowling every corner of the Internet in search of their next victims. Some statistics:

- According to NetSafe/Internet Safety Group, 50,000 sexual predators are online at any given time. And other reports are just as disturbing.

- According to congressional sources, in 2004 the global commercial revenue for selling music online was $3 billion. Sales of child sexual abuse images in the same year totaled an estimated **$20 billion**.

- A July 2005 Pew Internet study reported that there were more than 21 million Americans under 18 online. They're spending more and more time in front of those computer screens, and their methods for interacting in the cyber world are changing almost daily.

The nation's youth is under attack. One in five has been a victim of an indecent proposition online, according to a groundbreaking sur-

vey called *Online Victimization* for the National Center for Missing and Exploited Children.

Anecdotal evidence suggests that number could be higher if the survey were conducted again today.

The *Online Victimization* report estimates that fewer than 10 percent of the unwanted advances aimed at children are actually reported to authorities, and in these pages are some of the reasons that kids are keeping it to themselves.

Imagine trying to understand a page of a book or an idea on the computer screen—and suddenly thousands of new words flood into the field of view. And they keep crowding over each other.

It becomes impossible to catch up.

That barrage of words is how chat rooms are scrolling across thousands of computer screens at every moment of every day.

To make matters more complex, for adults and children, the world of chatting is usually a secret part of their lives.

The chat someone has with one friend is a secret from the others. And the chats people have with strangers are often never discussed with friends or relatives—or anyone away from the computer.

Most parents don't have a very clear idea of what their teenage children are doing on the Internet. According to research conducted by the online safety group NetAlert:

- 71 percent of parents believe their children use the Internet for school-related research—but only 23 percent of teens say they do, and

- 24 percent of teens claim that their parents are "never around" when they're online.

And a parent won't find out about online sexual advances unless he or she asks. According to a Youth Internet Safety Survey conducted by the Crimes Against Children Research Center at the University of New Hampshire:

- one out of five children age 10 to 17 have received unwanted sexual solicitations online,

- 70 percent of the unwanted sexual solicitations occurred on the youth's home computer, and

- over 75 percent of these solicitations are not reported to the child's parents.

So, those are the statistics. Now I should tell you a little about myself.

My name is Stephen Dean. I've been an investigative journalist since 1984.

Since early 2001, I have been on the air at KPRC-TV, the NBC affiliate in Houston—the nation's fourth-largest city and the 10th-largest television market.

My career has always been focused on staying ahead of emerging threats and keeping people informed about new dangers.

My reporting started breaking new ground nationally on child pornography cases and law enforcement stings in 1996. Sometimes I've worked closely with the Justice Department; and other times I've exposed weaknesses in Justice Department methods.

Since February 2004, I have been immersed in the world of Internet predators, waging one of the first televised stings in the country. Never before have I encountered a criminal world that compelled me to write a book so that others could understand the depths of such a dark problem.

I am not a licensed counselor, a police officer or an academically trained researcher. This is not an exhaustive psychological study of predators, using double-blind methods or statistical tabulations. Much of the evidence is anecdotal.

However, being a Peabody Award-winning investigative reporter, I have a distinct body of work that examines all of these worlds: psy-

chologists, criminals, police, prosecutors, computer experts, teenagers and families.

I've had to become an expert on the world I investigate, following the cues and the behaviors of the people I interview.

Posing as a vulnerable child in thousands of chat rooms and then exposing the men who come knocking on the door for sex has allowed me to assemble a thorough picture of how this exploitation unfolds every day.

I have fooled hundreds of predators into thinking they were chatting with children. Some police agencies have asked for my help with their own Internet investigations.

There are few law enforcement officers and other professionals who specialize in this type of investigation. There are even fewer experienced people in a position to write about it.

In presenting these reports on the air in Houston and on network television, I have gone further than the police do. I've interviewed dozens of teens and parents…and the predators and the *families* of predators. Many of these people are inconsequential in police cases; but I think they provide a more complete picture of what goes on.

I hope that picture comes to life in these pages.

The goal here is to keep kids safe. To do that, I want to arm parents and others with my experiences—so that they can turn this knowledge against the people who would prey on children.

1 Hooking Up

`do u like older guys? im 35 and i like`
`younger girls.`

With children and their parents waiting patiently in the reception area of his Houston clinic, a licensed orthodontist sits at his computer in his private back office. He's not researching a new dental device or studying up on the latest methods for moving teeth. He's scanning the Internet for chat rooms in search of young—*very* young—girls who want to have sex.

He goes to Web sites dedicated to connecting people who are looking for quick or anonymous sex in his area. These sites are supposed to be for adults only; but minors often "sneak in" to read or write graphic sexual messages. He also goes to Web sites where teens swap messages about music, movies or the day-to-day doings of their lives.

He looks for a particular mix of vulgarity and simplicity in the short messages full of abbreviations and code words. The best prospects for sexual encounters are girls who write about sex graphically but aren't bright enough to know that the lines he uses are calculated to make them feel wanted.

His main skill in finding girls online is knowing how to talk their language in real-time messaging or chatting. Maybe it makes him feel young, to talk like a teenager; or maybe the truth is darker, that the childish texting heightens the forbidden flavor of what he's doing.

At this particular moment, he's found the profile of a 13-year-old girl in an Internet chat room dedicated to people who want to meet for illicit sex (not necessarily with teens) in the Houston area. He contacts her through a personal profile she has posted and asks her to exchange "private" chat messages—real-time typed messages between only two parties.

The orthodontist calls himself SLOWHANDTX and he's talking to JEN288COWGRL:

```
SLOWHANDTX: im 35/m/houston
JEN288COWGRL: sup slow!!!
SLOWHANDTX: not alot...just here at work...but
    not really working...lol (short for Laugh Out Loud)
JEN288COWGRL: gotcha
SLOWHANDTX: what are u up to?
JEN288COWGRL: TV sux so just checkin the
    roomks
SLOWHANDTX: cool where in houston are u?
```

The orthodontist thinks JEN288COWGIRL is a flirty 13-year-old. In fact, "she" is me—an investigative reporter for a local television news program, working undercover.

Who Does This Stuff?

The orthodontist had a lot to lose. A tall, handsome man in his forties, he was in business with his wife—a fellow orthodontist. Together, they operated three clinics for families in the Houston area.

They drove luxury cars and lived in a home worth over a million dollars in an exclusive neighborhood.

This couple had a son who could enjoy a large playground in the backyard as he grew through his toddler years. In addition to the fenced playground, a wagon and other colorful toys were easily visible through a large pane window on the upper floor of the house. A nanny cared for him during the day while his mom was adjusting teeth and his dad was…supposed to be.

The orthodontist and his wife split their duties among their several offices, so they were rarely in the same place at the same time. This arrangement was supposed to allow them to see more patients; in fact, it gave him lots of time to prowl Internet sex sites and chat rooms.

On this particular day, he's looking at a picture of JEN288COWGIRL. What he sees is a photograph of an actual 13-year-old girl, posted on a Web site where teens can make personal pages. He sees a striking blonde girl, trying to look older than her age—as many teenage girls do. He likes what he sees.

In reality, the picture is an old one and the girl in it has long since grown into an adult woman. Her parents, personal friends of mine, have agreed to let my team use their daughter's pictures to build a "profile" for JEN288COWGIRL. The girl's mother remembered this picture because she didn't like it; she thought her teenage daughter was trying to look sexy too early in life.

And the mother was right. The teenage girl was definitely trying to look older and more sexual. She was wearing a lot of makeup and posing with a rather provocative look in her eye, leaning back in the grass. She was wearing a top that exposed just enough stomach…to make her mother uncomfortable.

The girl's true identity would never be disclosed—to law enforcement agents or anyone else—despite the many legal proceedings that resulted from its use. But her precocious picture was the perfect lure in an undercover investigation of sexual predators.

Predators Exploit Common Teen Anxieties

Teenagers have always lived through an awkward balance of the childhoods they're leaving and the adult lives they're just approaching. Sex is a big part of this awkward balance; teens often begin to develop sexual characteristics before they understand what those things mean. As a result, they may equate their first sexual impulses with fear and anxious fascination with their own bodies—the familiar stories of young girls feeling ugly when they develop breasts or boys being frightened by their first nocturnal emissions.

Even the healthiest child can feel these anxieties; and the anxieties can mean some missteps or bad choices. These missteps may be as simple as dressing inappropriately; they may be more severe, like having sexual intercourse at too young an age. This is why adults who work with teens are in positions of trust—they're not supposed to exploit common teenage anxieties and weaknesses.

Sexual predators *look* for those weaknesses.

The orthodontist wants to meet JEN288COWGIRL. Now. He spends a few minutes chatting about geography and locations with the girl. He asks what neighborhood she lives in. When "she" tells him, he says he used to live in the same area. Then, he moves abruptly to the details of "hooking up"—teen slang for casual sex, without any social or romantic attachments.

```
SLOWHANDTX: im 6'3, 195, flat stomach
    cleancut brown hair, hazel eyes
JEN288COWGRL: super
SLOWHANDTX: how tall are u?
JEN288COWGRL: just over 5'
SLOWHANDTX: nice...i like short girls
    do u like tall guys?
```

```
JEN288COWGRL: god yes.
SLOWHANDTX: good
    do u like older guys?
JEN288COWGRL: all i look at. its a hangup
    friends givin me sh it all th tme
SLOWHANDTX: lol...cool...im 35
    and i like younger girls
JEN288COWGRL: never dated a 35m
SLOWHANDTX: how old are u?
JEN288COWGRL: 13fHeights
SLOWHANDTX: cool
    thats ok with me
    is my being 35 ok with u?
JEN288COWGRL: you look youngr?
SLOWHANDTX: yeah, i do
JEN288COWGRL: i messd raround with a guy i
    think was 30, but thats it.
SLOWHANDTX: thats pretty close
    when was that?
JEN288COWGRL: befor thanksgivng
    im not sur he was 30. someone said that
SLOWHANDTX: thats cool...im glad u like older
    guys.
```

Moving the Talk to Action

Next, JEN288COWGIRL says that she cries sometimes because her best friend makes fun of her being attracted to older guys. The orthodontist offers a cagey rationalization of the girl's interest, couched in tones of self-help psychology:

```
u cant let her bother u...everyone likes
different things.
```

Predators often rationalize their abuse in terms of helping young people improve their self-esteem.

The girl asks what kind of job SLOWHANDTX has and whether his coworkers would miss him if he left suddenly.

The orthodontist is still trying to cling to anonymity, so he doesn't mention his dental practice. He only suggests, "yeah, i would be missed."

Finally, he wonders why she's not in school in the middle of the day. When she answers that she's "playin sick," he seems to like that notion. He answers, "naughty girl."

```
SLOWHANDTX: would u like to meet?
JEN288COWGRL: you sound neat
SLOWHANDTX: u do too...i'd love to get to-
    gether.
JEN288COWGRL: you come here or what>
SLOWHANDTX: yeah, i could do that.
```

He asks for her phone number, but the girl says she's afraid to give out her parents' number for fear of getting caught. He says that he's "very discreet" and:

```
SLOWHANDTX: i dont want to get into trouble
    either...lol.
    if u want to meet, i'd want to talk to u
    on the phone first...i'd be too nervous
    otherwise..."
```

JEN288COWGIRL tries to set up a meeting a few days later. She tells the orthodontist what time she gets home from school on a typical day; and she mentions that her parents will take away her computer if he calls her phone when she's not expecting the call.

JEN288COWGRL: i cant do the phone sex thing.
SLOWHANDTX: no, that's not what im inter-
 ested in
JEN288COWGRL: what you wnat to do
SLOWHANDTX: meet up for real
JEN288COWGRL: i keep tryng to find a guy who
 tels me what he wants, but you wont
SLOWHANDTX: can we talk about it on the
 phone?
JEN288COWGRL: i want to stay on computer
SLOWHANDTX: ok then
but i never know if a girl is for real until
 i talk to her on the phone...even if its
 just for 5 minutes.
 as soon as i know youre for real, then we
 can talk about everything on the com-
 puter.

JEN288COWGIRL gives the orthodontist a cell phone number
and they agree to a "safe" time that he can call.

He sounds experienced. He says he "never" knows if a girl is real
until the phone call.

Since it's an integral part of this man's well-rehearsed verification
process, our undercover team has already mapped out precisely how
phone calls will be handled. A twenty-something female producer
from the TV station—who has a young-sounding voice—will take
the call.

This producer watched some of the text messages scroll on the
computer screen as the initial chats happened, so she's familiar with
the general progression of things.

Her instructions are to make the orthodontist feel comfortable that she's the girl he found on the sex site and with whom he was flirting by text message. If he asks, she will state clearly that she's 13; but she will not do anything to convince him to come over.

No coaxing is allowed.

At the agreed-upon time, the orthodontist calls JEN288COWGIRL and asks her a series of questions—including when her parents will be home. The girl acts distracted and nervous, as if she's more comfortable chatting on the computer.

The orthodontist seems satisfied. He agrees he'll chat with her more online.

```
SLOWHANDTX: u have a nice voice
JEN288COWGRL: i hate it
SLOWHANDTX: lol...why?...its so cute
JEN288COWGRL: peoople treat me like an idiot
SLOWHANDTX: lol...well, i wont...your voice
   turns me on.
JEN288COWGRL: ty (an abbreviation for Thank You)
SLOWHANDTX: so, when did u have sex for the
   first time?
JEN288COWGRL: last year. is that sick?
SLOWHANDTX: not at all
   thats cool
   how old was the guy?
JEN288COWGRL: my frnd said he was 30 but i
   dont think so
SLOWHANDTX: cool...how many guys have u been
   with in all?
JEN288COWGRL: just that 1, but iv messed
   around some
SLOWHANDTX: are u ready for number 2?
```

```
JEN288COWGRL: dont knw when id see you. i
    want to know what u look lk.
    you sound neat
SLOWHANDTX: if u think i look good when u
    see me, will u be ready?
```

Swapping Pictures

One picture contained in the orthodontist's profile was truly re-markable. And not in a good way.

A man is standing at a backyard party with other guests visible. He is holding a silver party platter at crotch level. He's placed his penis on one bun amid a row of hot dogs.

JEN288COWGIRL continues to push for a photograph of his face. He resists for a while, assuring her that:

```
im a good looking guy...thats what im
always told by girls. if u like older
guys, then u definitely wont be disap-
pointed.
```

Then, he tells her to look in the "photo album" feature on his profile page in a personals Web site. This feature is a collection of photos displayed apart from the profile page, which can be opened by clicking on a link.

Suddenly, pictures are available in his photo album that weren't there just minutes earlier. He's posting pictures as he chats with JEN288COWGIRL; and it's likely he'll remove the pictures soon after. Predators don't like to show their faces online.

The orthodontist says he may have to reboot his own computer in order for all of his pictures to be visible. He seems keenly aware of the risks he's taking by making a picture of his face available.

Finally, my investigative team has a smiling photograph of the man who wants to meet a 13-year-old for sex.

We'd later realize this was a real picture of the orthodontist—but it had been taken five to 10 years earlier. This turned out to be a common tactic among men and women in any sort of Internet-based sexual relationship. (And, frankly, it's the same tactic we used with the picture for JEN288COWGIRL.)

The saying "a picture doesn't lie" *doesn't* apply on the Internet.

Predators Lie about Their Age

The orthodontist has claimed to be 35; this is a critical lie.

Male sex predators often say that they're in their thirties; this is often less intimidating to teenagers, for several reasons.

First, and most important, it usually places the predator in an age range between the teen and his or her parents. If the predator seems too close to a parent's age, he becomes frightening or unattractive even to the most experimental teens.

Second, popular culture personalities from music, television shows and movies aimed at teens often give their age as "in the thirties" (even when it's not). Teenagers are accustomed to thinking of the thirties as an age that's older—but still connected to their world.

But age isn't the only thing that the orthodontist wants to convey in his pictures. He wants to get across the message that he's into sex. His photo album contains the hot dog bun picture, his young portrait and two pictures of him engaged in sex acts with different women.

This isn't subtle stuff. It's a blunt collection of pictures, likely to spark a reaction from anyone who sees it.

And that is the entire goal.

What the Prosecutors Say

"Sometimes they offer money, some offer them things," said Michael Shelby, the top Justice Department prosecutor in the Houston area at

the time of the orthodontist's hookups. "Sometimes they don't offer anything, just play on the natural curiosity of [young] people toward adults who ought to know better."

Shelby's office and other U.S. Attorney offices across the country are prosecuting more of these so-called "child enticement" cases. "Many of the people who offend in this way do so in a serial way. They do it again and again and again and again. It's a huge problem," he said.

But here's the *real* problem: The sex meeting with the orthodontist came together much more quickly than a law enforcement agency would typically be able to obtain a search or arrest warrant.

"There are undoubtedly children that are falling prey to this and meeting these people the same day they start this chat with them," Shelby said with frustration. He pointed out that it usually takes federal agents more than 24 hours to get information from the Internet Service Providers that will tie a screen name to a living and breathing predator.

A 2003 Justice Department report on juvenile crime stated plainly that investigations can take weeks or even *months* to reach the proper agency and to establish jurisdiction for complex matters like where a predator's computer is located.

An undercover agent may be posing as a 12-year-old child in Baltimore and a 52-year-old man from Kansas tries to arrange a meeting. The Kansas field office of the FBI or Secret Service has to be informed and get involved—and the Justice Department report says this just doesn't happen fast enough.

Shelby says that the Justice Department is trying to change that:

> *We are in the process of attempting to streamline how we go about getting information from the Internet Service Providers so we can get it in a more real time way. Because the victimization we've found in these cases is sometimes the very same day.*

Sneaking Around

Meanwhile, the orthodontist is tired of chatting. He wants to hook up with JEN288COWGIRL.

SLOWHANDTX: can u meet me at a conveneince
 store down the street
from your house?
JEN288COWGRL: no
SLOWHANDTX: im nervous about going to yourh
 ouse though
JEN288COWGRL: safest here!
SLOWHANDTX: what about your parents...does
 either one of them ever come home for
 lunch?
JEN288COWGRL: never come home then.

Most men who arrange sex meetings with teenage girls or boys ask about meeting the teen a block away or in a public place. This allows the predator to maintain control of his surroundings and keep the first contact on neutral ground—away from the child's family and home.

The orthodontist asks where the girl goes to school. She answers with the name of a well-known middle school in the neighborhood. He says that he knows the school well.

Then he asks, "do you want me to be forceful with you?" This is consistent with his habit of switching abruptly to graphic sex talk during the chats. JEN288COWGIRL doesn't respond...which doesn't seem to bother the orthodontist. He switches back to negotiating the details.

At one point during this process, the orthodontist tells JEN288COWGIRL that he has to go take care of something for 10 minutes. That's about how long an adjustment of braces usually takes.

He comes back and says he can meet the girl during his lunch break.

This is a big concession on his part. He'd been pressing to meet in a public place; but JEN288COWGIRL had insisted that her neighbors might spot her if she were out in the neighborhood…or police might pick her up for truancy.

Now, the orthodontist has accepted that he'll have to come to the door in order to get this girl. And he'll need to keep a low profile because of her neighbors. So he keeps on working out the details:

```
SLOWHANDTX: i dont think i should park in
    front of your house, do u?
JEN288COWGRL: no
SLOWHANDTX: where is a good place to park?
JEN288COWGRL: down a few houses?
```

And, within minutes, he's on his way.

The man in the online portraits drove past the house—a brick duplex in a trendy and upscale neighborhood in Houston. He drove a grey BMW. He wore a long-sleeve shirt but wasn't dressed like a salesman or a corporate minion. He was a confident man who looked like he had money.

Television cameras were hidden a various places in and around the house—in the peephole of the door, the nearby bushes and inside the living room, facing the door.

The orthodontist strolled up to the front door. He had good posture and a calm demeanor—no sleazy flasher, this fellow. And the neighborhood was a good one. The street was lined with bungalows built in the 1930s; real estate prices in this section of town were rising fast.

A girl's shoes were kicked off near the front door. A broom was propped up against the wall. Mail was stuffed into the mailbox. Cat

food dishes were sitting neatly near one of the brick pillars. A typical middle-class urban home.

Camera crews were ready to jump out from both of the duplex doors when the orthodontist knocked. The female producer was standing behind the door with the reporter. Her voice—which he knew—would greet him when he knocked.

"Who is it?" she asked, through the closed door.

He answered with a name he had given her during their online chats, "Scott."

The Bust

I swung the door open and the orthodontist's whole life changed in a second.

"Scott, Channel 2 News......wondering what you're doing here."

He said nothing at first, looking downward and then turning around to leave the porch.

I began to read from the chat transcript as the team followed the orthodontist down the sidewalk, "She said *yeah* and now here you are, meeting her for sex when she's supposed to be in school. I'd like to hear your side of it, sir."

The orthodontist answered calmly in a low voice as he walked toward his car, "That's not what happened."

I shot back, "What happened?"

The "couple of houses" seemed like a much longer distance. The team—one reporter, two photographers and a security guard the TV station hired to protect its people—followed the orthodontist down the street of the quiet neighborhood.

The orthodontist continued walking to the end of the block and he stopped. He glanced at his BMW and considered his next move. Should he rush straight to his car and drive away? Or should he try to draw the news crew's attention away from his BMW—and its license plate?

He turned away from his car and then continued walking away, saying, "I didn't know who I was talking to."

I responded, "Right, we told you she was a 13-year-old. You believed it was a 13-year-old girl. That's the whole point."

The orthodontist grabbed at a denial, "I didn't think it was a 13-year-old girl."

The best way to get someone to talk under pressure is to keep asking questions. So, I kept at him: "We said it again and again. You said *is my being 35 okay with you*. I have the transcript here."

That transcript showed plenty of discussion about their age disparity, the girl's parents, the girl attending a middle school and her "only" having had one sex partner previously. But the orthodontist offered nothing else as he walked away from the cameras and climbed into his BMW.

Within 90 minutes of the encounter, the orthodontist had retained a Houston attorney. The lawyer would appear in later news broadcasts to say that no law had been broken and the sting had not been conducted by law enforcement authorities.

True, we weren't law enforcement. (Of course, we'd never claimed that we were.)

"As far as I know my client did nothing wrong and he had no idea that there was a 13-year-old girl involved," the lawyer said.

Not so true.

The lawyer was wrong on one point: A predator doesn't have to have sex with a minor in order to break the law. Federal law says that *arranging* to have sex with someone the predator believes is a minor is a crime. Texas state law—and most state law—says the same.

Exposing the Trail of Other Trysts

The next major twist in the orthodontist's story came months later, when police knocked on his door with a felony indictment. He was indicted for two real sex meetings with an underage girl. *Those*

meetings were unrelated to anything we'd discovered in our undercover investigation; but they'd come to light because of the TV piece.

Law enforcement agents generally agree that, when a person is exposed in the media as a sexual predator, a "trail of victims" often emerges in the days or weeks that follow.

As the orthodontist had climbed into his BMW to drive away from our confrontation, our TV cameras focused on a child safety seat in the back seat. He went home to tell his wife, as their young son sat in the next room.

His wife stood by her man.

And that took a lot of effort. As it turned out, the last orthodontic procedure SLOWHANDTX performed before leaving for his tryst with JEN288COWGIRL would be his last procedure for good. The exposure put him out of business.

Parents lined up at the clinics where the orthodontist and his wife were in business together, many demanding their files so they could find new doctors to handle their kids' braces.

The wife assured the patients that her husband would no longer be practicing. Some parents trusted the wife enough to keep their children with her; others wanted no part of the woman or her husband.

One adult patient pulled his business from the firm, saying he felt like he was funding the orthodontist's addiction to sexual encounters with children.

One teenager summed up people's worst fears, as she and her parents left the clinic with her files:

"He had his hands in my mouth!"

2 How Sexual Predators Stalk Their Prey

```
lovely hottie you are dear....care to ex-
plore possibilities?
```

While some sexual predators approach children subtly—and care-fully *groom* their prey—online predators tend to use approaches that are plainer and more crude. They approach many children constantly, so they don't waste time on subtlty.

One predator's crude come-on lines appear on the screen of any curious teenage girl who happens into a sexually-oriented chat room, where he has set up his "trolling" operation. He uses ordinary tools available in most chat rooms to contact participants directly via in-stant message (IM) software.

If he sends exactly the same instant message to 20 little girls, most will simply block his messages by hitting "Block Sender" or "Ignore" and then moving on. He doesn't mind; he's playing a numbers game. All it takes is one foolish girl to respond.

Then, he focuses his attention intensely on *her*.

"I was just seeing what thoughts could trigger her to want to meet someone," a predator who used the Internet name PLEASUREGIVER admitted, after getting caught in one of our

stings. "I've never been involved in anything that has given me that sort of compelling motivation to return to it."

As he says this, he shakes his head and looks down at the ground. He says he's ashamed because he was caught; but his rationalizations seem to blind him to the enormity of what he's done.

PLEASUREGIVER knocked on the door of an upscale Houston home after chatting with what he thought was a 13-year-old girl. He arrived to have sex with her, but instead he was surrounded by television cameras and sharp questions from an investigative reporter.

Federal agents and police are waging operations like this—known as *proactive stings*—all over the country. Some legal activists argue that the stings are a form of entrapment. But these talking heads fail to understand an important point: Federal laws (as well as laws in many states) make it a crime for an adult to *arrange* to have sex with a child.

That's a different standard than those that apply to most criminal activities.

When we set up our stings, my Houston-based investigative reporting team employed the same strict guidelines used by law enforcement agencies:

1) the predator has to initiate the contact,

2) he has to make the first mention of sex, and,

3) if he wants to back out, we can make no effort to coax him into the sex meeting.

PLEASUREGIVER was a busy predator; in the first hours that we set up our investigation, he was already plying the same crude lines on two separate undercover child identities.

Both of the minor's screen names appeared as PLEASUREGIVER was prowling in an adult-oriented chat room titled, "Meet in Houston for Sex Now." Unlike some adult sex sites, this chat forum had only a standard disclaimer that adult content might be involved; any curious child could log on and read graphic sexual posts.

Before learning their ages, his greetings to both girls were so strikingly similar, it seemed as though he'd used a cut-and-paste function to send identical messages:

```
PLEASUREGIVER: hey there Jen.......lovely
    hottie you are dear....care to explore
    possibilities??????
JEN13COWGRL: not sure
PLEASUREGIVER: ok......so presume u looking
    for same as me in here.....friends with
    benefits......pleasurable times.......no
    strings   attached......complete   and
    passionate......satisfying sex???
JEN13COWGRL: sounds good
PLEASUREGIVER:       lil       bout
    me.......6'2".......230lbs......muscular/
    athletic build.....extreme stamina.....and
    yes well endowed......any interest???
JEN13COWGRL: youd kill me
PLEASUREGIVER: oh no dear.......i can keep
    my body weight off of you....quite agile
    i am......heh heh
    you on top.....doggy style.....love giving
    oral too......one of my favorites.....and
    my specialty.......
```

This is a common tactic among male sexual predators. Whether they're chatting to boys or young girls, the predators will quickly move to talk of oral sex if intercourse seems too threatening. This follows a more general strategy that predators use: A bold statement, followed by fuzzy talk that backs away from the bold statement. They use this strategy with their victims—and with authority figures when they're confronted or arrested.

In the meantime, predators often boast about their sexual technique and promise to "teach" the young victims what they know.

PLEASUREGIVER: talk to me jen

JEN13COWGRL: you asl? I'm 13fnw side

PLEASUREGIVER: i live in kingwood.......work
 downtown.......31..and all man........

JEN13COWGRL: you sound awewsomme

PLEASUREGIVER: am awesome dear.......you
 would be in ecstasy like you would never
 imagine.

While chatting with the other undercover screen name—this time a 13-year-old "girl" using the screen name BEBEGRL—he figures she's looking for an older man because he found her in a chat room that's all about finding sex. Again, he wastes little time on niceties; he tells her he's married but looking for sex on the side.

PLEASUREGIVER: can meet you........can go
 pick u up......u name it

BEBEGRL: you really married?

PLEASUREGIVER: yes i am...........

BEBEGRL: geez

PLEASUREGIVER: are you interested in play-
 ing around with a married
 fellow.......???........the safest kind
 you know......

BEBEGRL: why safest

PLEASUREGIVER: what????

BEBEGRL: why is marry the safest guy?

PLEASUREGIVER: safest sexwise.......as con-
 cern for catching diseases are so un-
 likely from someone that is married.

```
BEBEGRL: oh true i gues
PLEASUREGIVER: a very important consider-
    ation these days u know........
```

Getting More Info on the Child

As the exchanges proceed through some banal flattery, PLEASUREGIVER asks for more details about the girl. BEBEGRL says that he can find her profile on a popular personal-page Web site.

Then, she mentions again that she's just 13 and doesn't have much sexual experience. This seems to excite PLEASUREGIVER even more. He turns the exchange to the details of how they can meet for sex:

```
PLEASUREGIVER: u look much older than 13 in
    ur pic........
BEBEGRL: sorry
PLEASUREGIVER: u want me to come over
    still......???........man i would do that
    for sure.......would be very concerned
    bout getting caught there though.....by
    ur parents or friends.....
BEBEGRL: not possible. no one can be here
    before 430
PLEASUREGIVER: so noone will be there before
    4.30 then???
BEBEGLR: yea free and clr
```

Both JEN13 and BEBEGRL mention they are home from school. They both ask PLEASUREGIVER to send pictures. After all, they're talking about an intimate meeting with an older man. He sends an e-mail with several shirtless pictures of a middle aged man, seeming to be standing near a weight-lifting bench.

In each photo, the entire head is cut out of the picture—leaving only the body and a black box where the head should be.

One of the "girls" insists that she wants to see what his eyes look like, but his apprehension kicks in and he explains those cut-out boxes where his head should be.

```
PLEASUREGIVER: can't send my facial pics out
    on the internet dear.....i have too much
    to lose....
    heard to many horror stories of abuse
    with pics on the internet.....
```

This is a common fear for married men in the chat rooms. They are leading double lives and most are afraid of leaving a trail of evidence. But it's also a form of bragging: The predator is impressing on the child that their encounter is dangerous...and, therefore, thrilling.

Caution that Piques Naive Interest

Nearly all of the married men involved in our stings would only send pictures as e-mail attachments; they wouldn't make their photos available to anyone who might click through a public profile—even though they counted on public profiles to find underage partners.

Why the double standard? It could be a generational thing—middle-aged men simply feel less comfortable about making personal images available to anyone.

It could be a matter of *tactical* vanity. Showing his face usually means that a predator would have to admit he's older than he claims. And this might frighten a teenage girl away.

Or, it could be even more cunning. The predators know they're using personal profiles to exploit naive children...and that posting personal details online isn't a good idea.

Most predators are cautious about how they proceed. They usually want to feel certain they are talking with a real child; and only then do they send e-mails with their photographs. But they are often stupid about their feelings of certainty. Many mistakenly believe that a law enforcement agent *must* tell the truth when asked during chats whether she (or he) is a cop.

This isn't true. A law enforcement officer can pose as an underage person as part of a sex crime investigation.

Still, many predators think that by mentioning "entrapment" or asking a chat partner if she is a police officer they ward off any trouble. Most do this in a nervous, indirect manner. They seem more worried about scaring off the potential sex partner than warding off the law.

In the end, this nervous caution gets lost in long exchanges that wander from teenage gossip to popular music to hollow flattery to graphic sex talk.

So, most predators who work online—like sex predators everywhere—are a mix of ignorance and cunning. They know a few basic tactics for getting information on a potential victim; and they use these tactics aggressively. For example, on many Internet services screen names in chat rooms are based on users' e-mail addresses. This means that the screen name BEBEGRL in a Yahoo chat room will likely the e-mail address of BEBEGRL@Yahoo.com.

PLEASUREGIVER used simple tools like this to contact BEBEGRL directly. But, even when sending e-mails, he took the precaution of blocking out the faces in "his" pictures. He might have known that while e-mails are more discrete than chat room posts or user profiles, they're still not secure communications.

He set up a sex meeting, promising to make BEBEGRL's "body quiver all over with ecstasy." And he wasn't surprised that she agreed to invite him into her family's home, even though she had only seen photos of his torso.

After more promises of sexual expertise, PLEASUREGIVER tells BEBEGRL he's leaving his office and is on his way over.

Confrontation and Excuses

PLEASUREGIVER arrives right on schedule, driving the pickup truck he described in the chats. He knocks on the door. But then, instead of finding a child who's ready for sex, he finds television cameras pointed at him from every direction.

He sees his entire life collapsing around him. His double life is being exposed.

As he is pelted with questions, he offers little in the way of explanation or defense. At least at first.

"What is there to say? You got me," he says with a low voice as his shoulders slump down and turns away from the camera. His panic causes him to walk toward his pickup truck in the driveway; but he turns back around before reaching his truck, as if he's lost or trying to figure out what to do or say next.

He struggles with an explanation—saying that he's been trying to arrange sex meetings from his cubicle at work, sometimes spending hours every day online with girls.

"I started accessing it from work only within the past three weeks," he says. "It's an addictive kind of behavior, no doubt. It should be viewed as a sickness...can lead to devastating results."

This is another example of a bold statement ("only three weeks") followed by the weakly-stated hedge ("it's a sickness").

Of course, he's not talking about devastating results for a *child* who may be opening the door to rape or being kidnapped because of a secret sex meeting with a stranger. He's only referring to his wife and children—and anyone who knows him—now finding out what he's doing when he professes to be at work, earning money for his family.

PLEASUREGIVER climbs into his pickup and goes home to his family, just as he would on any afternoon. He doesn't say a word about his encounter, although he flips on the television news while alone in a secluded room of the house.

He'll later admit he imagined the news anchor being handed a slip of paper—and his picture being plastered on the screen. In this dream, the anchor announced, "This just in, a local man is busted trying to meet a child for sex today."

But it doesn't happen. Yet.

Maybe it will blow over, he figures. Why confess to his wife when he might luck out and the sting might remain his secret?

His Wife and Children Find Out

A week later, PLEASUREGIVER is beginning to feel confident that he's gotten away with it. He still watches the local news every night on the station that organized the sting. But he's started watching it with his wife.

This is typical of the self-deluding tricks that many sexual predators use to manage their lives around their abusive acts. To call it "denial" isn't really precise enough; the process is more like a kind of extreme compartmentalization. The predators separate their lives so completely that they believe the effects of a "secret" life will never touch the "normal" life.

One night, PLEASUREGIVER and his wife are sitting on their living room couch when the station runs a piece on local sexual predators.

Is this going to be the end of his double life?

No. The news piece focuses on other men running away from the same cameras in the same sting—but his face and truck don't appear.

His wife of 18 years turns to PLEASUREGIVER and says, "can you believe these guys? These are perverts, I mean, what's the world coming to? These are kids!"

He gets up without responding directly and says, "I'm going out-side for a cigarette."

A few more days pass and, just as he'd knocked on BEBEGRL's door, PLEASUREGIVER hears a firm knock at his door.

A team of U.S. Secret Service agents presents a search warrant for his home computer.

His wife and children are confused and frightened. It's not clear what's happening...or why federal agents are in their home.

As agents look around the house and begin unplugging cables on the family's one computer, PLEASUREGIVER's wife asks them why they have a search warrant. One agent says that she should talk to her husband for that information.

Only then does her husband admit that he was caught in the same investigation she commented on that night on the couch.

His bust was being saved for a different broadcast—one to take place after the Feds completed their investigation.

A Family Falls Apart

Later, PLEASUREGIVER'S wife sat down for an interview with our investigative team. Lighted in silhouette to protect her identity, she candidly described her response to the shocking news:

> My whole life fell apart. My whole life fell apart when I found out that he was part of the investigation. I couldn't believe it! It just totally blows me away. I just can't believe it's the man I'm married to.

When PLEASUREGIVER offered weak denials that he'd gone to the house to have sex with a young girl, his wife shot back: "Why would you go there? If you went there, you had every intent on doing something. I know you would!"

When he realized she wasn't believing the mumbled excuses that she had before, he confessed that he'd had sexual encounters with at least five women that he had "met" on the Internet. He admitted that

he'd found them at the same Web sites and chatted with them in the same manner that he had with BEBEGRL. He swore that the other five were all adults; but no one could verify that. And his wife wasn't inclined to believe him.

After the confrontation with PLEASUREGIVER and his confessions, his wife started thinking about diseases and other worries that a faithful, married woman normally doesn't have to consider.

During her on-air interview, PLEASUREGIVER's wife listens to excerpts from the transcripts of chats between her husband and BEBEGRL. When the reporter gets to the part about a married guy being the safest "sexwise" because he's less likely to have sexually-transmitted diseases, the wife's face twists in disgust.

Clearly, PLEASUREGIVER knew his nearly-anonymous sexual trysts were putting his wife in some physical danger. At least exposing her to risks she didn't understand or agree to take.

Of everything that had happened, the health risk seemed to hit her the hardest:

That's what I told him. I said, how dare you risk my life? I had to go to my family doctor and get tested for everything. I said, "Why should I have to do this?" I said, "You should do this! All those women you slept with should do this, not me!" I said, "You could have given me a death sentence!"

The couple had two sons—aged 12 and 16. The wife said both were ashamed. And confused about why their father had done so much harm to his family. The older son said, ruefully, that his dad was going after girls *he* ought to be dating.

Meanwhile, PLEASUREGIVER's wife felt stuck in the marriage. In part, she wanted to try to minimize the damage and keep her family together...in some fashion. But she also admitted that money was a factor. She didn't think that she could get a divorce and support her sons alone, since her husband had been the family's sole breadwinner for many years.

And she said her husband was continuing his ways. Months after the Secret Service agents had taken the family computer, PLEASUREGIVER had not been indicted—and she'd found a candy tin loaded with Viagra in his pickup truck.

They'd never used that drug as a couple.

She broke down in tears as she described how she hated PLEASUREGIVER—but was still sharing a home with him. She said that she had turned to drinking and had occasional thoughts of suicide.

PLEASUREGIVER's wife said she understood how risky her interview was, even though she would be disguised for the broadcast. Not knowing she'd agreed to talk to our news crew, her husband might lash out at her when the interview was broadcast.

But she was a rational woman who wanted to explain her experiences from her perspective.

It was a brave thing to do.

As it turned out, her fears were warranted. Several months after the raid on their home, PLEASUREGIVER saw his wife on the news. Even though she was shot in silhouette for the interview, he recognized her instantly.

She knew that her interview would be running that night. So, she managed to be at a neighbor's house—borrowing $2,500 to begin divorce proceedings—when the segment aired.

She didn't even get back inside the house. He met her in their yard, grabbed her by the throat and jerked her purse off her arm, tossing her to the ground. The neighbors, who'd expected trouble, immediately called 911 and the local police quickly arrived to arrest PLEASUREGIVER on charges of Assault/Family Violence.

He spent a couple days in jail while his wife moved herself and her children out.

Eventually, he pleaded guilty to the domestic assault charge. He got probation—but he lost his marriage.

This Family is Not Alone

Along with the children who are sexually abused by predators, the predators' families are sometimes victims too.

Children, depending on their ages, hear varying stories about why mommy and daddy are splitting up. Spouses find themselves thrust into financial crises—legal costs, job loss, fines and court fees—that they never imagined.

Anecdotally, divorce lawyers say they're seeing growing numbers of couples breaking up because of encounters that started online. And most of *those* are encounters between consenting adults; sex with minors adds an unbearable amount of stress to the affected marriages and families.

The wife of a different man who knocked on the door in search of sex during our sting had no idea the life her husband was leading. In the days after he was exposed, she found out that he had set up a secret screen name to begin graphic sexual chats with underage girls nearly six months before.

That man confessed to his wife in their home just hours after meeting the TV cameras—although he swore he thought he was meeting an older girl.

The wife didn't care. She told him to get out of the house.

Most of the men acknowledge these risks in the chats with the little girls. They talk of how much they have to lose and how careful they have to be to avoid getting caught.

Some have more to lose than others. And legal problems are sometimes trivial, compared to the devastation to their own families.

But sexual predators keep the risks rigidly compartmentalized—and out of their minds when they're chatting up young prey.

Sexual Predators

3 Selfishness, Desperation and Vanity

I just imagined my face being plastered
all over a news channel.

Instead of flowers, a 41-year-old man who calls himself GOOMAN shows off a quick wit as he tries to lure a child into a sexual encounter.

He's a married man; but in the chat room his marriage is not a hindrance. He mentions it in passing—like some character from a 1930s screwball comedy.

In meet-to-have-sex Internet chat rooms, the competition is fierce. Reliable statistics are difficult to find (in part, because at least some of the people in sex-themed chat rooms are men pretending to be women or girls); but there's little doubt that males outnumber females. *Far* outnumber. So, the males have to impress the females quickly. It's a desperate arena, filled with desperate players. They often have just a few seconds to distinguish themselves from the crowd before a girl breaks off an IM exchange.

GOOMAN knows it. He's good at keeping girls on the line.

He sees the nickname BORI appear on the list of fellow participants in an adult—but not overtly sexual—chat room. He's intrigued and clicks through to Bori's profile to see her picture.

She looks young. And a young girl is what GOOMAN wants.

He sends her a private message that says BORI sounds like a Russian spy. The girl responds by saying his comment is cute.

In a series of IM exchanges that often include just a few letters or numbers, they swap some basic information about each other. And then BORI gives GOOMAN the critical information—her age.

GOOMAN responds with three different messages that indicate surprise at just how young she is:

```
GOOMAN: 14?
GOOMAN: 14?!
GOOMAN: FOURTEEN?!
```

Then, he writes three more messages with quick little jokes about his own age, starting out:
```
GOOMAN: if you reverse that, you would have
        my age. Good ol 41.
```

This may not sound like Noel Coward...or even Nora Ephron. But in the ham-fisted, hormonal world of Internet chat, it counts as snappy dialogue. In fact, having read many online chats, our investigative team wondered whether a real child would follow GOOMAN's attempts at wit.

BORI seems to keep up with him and tells him she loves how funny he is. This is exactly what he wants to hear:

```
GOOMAN: Yeah. I'm funny and old
        way old
BORI: k i understand
GOOMAN: But.....if I can at least entertain
        you
        well...I guess that's good in itself.
        Just realize.... the man you are being
        entertained by is a typical old perv.
```

GOOMAN refers to himself as a "perv"—IM slang for *pervert*—several times during his chat with BORI.

Dr. Melinda Kanner, a University of Houston professor who studies deviant sexual behavior, says that jokey references to a big age difference "de-scarify" it and make the whole exchange less intimidating for the child.

"It creates the illusion that [the predators] are being straightforward," she says. "It creates for them a sense that they are informing their victims of who they are dealing with."

This is important because the predator's main goal in the first exchanges is to keep the child talking (or, actually, texting). Most predators understand that children and teens tend to be insecure, self-centered and vain. And they know that, if an underage girl is doing most of the talking, she's likely to believe she's the center of the predator's attention.

Which she may, in fact, be—but not in the way she thinks. Her brittle teenage vanity blinds her to the dangers that her "friend" poses.

To the predator, the victim exists only as a sex object—a *thing* to be coveted and taken, rather than a person. How to downplay this inherently unkind perspective? Hide behind false honesty and shallow candor.

Kanner likens this self-reference to the classic fable of the frog who sees a scorpion drowning in a river and offers to help. The frog says he'll save the scorpion if it promises not to sting him. The scorpion promises. The frog takes the scorpion onto his back—but the scorpion promptly stings the frog and both animals sink into the water. As the frog sinks to his death, he says "You promised not to sting me! Now you've killed us both. Why?" The scorpion, also drowning, replies "I told you twice I was a scorpion when I got on your back."

Kanner says GOOMAN's calling himself a "perv" is "a way of pretending he won't sting the victim but keeping the option of saying, 'I told you I'm a dirty old man.'" It's a familiar post-modern loop—downplaying bad intention by admitting it from the start.

```
GOOMAN: <<< yup
   I admit it
BORI: were all pervs tho
GOOMAN: ya think?
```

This man tells his young victim that he wants to know what would make her happy on this day that she's skipping school. He says he'd like to offer a few suggestions of what they could do together.

He asks her if she has any other pictures he could see, and he remarks on the one picture she already has posted on her profile.

```
GOOMAN: Well Bori....you are a cutie-pa-
   tootie
But you prolly already know that
BORI: u sure are funny. i love that.
GOOMAN: Have I warned you I'm a perv yet?
BORI: yes
GOOMAN: ....cause after saying nice things
   like that...my mind gets a bit more pervy
   sorry
```

He quickly moves to new territory, asking her whether she would let a 41 year-old man kiss her.

She answers yes and he replies:

```
Well then, let's get it on!
```

He Knows the Consequences...and Ignores Then

Now GOOMAN is working out the logistics in his head. When BORI suggests her family's home is the safest place for the hook-up because her mom never comes home during the day, he's still concerned.

```
GOOMAN: Just... being a 41 yo man with a 14
    yo girl... well,
    that usually adds up to jail time
BORI: she cant come home
GOOMAN: Well Bori.... here is my dilema.....
    I need to know that you are indeed Bori,
    and not one of the honorable law enforce-
    ment officiers that could put a 41 yo man
    in jail."
GOOMAN: <<< Is allergic to jail
```

But GOOMAN's lust trumps his caution. Through their mean-dering text chat, BORI tells him where she lives, details of her sex life, the fact that her mother is out of town on vacation and why she's at home alone. GOOMAN writes some graphic detail about the things he'd like to do to BORI sexually.

Around 10:40 a.m., they've been chatting for almost two hours. And GOOMAN is aroused enough that he says he's on the way over to her house. BORI says she'll take a hot shower to get ready for him.

Of course, BORI is a fictional "girl" made up by our investigative team.

The sting house is ready and set to look like a real home. During the text chat, GOOMAN has described the car he drives. Around 11:30 a.m., a car matching that description drives by once…then twice. Very slowly. But, at the last minute, GOOMAN panics.

At 12:18 p.m. he's back online.

```
GOOMAN: Sorry...I just can't afford to be
    caught in some type of sing operation. I
    wanna trust you....and online I do....
    but as I drove by, I just imagined my face
    being plastered all over a news channel.
```

> ```
> There were too many car's & SUV's with
> tended windows parked on your street and
> even your front porch window had
> mirrors...so I freaked
> ```
> BORI: k
> i have no idea what ppl here drive.

She uses the chat room abbreviation "ppl" for *people*.

Now the interrogation begins.

GOOMAN asks BORI again about her mother's vacation and why she's alone at home. He seems to be trying to talk *himself* into the tryst. Perhaps if the child can explain away the inconsistencies in her story, he will feel ready to come to her door.

This is where the surprises start.

BORI changes her tone and offers GOOMAN reasons that he should back out. Instead of trying to convince him to come by again, she tells him it's understandable that he's afraid. If it's not feeling right, they should both just forget about meeting for sex.

The prospect of losing the tryst seems to push the man past his rational limits.

Worry and Rage

FBI Behavioral Sciences agents, who study the characteristics and methods of predators, say this is common. It's known as "need-driven behavior" and has little to do with thinking. Such behavior makes predators vulnerable to getting caught in proactive stings like this one, even though the stings get news coverage nationwide.

GOOMAN begs the girl not to stop chatting with him.

The computer scrolls with line after line, as he tries to get her back into the groove they had earlier. He didn't like the way she was backing away from him.

```
GOOMAN: Bori?
GOOMAN: Helloooooo?
GOOMAN: Please answer me!
```

Many predators behave this way in a chat room. They know that children are often chatting with a dozen different people at once, and yet they become concerned if the child doesn't answer them quickly enough.

Some predators will fly into fits of jealous rage if they feel a girl is chatting with another man, delaying her answers to the predator's come-ons. And this is before the predator and girl have even met.

GOOMAN starts asking BORI more questions in an effort to verify she's a young girl. He points out inconsistencies in her earlier chats: Why would she say she's concerned about her neighbors seeing her if she would walk down the street to meet him away from her house? He says it makes no sense for her to be worried about neighbors seeing her leaving, and yet she's not afraid of neighbors seeing him actually coming up to knock on the door.

BORI backs away again and says GOOMAN's questions are getting tiring.

Again, he panics and tries to draw her back in again. He assures her he really will come over now.

She expresses doubt:

```
that's what you said last time.
```

Now he's on the way *for real*, he insists.

A few minutes later, the same car rounds the corner—but this time it stops and parks right in front of the house.

A well-dressed man who looks in his forties steps out of the car and confidently walks toward the door. He wears fashionable sun-

glasses and has a full head of grey hair. He's carrying a leather folder. (The folder will be his cover story, so he can say he has the wrong house, if confronted by a stranger or a parent who doesn't understand why he's there.)

He knocks on the door.

The leather folder doesn't help him in the slightest when his fear comes true and TV cameras surround him.

GOOMAN bolts back toward his car.

The camera operators have to sprint to stay up with him. But, just as suddenly as he bolted, he stops and begins to turn as he digs into the folder. He tries to articulate an excuse for his visit, but his thoughts don't quite materialize into words.

While GOOMAN stammers, the reporter peppers him with questions—reading some of his words back to him from the long text chat that had taken place that morning. As GOOMAN climbs into his car, the reporter says, "You were really explicit about what you were going to do to this girl in the chats."

From the safety of his vehicle, he fires back, "No I wasn't!"

He peels away from the curb and speeds out of the neighborhood, then goes home to his computer. We'll hear more from him later.

An Intensity that Borders on Insanity

GOOMAN knew the risk because he'd seen so many reports on the news over the previous year. He had seen other men running from the cameras and he could imagine it happening to him.

But he couldn't control the urge to hook up. Once he found the stimulation of a little girl who was actually ready to meet him, he was unable to let it go. (This same uncontrollable urge causes some predators to continue contacting girls after the girls have dismissed them—turning them into virtual...or literal...stalkers.)

Sexual predators are persistent. They have to be. Often, a child will have second thoughts after agreeing to meet an older man. Friends

or schoolmates might distract her from the online encounter; or the predator might say something that frightens her. The predator knows that a child's attention is fleeting, so he works hard to keep it directed toward him.

Among all of the trends that we saw in our text chats, nothing seemed to stir a predator's attention more than a child who's interested at first and then pushes the predator away. This drives some to begging or pleading and others to desperate levels of flattery.

Whatever the form of their desperation, these predators keep on pushing. They will post dozens of text messages in rapid succession, hoping to come up with that one perfect line that causes the dialogue to resume or continue.

A False Kind of Honesty

One of GOOMAN's online profiles clearly stated that he was married but hoping to mess around—"married but looking" or MBL in chat room shorthand. It's a shallow kind of honesty that's fairly common online—just like his honesty about being a "perv." Many men set up their profiles with this kind of information, hoping the narrowly honest confession will make them seem approachable.

To a teenager or inexperienced young woman, this kind of admission often works especially well. Their lack of social—and, frankly, sexual—experience often leaves them with a self-centered perspective on emotional or romantic attachment. Being naïve, they believe that a man who's honest about cheating on his spouse has some kind of integrity.

A smarter girl or a woman a few years older probably understands that there's no integrity in deceit. But predators aren't looking for smart girls or wise women. They're looking for weak children.

GOOMAN certainly had no integrity—even in his smugly self-professed perversion.

His marriage didn't seem to concern him much when he was suggesting "Let's get it on" to BORI; but, after he'd been caught by TV cameras, his marriage was suddenly his primary concern.

Later that day, he sends text messages to BORI's screen name—realizing now that he's communicating with a news crew. When he thought he was texting a teen, his rapid-fire posts had a tone that suggested a junior-high version of wit. Now, his posts—still scrolling quickly across the screen—have a different tone. They sound scared and desperate...the words of someone who's been exposed.

GOOMAN: What should I do now?
GOOMAN: I have been trying to call in order
 to get some direction

We didn't answer any of these messages. And our silence seemed to provoke him even more than any response would. Just as the girl pulling away seemed to drive him crazy before, our silence prompts message after message—with only a few seconds ticking between each.

GOOMAN: Hello?
GOOMAN: Do I need to turn myself in?
GOOMAN: Is my life ruined?
GOOMAN: Please.... I need some direction.
GOOMAN: Please
GOOMAN: I'm sorry
 curiosity got the better of me. Please
 just [instant message] me and let me know
 what I should do
GOOMAN:and I will do it

The main impression that this one-way communication leaves: A man whose egocentrism may be more dysfunctional than the fragile egos of the children on whom he preys.

Panic...and More Deceit

GOOMAN telephones several of the newsroom managers at the TV station and pleads that his wife will be hurt if the encounter is broadcast.

He tells managers his real name is Charles and that he's 41 years old. The managers—following standard journalistic practice—listen to his excuses and talk of how his life will be ruined...but make no substantive response. They say that they will pass his remarks on to the reporters.

When it became clear that GOOMAN was going to respond more actively than most of the predators we profiled, we did some basic research based on the information he provided in his Internet profiles. It didn't take long to find his real name, age and other personal information.

We knew he was lying about his name—it wasn't Charles. But he was telling the truth about his age. He'd been consistent about that from the beginning of his chats with BORI.

When we finally responded to GOOMAN's pleading messages, we also followed standard journalistic practice. We offered him the opportunity to give his version of what happened on the record and on-camera.

We invited him to sit down for a more relaxed interview where he could talk about his experience with BORI—and, since he'd raised the issue, how it had affected his life and his marriage.

We didn't call out the fake name that GOOMAN had given the station managers...directly. But we did mention his wife's name in this offer, knowing that he hadn't provided her name to the station managers. (We'd found it by searching ordinary public records, based on *his* name.)

From this, he could conclude that we knew his real name.

And, if an on-camera interview was too intimidating, we offered him a less public option. We gave him a special e-mail address where he could explain his perspective, in writing. He could include any comments he wished; we would mention them on air when the story was broadcast.

After our offers, the talkative GOOMAN was unexpectedly silent. We never heard from him again.

Maybe we should have *expected* the sudden silence. The hard reality of his actions must have been too much for a predator who seemed used to talking his way in and out of trouble.

It was too late for him to "spin" this situation. Jokes or witty banter wouldn't do it; the melodrama of desperate pleas wouldn't do it. GOOMAN wasn't going to talk his way out of appearing on television—for his wife, his friends, his employer and many others to see.

We see this behavior with many of the predators searching for children in Internet chat rooms. They're talkative and ready to offer every excuse or sympathetic story imaginable—but only when they think it will keep their "secret life" from being exposed.

Once that battle is lost, there's little these predators have to say in their own defense. They're exposed as sexual exploiters; but they're also exposed as cowards.

4 Predators Like to Move Fast

```
Come on cutie.
Your dad won't really catch you.
You're just being paranoid.
```

Some predators are in too much of a hurry to be careful.

This man calls himself GATORTAIL. He wakes up and begins "chatting" on the computer, and within minutes he is jumping in the shower and driving over to meet a child for sex.

He's one of the thousands of American men who are searching local forums for children at any given time of every day. And he's a prime example of how quickly a predator's pursuit can move from an Internet chat room to a child's bedroom.

The constant need to satisfy impulsive urges will usually cause the predator to make stupid mistakes. Thinking has little to do with predators' behavior when they find children who may be willing. That's part of what makes them so dangerous.

GATORTAIL'S member profile page on a Yahoo! user group contains no photograph, but it does offer a glimpse into what makes him tick:

Yahoo! ID: GATORTAIL
Real Name: Kevin
Location: houston
Age: 36
Marital Status: Single And Looking
Gender: Male
Occupation:
More About Me
Hobbies: TRAVEL...hunting,
 fishing..anything outdoors
 ...reading..movies..hikes enjoying the
 moonlite, good WINE, and of
 course.....LIFE.
Latest News: not much here....I just finihsed
 doing some pottery work for my self.really
 fun. I finaly broke 100000 this yr (not
 takehome..haha)..enjoying the
 weather...and started my joggin again
 3miles in morning

Since GATORTAIL is cruising a local chat room, geared toward people in one particular city, he only needs to hear a particular side of town when he asks BEBEGRL her ASL (age-sex-location):

BEBEGRL: 13fNW

She goes on to write that she's playing sick and skipping school today. GATORTAIL wants more detail:

GATORTAIL: What part of NW?

She answers by naming a particular busy intersection—and GATORTAIL quickly responds that he lives in the same area.

Then the flattery begins. GATORTAIL compliments BEBEGRL on the picture that's attached to her member profile. Then, he sends her flowers.

He does this by clicking an icon on his screen that sends the image of a rose next to the message he's typed to her.

It's called an *emoticon* in the AOL system; other systems offer similar tools. Emoticons allow a user to click on a certain image—such as a smiling face to signify a happy response or a person scratching his head to signify confusion. The rose is just one of the many images available.

BEBEGRL responds positively:

BEBEGRL: How sweet! A girl always loves
flowers!

Showing the kind of romantic he is, GATORTAIL answers that he woke up "horny" and wants to hook up with her right away.

The chat hasn't passed the 20-minute mark and he's ready to meet her for sex.

BEBEGRL texts that she's a little nervous—her dad is working in the same part of part of town today and she's afraid he might stop by to check in on her.

GATORTAIL keeps pressing.

GATORTAIL: Has he ever dropped in on you
 before? Maybe you're just being paranoid.

She answers that her father checks up on her all the time, so she has to be careful. But, in a few days, he's leaving town for work. The coast would be clear to hook up then.

But GATORTAIL still presses:

GATORTAIL: Come on, cutie. Your dad won't
 really catch you.

He says it would be simple for her to walk down the street; they could meet at a business or something and he'd pick her up. They could go back to his place or mess around in the car around the corner. Mixed in with the high-pressure tactics are a few desperate pleas:

GATORTAIL: Please!

Finally, the girl gives in. She agrees she'll try it.
GATORTAIL says he can meet her at a nearby donut shop in 15 minutes.

GATORTAIL: I'll just put my shoes on and
 maybe I should shave. Kinda got a 5 o'clock
 shadow.

He leaves his computer and he's out the door.

The Sting Wasn't Ready Yet

The "cutie" on the other end of this message exchange is just as anxious and excited as GATORTAIL, but for different reasons.

Our investigative team isn't ready for such a sudden response. GATORTAIL is moving faster than we can set up the sting.

This episode happened early on in our investigations; our team was only trying to learn the lingo, abbreviations and the way sexual predators and their prey phrase things online. We didn't expect that predators would be accustomed to moving so quickly.

GATORTAIL had found us before we were ready. But, from previous undercover work, we'd learned that it was best to follow the lead of the people we were investigating. And it would have been a shame to dump out of this conversation, given how GATORTAIL had all the signs of an experienced predator.

By agreeing to the meeting at the donut shop, we were hoping to keep him on the line.

While GATORTAIL is cleaning himself up and driving a short distance to the donut shop, we have time to develop an explanation for why BEBEGRL wasn't waiting there to meet him. We have to make things sound promising for a meeting later, when we're better prepared.

Forty minutes after GATORTAIL wrote that he was putting on his shoes, he's back online.

GATORTAIL: Where'd you go? I looked all over the donut shop.

BEBEGRL answers her dad had, indeed, come home to check on her—and he spotted her standing at the donut shop. He pulled over, drove her back to the house and now she's in trouble.

GATORTAIL asks if her dad is still at home.

BEBEGRL says that he is. Now she's afraid he'll catch her chatting with someone and he'll connect the dots—so she had better sign off.

GATORTAIL seems to understand.

GATORTAIL: it's cool. Maybe tomorrow?

BEBEGRL answers—in rushed shorthand we hope is convincing—that she's definitely planning on skipping school again in the next few days. She concludes the chat by texting:

BEBEGRL: I sure hope we get to meet because you really sound neat.

Some members on the team worry that we don't sound authentic—that maybe our texting style sounds *too* young.

GATORTAIL sends more emoticon flowers.

Setting Up Another Meeting

Once we realized how quickly sexual predators move, we knew that we had to get the elements of our sting in place quickly.

We rented a duplex in an up-and-coming, slightly trendy part of Houston. We set up TV cameras inside and outside of the house and created spaces for hand-held cameras (and camera operators) to follow the predators wherever they might go, once exposed. We set up various Internet services to be the online homes for our fictional young girls; and we took care of other logistical details. Also, we reviewed our sting procedures with friends in local law enforcement.

Our stings were not part of any official police action—but we shared our information on an informal, background basis with law enforcement contacts that we've had for many years. We didn't want to do anything that would prevent law enforcement agencies from using our stings as a starting point for formal investigation and prosecution of the predators we would find.

In a few days, everything was in place and all systems were go. We could begin inviting men over to the house for sex with what they believes were underage children.

GATORTAIL helped us more than he'd ever know. His impatience forced us to get set up quickly. The next time a "cutie" said she was skipping school and GATORTAIL was quick to jump in his car, our cameras would be ready for him.

It doesn't take long to find him again. His computer chat program alerts him that the "cutie" is online, so he quickly sends her a message.

GATORTAIL: good morning.
BEBEGRL: hey darlin
GATORTAIL: hey ya missed ya monday. what are
 you doing?
BEBEGRL: dont know yet
GATORTAIL: what u up too?..
BEBEGRL: tryin to wak up
GATORTAIL: want to get out for a bit?
BEBEGRL: hhmm
GATORTAIL: I hear ya same place?

At this point, BEBEGRL has to explain why she wasn't just a few blocks away from GATORTAIL, as she claimed during their chats a few days earlier.

BEBEGRL: cant get up thr. im trapped at my
 aunts dump
GATORTAIL: awwwww. where?

BEBEGRL mentions the neighborhood where we've set up the sting house.
GATORTAIL: oh ok...kew can u get out??.
BEBEGRL: yeh
GATORTAIL: could come get ya....meet ya down
 the street or something
BEBEGRL: oh god i been thinkin bout you
 since that stupid day.
was so close but then i got jammed up
GATORTAIL: i hear ya. lol. no biggies.

well...i can come get ya....take a ride...or
 go to park.....or whatever.
ur call....I am off and bored....at least
 until later.
BEBEGRL: we could mess around here
GATORTAIL: makes u smile/blush.hahah
MMMMMMM..at ur aunts?......mmmm.maybe bet-
 ter not to be there...
we can see once we hook up.
BEBEGRL: true true
GATORTAIL: all i would need to do is put
 stop by store.....
 <<already put on shoes...lol
BEBEGRL: the store? too early to drintk?
GATORTAIL: lol.....when the last time u were
 eaten till ur legs got wobbly?...
BEBEGRL: iv neeever been eaten like that.
 maybe noone good at it.

The cameras were rolling when GATORTAIL's late-model pickup truck rolled to a stop in front of the house. A stocky man who seemed to be in his mid-thirties stepped out; he stood about 6'3" and looked like he weighed about 230 pounds. He wore a baseball cap over his shaved head and walked with good posture. He seemed pumped up, as if he'd recently worked out or his muscles were stiff from a lot of weight-lifting. The man wasn't particularly handsome or sophisticated; but he looked like he might hold a good job—as his online profile had boasted.

GATORTAIL walked quickly, as if getting to the door in a hurry would make this encounter less risky. But he didn't look nervous; overall, he seemed excited—like he was looking forward to hooking up with this 13-year-old.

He knocked decisively.

We opened the door with the lights and cameras on and announced that we were a TV news team. We wanted to hear his explanation for his sexually explicit chats with an underage girl.

Impatience Gives Way to Impotence

Online, GATORTAIL had been impulsive and impatient.

Now, he responded slowly. He paused for a moment—long enough for some members of our team to wonder whether he was going to get physical.

But he didn't. After thinking for a little while, he did what most of the other predators did when we confronted them. He bolted back toward his truck.

I followed him into the street with two photographers chasing behind. I asked GATORTAIL his chat room promise to make the teenager's knees wobbly with oral sex.

He laughed while making several syllables out of the word, "Noooooo!"

His reaction dismissed the question as if it were the most ludicrous notion in the world. He seemed to imply, "Of course I wouldn't ever say such a thing to a child." But he didn't say so much.

In person, under the lights of public exposure, GATORTAIL's flirty impatience gave way to tongue-tied caution. In the real world, speaking to adults, he couldn't find the words to explain himself. He clearly wasn't good under pressure; and he hadn't planned any excuse, most likely because he'd figured he'd never be confronted about his morning meetings with children.

"They live in the moment. There is only *now*," says Dr. Melinda Kanner, an anthropologist who teaches classes on deviant behavior, most recently at University of Houston.

Even though most predators know what they are doing is wrong, Kanner explains that "It couldn't matter to them less. It's not *here*. It's not in front of them."

GATORTAIL's change in behavior suggests many things. But the most evident thing is that he's not equipped intellectually to deal with bright lights and hard reality. This may explain, in part, why he seeks illicit sex with children. In that environment—and, especially, online—he has an illusion of control that he probably doesn't have in normal daily life.

Kanner says that predators are most at ease when they're fulfilling their immediate urges. They think about their desires so much and keep so busy working to arrange the next encounter that, when they are actually in the middle of it, they find a sort of peace.

But GATORTAIL's peace was over now.

He jumped into his truck and pulled the door shut in the same sweeping motion that seemed to start the engine. He pulled away and was gone from the neighborhood.

Since no police were involved in this sting, the only consequences would be his secret life being exposed on the evening news.

Even though his actions are a felony crime, the Justice Department and several local police agencies chose not to act on what we documented in GATORTAIL's case.

Our investigation followed the same, strict guidelines and legal procedures that law enforcement uses when arrests are made in sting operations. But most government agencies are extremely slow to react to the world of online child enticement; and they want multiple streams of evidence before they proceed. The apprehension is based on their lack of experience with online crimes.

This apprehension meant that most of the men who knocked on the doors of our sting houses would avoid being arrested—even though they all had broken state laws against adults arranging to have sex with minors.

Most people have short memories for what they see on TV. So, it was likely that these impatient predators would resume their old tricks. Some might stop for a while, frightened by the cameras and lights; but, if they're not arrested, they'll eventually start moving again.

GATORTAIL didn't wait very long.

A few days after being confronted with our cameras and having his shamed and inarticulate face shown on TV, he was back online.

In the same chat rooms.

Using the same lines.

5 Predators Groom Their Victims

"(Someone) in the next cubicle online with your teenage daughter who is at home, who you think is safe."

The men prowling for children on the Internet may lack the social or intellectual skills to interact well with other adults in the real world; but most of them know how to make a child trust them more than common sense would suggest.

As we've seen, most predators claim that they're younger than they really are. And they back these claims up by *seeming* younger and less mature during their text chats. This youthful persona is designed to make the child feel more comfortable with the predator.

In real life, predators may be involved in real estate or business deals and shaking hands with CEOs (we never encountered a predator who *was* a CEO, though some clearly had white collar jobs); in the online chat rooms, they dumb down their words and actions.

They pretend they can't spell. They use slang and abbreviations. They ask questions you would expect a child to ask—for example, they frequently ask the child what he or she does for fun. They'll change the subject suddenly (this also works for slipping in graphic sex talk).

Sexual Predators

There are a lot of the people on the Internet. According to a 2005 survey conducted by the Polly Klaas Foundation:

- 56 percent of teen girls who have Internet access have posted a personal profile on the Internet,

- 33 percent of teen girls with Internet access have been asked about sexual topics while online,

- 27 percent of teens with Internet access have text chatted about sex with someone they've never met in person, and

- 12 percent of children with Internet access have learned that someone they were communicating with online was an adult pretending to be younger.

Charles Clickman, the Texas regional director for a safety group called Child Watch of North America, said "You literally could be at work in your cubicle and have a subordinate, a manager, in the next cubicle online with your teenage daughter who is at home, who you think is safe."

Some predators in their forties and older will joke about their lack of computer skills. Others, like this 43-year-old father of an 11-year-old daughter in Dallas, actually joke while grooming their victim in the same sentence. He thinks he's talking to a 12-year-old:

```
DAN55: youll be 13?
AMBERVBALL: yuppr in 2 more mosnth!
DAN55: you need to borrow a cam...so i can
    at least watchu.
AMBERVBALL: whats the fun in that
DAN55: i'd rather be there for sure
AMBERVBALL: u sound like a blast
DAN55: so are you a setter or a hitter?
```

```
AMBERVBALL: setter?
DAN55: in volleyball
AMBERVBALL: we dont call em that.
DAN55: lol....okay i'm old sorry.
AMBERVBALL: i play the net baby! im all over
  it
DAN55: i bet you look good doing it too.
you in the 7th or 8th grade???
```

Grooming

What's the purpose of all this engagement and deceit? Law enforcement experts call it "grooming."

Grooming can be defined as friendly, flattering or supportive actions intended to win the trust of a child—as a first step toward the sexual abuse of that child. Importantly, sexual predators also use the grooming process to isolate the child from people who might protect him or her. Creating this isolation is a big reason that the predator will act like a teen himself.

Of course, grooming can happen online or offline. It's nothing new. But, in the past, a predator had to spend a lot of time in the physical company of a child in order to groom that child. So much time together could draw suspicion. Online text chatting doesn't.

Predators often move between different online formats as they groom their prey. A predator might select a victim from a picture and profile at a school Web site. Then, the predator surfs the Internet, looking for online names the child used on the school site. He'll start by cruising Web sites dedicated to local activities...or interests the child has expressed. If the predator finds the child in an open chat room, he will suggest they move to a private IM chat.

The predator and prey start exchanging emails, messages, pictures and videos. A next step might be even more personal communi-

cation—on the phone or, in some cases, the predator may send the child a prepaid cell phone for private talks.

This all sets up the eventual face-to-face meeting.

According to a 2004 report on sexual predator behavior published of the University of Central Lancashire (located in Preston, England and on the Internet at www.uclan.ac.uk):

> Grooming often involves targeting children who are vulnerable, depressed or lonely. The groomer uses this lack of confidence to develop a relationship with the individual, often the groomer makes promises of true love; and, despite the apparent depth of these relationships, . . .the groomer insists that it is kept secret. Online grooming can take place over a long period of time and a relationship can be developed over months or years before a meeting is arranged.

One important point: A grooming relationship may not be obviously sexual nature—but the reason for the relationship is some form of sexual gratification. . .eventually.

What are the signs that a child is being groomed? There are many; but the most common include:

- the child quickly turns his or her computer monitor off when a parent or authority figure approaches,

- the child receives questionable gifts or money,

- the child receives unexplained phone or credit card charges,

- the child exhibits secretive or changed social behavior.

Despite the impatient men that *we* tended to find in our investigations, sex-abuse experts say that many predators take a lot of time—weeks and even months—grooming their prey.

This is because most predators will be grooming several children at the same time.

Common Traits of Predators

As I've mentioned before (and will again) my conclusions and insights are based on a limited amount of research that took place in one specific city. I probably have more detailed information from actual sex predators than most people reporting on this topic; but I don't pretend to have the kind of data that would allow me to make broad characterizations.

But many law enforcement agencies *do* have that data.

At a 2005 hearing before Congress, an FBI Behavioral Sciences agent testified that sexual predators tend to be white men in their thirties and forties with above average intelligence. Other than that, he said, the men arrested for such crimes come from all walks of life.

A report by a behavioral scientist published by the Justice Department in 2001 listed many traits that are common among predators. The report stresses that each individual trait may be meaningless when taken alone; but, if several of the traits combine, they could suggest to someone who looks at children as sex objects. The listed traits include:

- older than 25 and never married,
- lives alone or with parents,
- limited dating relationships,
- prior target or victim of abuse,
- limited social contact as a teen,
- home or room decorated as a child's would be,
- maintains at least one online profile as if he were a teen (this allows him to talk to more teens),
- premature separation from the military,
- frequent moves from town to town,

- limited social interaction with adults his own age,

- interest in photographing children,

- interest in hobbies that appeal to kids (video games, etc.),

- socializes with kids or participates in youth activities.

There are two other characteristics that are a little more difficult to describe.

First, a predator may seek adult relationships that allow him access to children. Some seek social or romantic relationships with single mothers, so that they can have access to the children. In these cases, the predator will trade time—or even a sexual relationship—with the mother as a means to achieve his goal of sex with her children.

Second, if he's married, a predator's relationship with his spouse will usually be out of balance. This imbalance can take different— even opposite—forms: In some cases, a predator may have a domineering wife; in other cases, he may have a passive "woman-child" spouse. The common theme is that the predator does not have (and may never have *sought*) a balanced partnership with a woman. And the woman he does marry will have low sexual expectations for him; in fact, she may be little more than a cover for his preferred sexual relations with children.

These traits only make up a "typology" of a sexual predator. The typology simply lists factors that, considered together, are traits common to predators.

In other words, the FBI report cautions that simply being a man who's over 25 and never married *doesn't* make someone a predator.

Troubling Words

Predators talk and act like children because nearly everything in their lives is aimed at maintaining contact with children. They are constantly working at it; their online disguises will be truly creative.

In the real world, disguises don't work so well for predators. They can't dress up like a classmate or a cousin and then suddenly shift to suggesting graphic sex acts. But, with relationships that start online, disguises work. Often. A child can feel comfortable that he or she knows an online "friend" and then be confused when this friend starts acting strange.

Of course, what the confused child or teen sees as strange behavior is what the predator has been intending all along. It's the disguise of friendship that's the lie.

What can a parent or family member do to prevent innocent kids from being fooled by tricky predators? One thing, more than any other: *Pay attention*.

Online, be wary of any text chats children have with adults—unless you are absolutely certain who the adult is and why he's chatting with kids.

If that sounds like being suspicious, it's because it *is* being suspicious. And you should be doubly suspicious if the chatting adult combines several of the traits listed in the FBI report.

In thousands of undercover text chats over several years, our investigative team found that nearly all predators employ a handful of common questions, words or phrases. Warning bells should go off for parents or guardians if any of the following exchanges take place in a child's chat room exchanges.

Within the first 10 minutes of a chat, the "friend":

- asks whether the child has any other pictures he or she can post online,

- asks if the child has any brothers or sisters,

- states that he or she is "probably too old" to be chatting with the child,

- suggests that the child should be chatting with someone his or her own age,

- seeks input from the child about the "friend's" looks or profile pictures,

- claims that he or she is a teacher or school bus driver,

- expresses jealousy or anxiety over the child not answering quickly enough.

Parents or guardians should get involved if, at *any* time during a chat, the "friend":

- asks the child if he or she is a virgin,

- asks how far the child has gone sexually with a partner,

- compliments the child's appearance or specific physical attributes (legs, hair),

- expresses interest in calling or trading text messages instead of public chats,

- asks the child if his or her parents are home or when he or she will be alone,

- asks the child if he or she has ever seen someone have sex or masturbate in front of a Web camera,

- asks the child if the child is really a police officer or working with police.

Also, be aware that predators often make abrupt changes in chats when they are grooming children. They may ask unexpectedly if the child wants to have sex or experiment sexually; they sometimes show pornographic images to children to desensitize sexual activity and develop a sexual relationship.

A Pedophile Describes His "System"

Children aren't the only ones experimenting and exploring their sexuality online. Pedophiles are able to experiment more and push their urges forward more directly in cyberspace.

What is a pedophile? Someone who prefers sex with children over sex with adults—even if that person hasn't yet *acted* on that preference.

In other words, a pedophile may not have actually molested a child. He wants to, or he thinks about it. Only when he touches a child does that pedophile become a sexual predator.

Years ago, it was more likely that a true pedophile could live an entire life without ever acting on his urges. In the Internet age, it has become much more likely that pedophiles will explore text chats (at the very least) or other online interactions with other adults who share their interests. And this sharing makes some bold enough to act on their impulses.

Notorious Texas pedophile Larry Don McQuay, who was released from prison in 2005, granted me an interview in 1997 while he was still incarcerated at the Ramsey I Prison in Huntsville, Texas. Among other things, he talked about his progression from a sexually-confused man with vivid fantasies to a serial predator.

He also talked about his system for grooming boys.

McQuay was accustomed to talking with the media; he'd made national headlines in the 1990s when he'd asked to be castrated because he was certain he'd molest again if paroled or released. When I interviewed him, just as the castration controversy was beginning, he described his actions with complete detachment—as if describing another person...or a force of nature that was beyond his control. He didn't seem to understand the fact that *he* was the person responsible for the abuse he described.

McQuay (who had been a school bus driver at one point) started grooming little boys who lived nearby, long before he molested them. He would invite them into his home after school and on weekends. He sometimes spent considerable amounts of time and money to gain a boy's trust. He'd flatter boys about their looks or—more often— their intelligence or athletic skills.

Then, he would gradually move toward discussions of sex and keeping secrets. At first, he'd talk about sex like an uncle or concerned family member—who happened to be a little more worldly or experienced than a boy's own parents.

After he'd talked about sex with a boy a few times, McQuay would cautiously move toward touching, so that he could gauge the boy's reaction. If the boy reacted strongly against, McQuay would back off and apologize; if the boy acted curious or confused, McQuay would touch more aggressively.

He was emboldened by a boy's *weakness* and *hesitation*.

Sitting at the interview table in prison, this predator blinked slowly and folded his hands while he described how he would groom his victims. And he'd been an equal-opportunity predator—while he preferred to talk about boys, he'd also served prison sentences for molesting and raping underage girls. Throughout it all, he didn't seem excited or repulsed by his descriptions; he remained calm, as if talking about the weather.

After McQuay had molested a boy, there would be more talk. He would reiterate the "trust" that he and his victim had in one another. He'd either imply—or sometimes come out and say—that the deep friendship and connection they shared wasn't affected by the physical line he'd just crossed.

McQuay expected to be arrested after he'd molested the first few boys. When he wasn't, he approached others...until he'd developed a "system" for victimizing children. And his system worked. At his criminal peak, during the 1980s, he spent all of his free time grooming new victims and growing hungrier for more.

Once he'd touched a boy's genitals, McQuay would move further into the sexual realm—including masturbation and sodomy. When the sex had gone that far, he needed to take more drastic measures to keep the child silent. He found that threatening to kill the boy's family worked best.

Later, when he finally had been arrested, McQuay claimed he'd molested or had sex with more than 200 children in the San Antonio area. (Some law enforcement officials dismissed that number as a perverted boast; others thought the real number could even be higher.)

The Internet as Grooming Tool

In the hands of a sexual predator, chat rooms, instant messaging and other Internet applications become—more than anything else—tools for grooming victims. Much of the "trust" that Larry Don McQuay worked weeks and months to build can developed before a predator and victim ever meet in real life.

This means much less risk for the predator. It also means psychological and emotional damage may already be done by the time any sexual act takes place.

One of the most important effects of grooming a child for sexual abuse: The child is conditioned to think of physical contact as a foregone conclusion. The predator will work to convince the child that they've already broken taboos—or laws—together by talking about sex online or sharing pornographic pictures. If the child believes he or she is already "in trouble," going through with a sex act (that he or she may barely understand, anyway) may seem like a small thing.

Something else that McQuay said seems to be true of most predators: When they get a system in place, they stick with it.

A grown woman in Texas remembers falling for a pedophile's well-rehearsed routine.

She was 15 and well developed, with blonde hair that fell below her waist. The school photographer was a good looking, "well put together" man in his fifties who picked up quickly on her interest in the mechanics of photography. The photographer offered to teach her about his art. He invited her to come by his studio after school one day; and she did.

In the studio, the photographer said he'd start by taking some pictures of the girl. After some routine shots, he asked her to pose for some "drape shots," where she draped a velvet sheet across her breasts.

The man lowered his voice and she remembers "as if it was yesterday" that he told her, "I don't know if you've ever made love with a man before, but at this moment you sure look like you have." He moved toward her, kissed her and their relationship quickly proceeded to sex.

The photographer knew what to say and how to act to create the illusion that he was a sophisticate and a worldly man. The girl liked the secret she was keeping from her parents—although she wasn't keeping it from her closest friends. "I thought it was cool. I thought it was swanky" to be involved with an older man, she says.

But suburban Texas wasn't the setting for *Dangerous Liaisons*. The girl worked occasionally in the man's photo studio for several years and they'd have sex sometimes. She got older, cut her hair...and the affair faded. He moved on to affairs with other young girls he was photographing.

Like today's predators, the photographer was grooming teenage girls and gullible women wherever and whenever he could. His system—using the pretext of pictures and art to lure prey—was as carefully-constructed as McQuay's or any other predator's.

Looking back, the woman realizes that her judgment was weak at an impressionable age. She knows she was a victim, just as so many kids become victims online today. And she wishes her parents had been paying more attention, because her trouble could have been spotted—if only they had been looking for it.

Female Predators

Although less common than men, female sexual predators follow many of the same grooming patterns—online or in person.

Frankly, female sexual predators aren't prosecuted as often as their male counterparts because of old-fashioned stereotypes about heterosexual sexual abuse not harming boys as much as it does girls.

Beginning in late 2004 and running through 2006, a number of stories about female sexual predators did make national news in the U.S. The women—including Floridians Debra LaFave and Tammy Huggins, Coloradans Gwen Anne Cardozo and Nicole Andrea Barnhart and Californian Margaret De Barraicua—were teachers or teacher's assistants who preyed on students they'd met at their schools. In some of these cases, the victims were in their late teens and the sexual encounters were arguably consensual—but, in some of the cases, the victims were under 14.

The cases seemed to provoke more jokes than serious discussion in the mainstream media.

In January 2006, Sarah Bench Salorio—who'd been a middle-school teacher in southern California—was sentenced to six years in prison after her conviction for molesting two of her students and one of their friends. (Two of the victims were 13 and one was 11 at the time of the encounters.) The court noted that Bench Salorio spent time "grooming students through dinners, e-mails and phone calls."

At her sentencing, Bench Salorio said: "I am a good person. I made some horrible mistakes. I will beg and pray for the forgiveness of the families and all of those that I hurt."

On the other hand, her attorney drew on every outdated stereotype when—at the same hearing—he argued that there is

> *a difference between a woman having sexual contact with male children and a man committing the same kind of crime against female children. There is a distinction. It's not right. It's still a crime. But it should make for a distinction.*

As long as biases like this remain—and they're likely to remain for a long time—female sexual predators will remain more of a punch line than a problem to be solved.

Sexual Predators

About the same time that Bench Salorio was being sentenced to prison, a Houston dental hygienist was fighting to keep a woman who'd preyed sexually on the hygienist's underage son behind bars. That female predator—a woman in her late thirties, at the time of the encounters—was eligible for release from prison after a shockingly short term.

The hygienist was bothered that female predators don't get the same attention that male predators get, because she said, "they are definitely out there."

Her son had never been the same since his "affair" came to light when he was 12.

The female predator found the boy online; and they chatted for months before finally meeting for sex after school. The two started a "relationship" that the son believed was genuine.

He was angry with his family for getting police involved when they found out that his "girlfriend" was actually a woman who was nearly 40 years old. Echoing the misbegotten beliefs of many groomed victims, the boy believed the woman was the only person who truly understood him. He believed he was in love.

And, years later, he still had some of these feelings for the woman.

Police told the hygienist that the female predator had used the same grooming techniques that male predators use—flattery, isolation, suggestion—to build an illusion of trust.

In fact, the police said, female predators often have an even more intense emotional lock on the young boys they groom than their male counterparts do.

6 Predators' Excuses

That wasn't me.

In an instant, the predators we confronted changed from arrogant, impatient roosters to stammering, uncertain cowards. They searched for excuses—but, most of the time, weren't able to offer them with much conviction.

They'd come to the door hoping to find a child; then they'd back off, looking for a way of escape.

One 44-year-old man held up a realtor's card in his trembling hand when the lights went on. Later, when he could manage to speak, he weakly asserted that he was checking out properties in the area.

Likewise, the predator who used the Internet handle GOOMAN held up a leather notebook like some kind of shield when he'd been confronted. It was meant to be his cover if a parent—rather than a child—answered the door; he didn't seem to know what to do with it when he saw cameras.

Both the real estate guru and GOOMAN abandoned their excuses pretty quickly when we kept pressing with questions.

Others blamed friends or computer pranksters for causing them to show up at the door.

When we read them excerpts of their sexually-explicit text chats, many said exactly the same thing: "That wasn't me!"

They claimed that friends or acquaintances had done the texting and arranged to meet the children. Then, these mysterious friends had convinced them—innocent dupes—to go to the house.

That story usually collapsed after a few moments. Few of the predators had the strength of will to stick with their ludicrous cover stories. But they usually didn't take responsibility for their actions, either. They remained in a confused state of vague denial.

Psychologists call this "cognitive dissonance"—when people try to separate themselves from their actions. The dissonance stems from a person needing to take two different stances on something...and those stances are in direct conflict with one another.

In the chat room, a 22-year-old Houston man calling himself CLEVER_BONILLA took only a few minutes to ask a 14-year-old "girl" if she liked older guys.

CLEVER_BONILLA: how old u been with
CLEVER_BONILLA: meanin like whats the odlest
u been with

She didn't answer. Instead, she asked him about a dog that appeared with him in the main picture on his online profile.

He quickly offered to send her other pictures of the dog; but he also wanted to send her "naughty ones." A series of e-mails proved he had plenty of pictures of male body parts that he claimed were his.

CLEVER_BONILLA: here is my pic
CLEVER_BONILLA: its a naughty one ok
LORI92: koo [chat room slang for *cool*]
CLEVER_BONILLA: u see it
LORI92: omg [*oh my gosh*] u r big

CLEVER_BONILLA: good or bad?

LORI92: u tell me?

CLEVER_BONILLA: good

CLEVER_BONILLA: what r u thinkin?
 whats the oldest u been with n what u did
 with him

LORI92: guy said he wuz 35
 we just messedd arounb

CLEVER_BONILLA: oh ok
 u still a virgin?

LORI92: yeh that ok?

CLEVER_BONILLA: yes i dont mind

LORI92: koo

CLEVER_BONILLA: anythin u want to learn

LORI92: everything hmmmmmmmmmmmmmmmmm

When CLEVER arrived at the house to meet LORI92 for sex, he appeared—like several of the other predators who'd come to the door—considerably older than he'd been in the pictures he'd posted on the Internet.

He had a thin face, some scraggly hair on his chin and a short haircut. He was tall and lanky—but in a gaunt rather than healthy way. In his chats, CLEVER had said he was a computer repairman by trade; but this seemed like a stretch. He was dressed in shorts and a cheap, baggy shirt. Maybe he wore these clothes by choice; but his demeanor suggested he couldn't afford anything better.

When the cameras and lights turned on, CLEVER's excuses made little sense. His voice was convincing...for a few seconds. But soon it trailed off into mumbling. He only had enough tricks up his sleeve to buy a few moments of talking his way out of trouble.

He hadn't thought through his emergency exit.

> *REPORTER: We got a transcript of you chatting with this 13-year-old girl. You're sending her pictures of your private parts, you're asking if she's a virgin.*
>
> *CLEVER: That wasn't me, sir.*
>
> *REPORTER: Well what are you doing here then?*
>
> *CLEVER: Hmm?*
>
> *REPORTER: What are you doing here then?*
>
> *CLEVER: I just came because someone told me to come.*
>
> *REPORTER: The picture you sent in the chat was you. I'm standing here looking at you, and now you're telling me it's not you?*
>
> *CLEVER: That's correct.*
>
> *REPORTER: So what are you doing here? {It says here:} "My name is Clever."*
>
> *Clever, what are you doing here?*
>
> *CLEVER: Somebody's been using my ID.*
>
> *REPORTER: Someone's using your ID and telling you to come over after a chat with a 13-year-old girl. Doesn't make much sense, does it?*
>
> *CLEVER: Not at all.*

Perhaps he was hoping to hear "Okay then, thanks for explaining that." And he could walk away. Instead, the questions kept getting worse; surprisingly, he stuck around to answer them.

> *REPORTER: Are you telling me that somebody else is sending your picture to this little girl?*
>
> *CLEVER: No, sir.*

REPORTER: What are you telling me?

CLEVER: I don't know.

REPORTER: Haven't you seen the news, people getting in trouble for this?

CLEVER: That's correct.

REPORTER: You've seen the news.

CLEVER: Correct.

REPORTER: And you're here anyway?

CLEVER: Correct.

REPORTER: Doesn't make any sense!

CLEVER: Correct.

REPORTER: Did you make a mistake here?

CLEVER: Yes, sir.

Then, as if the idea just popped into his head, he said he was only coming over, from all the way across town, because he felt sorry for the girl. He wasn't planning on doing anything with her, he said. Instead, he wanted to talk to her about her statements earlier in the chat room about skipping school.

We found several of the men who, when confronted, would say they were only there to talk. Or to help a troubled child. These are seemed to be the easiest—if not most believable—excuses.

"I just came over to talk to her!"

Even when their text chats focused on nothing but sex (or, in another man's case, he said he would shower with the girl as soon as he arrived), it made sense to these addled predators to claim they were only making the trip to talk to the teenager.

Sexual Predators

A 2001 report on predators' actions (cosponsored by the U.S. Justice Department and the National Center for Missing and Exploited Children) titled *Child Molesters: A Behavioral Analysis* says many men who show up for sex meetings employ this excuse. They'll claim it was just a fantasy or they were trying to help a troubled child.

The report says some men even claim that they have such vast experience online that they knew before leaving the chat room that they were not really chatting with a child. They claim their wealth of cyber-knowledge led them to believe they were really talking with an adult, so they were coming over to see that adult.

The report goes on to note:

> *Many individuals who report information to the authorities about deviant sexual activity they have discovered on the Internet must invent clever excuses for how and why they came upon such material. They often start out pursuing their own sexual/deviant interests, but then decide to report to law enforcement either because it went too far, they are afraid authorities might have monitored them, or they need to rationalize their perversions as having some higher purpose or value. Rather than honestly admitting their own deviant interests, they make up elaborate explanations to justify finding the material. Some claim to be journalists; researchers; or outraged, concerned members of society trying to protect a child or help law enforcement.*

Some experts say that sexual predators may even *enjoy* the lies. According to an online paper written by Prof. Tom O'Connor of North Carolina Wesleyen College:

> *Getting away with their lies empowers {predators}. Although rationalizations or excuses are sometimes used, most pedophiles prefer the outrageous lie or blatant denial to play on the human incapacity for dealing with something so outrageously the opposite of what's expected to be said.*

Dr. Melinda Kanner has seen this expert level of excuse making in her studies inside prisons and mental institutions. She said, "They think everybody else is stupid. They think we're all boobs....and they have magic answers that we're too stupid to see.

"We're not hard marks for them. We're easy. They worry little about us. All they care about is—is that *little girl* going to buy this story right now, this minute," Kanner said.

Breaking the Law

Assistant U.S. Attorney Martha Minnis, who prosecutes child enticement cases for the southern district of Texas, says that if a person chats sex with what they believe to be a child, and then takes a single "affirmative step" toward meeting that child for sex, it's a federal crime.

There doesn't have to be a real child. Any law enforcement officer or news reporter or parent could be posing as that child and the crime is committed once the man arrives at the meeting spot.

Minnis says she instructs agents to try to tie the chat dialogue to some defining characteristic of the person who arrives for the tryst. This means getting the predator to describe what he's wearing or what he's driving...or getting him to agree to bring beer or another specific item for the child.

Then, when the predator arrives in that car, or in those clothes, or holding that beer, it's tougher for him to say he wasn't the person doing the chatting.

In our operations, we got numerous men to knock on the door with alcohol in hand for a 13-year-old child.

We tried to get some to pick up a pizza for the hungry girl they were about to meet. It would have been quite a site to see the man arriving at our door with a steaming pizza, but it didn't happen. It seemed to be too much effort for the men who were in a hurry to meet the girl and were downright nervous about doing so.

"I Wasn't Thinking"

CLEVER_BONILLA was still being questioned with cameras in his face when he offered another common predator's excuse: "I wasn't thinking."

He was certainly thinking long enough to drive across a major city. He seemed to acknowledge this conflict—but he still insisted that he'd only come to talk. He didn't make much sense.

Then, he drove away in what turned out to be his mother's car. And he headed back to the large home in a new subdivision where he lived with his parents.

Officers in the Internet enticement unit of a small town police force near Houston recognized CLEVER_BONILLA when he appeared on the evening news. Detectives from that town contacted our investigative team and said CLEVER had sent the same lewd picture to them, when they were posing as a child online.

They'd even recorded the man's live Web camera feeds to their undercover "girl."

"It's practically the same chats, it's just like he had a script that he stuck by," said police detective Roger Williamson. The detectives were surprised by how similar his chats were, compared to CLEVER_BONILLA's chats during our TV news sting.

(Williamson asked that his specific city and police department name be withheld, so that future online enticement cases won't be jeopardized by publicity on his small department's efforts.)

"He was very forward with his chats," Williamson said. "Within a few lines, he was already asking if you like older men, do you have any nude photos, would you like to meet, and this was all within a couple of hours of talking to him on the Internet."

During their chats, CLEVER_BONILLA had asked the "underage girl" whether she would watch his web camera. Williamson's colleagues pressed the "Accept" button CLEVER provided. Then, a window opened up on the police computer and a live-feed video began of

a man fondling himself. A short while later, when the man sat down, his face could be made out clearly. And the police computers were recording everything.

A few days after the broadcast, local police arrived at CLEVER_BONILLA's parents' home and arrested him on charges of "Displaying Harmful Material to a Minor." Just like federal laws, Texas state law is written so that there doesn't really have to be a minor involved in order for a predator to be charged with the crime.

Police said they'd been clear about their "little girl's" age during the chats. Knowing this, CLEVER had provided photographs and the Web camera masturbation feeds; so, a crime had occurred.

While being led away handcuffed and in bare feet, CLEVER (whose handle seemed less fitting with each passing day) again denied that he'd done anything wrong.

He was actually 26 years old, four years older than he claimed to be during the chats with our investigative team's LORI92. His work history was nothing like the high-tech career that he'd claimed online.

Detective Williamson said, "He never denied any of the accusations. Whether or not he meets little girls, we don't know. But he did admit to sending explicit pictures across the Internet."

CLEVER_BONILLA posted bail within a couple of days and was back home with his family. Then, a few months later, he reached an agreement with local prosecutors and pleaded guilty to a misdemeanor. He was placed on probation; but he remained on the Internet.

Months later, in early 2006, CLEVER's main online profile continued to contain adult content, according to the disclaimers offered when anyone would try to access it.

Even though it was only a misdemeanor guilty plea and there was no solid evidence that CLEVER would actually harm a real child, Williamson looks at cases like this as warning signs that law enforcement has a hard time catching predators—until they've done more serious harm.

Sexual Predators

The officer shook his head as he said, "Every day we hear about children being taken from their homes, the security of their homes, by people that lured them away on the Internet."

And those people wrap themselves in psychological blankets of confusing, mumbled excuses.

7 Predators Don't Change Their Spots

Before all this, I thought a predator is someone who lurks in the bushes. I didn't think I was one. But then I realized the computer monitor was my bushes.

It was one close call after another for a predator named Jake Matthew Clawson.

He'd lost his virginity to a woman he met online—but that encounter didn't lead to a relationship. He preferred children. Later, police caught him with a naked child in his car but, for some reason, the officers let him go. He went right back to cruising Web sites for young girls interested in having sex with older men. A short time later he had another close call, nearly getting caught in a sexual rendezvous with another underage girl—but, again, he slipped away.

And he went right back to the Internet again. It didn't take long for him to find another teen he wanted to seduce.

```
MRMONDAYNIGHTWWE: hello how are you today?
    hello jenni
JENCOWGRL: sup
```

MRMONDAYNIGHTWWE: not much how are you?

JENCOWGRL: kinda bored

MRMONDAYNIGHTWWE: me too, where in the houston area do you live?

JENCOWGRL: NW

MRMONDAYNIGHTWWE: cool

wow your very sexy sweetie

i live in the clear lake area

JENCOWGRL: ty (saying *Thank You* for the sexy comment)

MRMONDAYNIGHTWWE: you like the rodeo alot?

JENCOWGRL: LOVE the rodeo

my favorite time

MRMONDAYNIGHTWWE: im hoping to go to see george strait

i have seen him the past 2 years at the rodeo

JENCOWGRL: i like reba, probly jessica simpsn this yr

MRMONDAYNIGHTWWE: yeah she is sooo dintzy i swear

JENCOWGRL: dumb as a hammer, but I love her singng

MRMONDAYNIGHTWWE: she has a good voice, i dont think i couldmarry her,

she would be annoying after a while

JENCOWGRL: i like when guys say that.

my last bf just didnt car. just said shes gorgous

MRMONDAYNIGHTWWE: yeah if you put a mussle on her

JENCOWGRL: nah

you asl?

MRMONDAYNIGHTWWE: 24/m/clear lake you
JENCOWGRL: 13fNW Houston

Clawson is a far cry from the college professor pedophile in the famous Vladimir Nabokov novel *Lolita*. He's a 24-year-old pizza shop manager whose screen name reflects his passion—for a World Wrestling Entertainment television show. Pro wrestling.

But his online chats could teach psychology professors a thing or two about grooming young girls. He starts slow, mentioning the girl's picture and information she's placed in her online profile. And he talks about usual teenage interests: music, media celebrities and going out. He asks the target what she thinks and encourages her to do a lot of the texting.

Once he establishes that the child isn't running away from him, he moves in.

MRMONDAYNIGHTWWE: wow is that really you in
 that pic?
JENCOWGRL: who els wuld it be?
MRMONDAYNIGHTWWE: cuz you really gorgeous
JENCOWGRL: ty
MRMONDAYNIGHTWWE: you go to school?
JENCOWGRL: yeh Hamilton (a local middle school)
MRMONDAYNIGHTWWE: you out of school for the
 day?
JENCOWGRL: playin sick (cough)
MRMONDAYNIGHTWWE: lol
 so are you still a virgin?
JENCOWGRL: early to ask that.
MRMONDAYNIGHTWWE: im sorry
 i just figure that alot of guys hit on
 you.

Vulgar and Effective

In a few minutes, Clawson sends JENCOWGRL a smiling and confident picture of himself. We'd eventually find out—as we did many times—that it was a picture from several years earlier.

Throughout the text chat, Clawson compliments JENCOWGRL on the picture she posted in her profile.

Over a period of several days, he chats with JENCOWGRL about various popular media personalities and celebrity news teenage girls usually follow. He also slips in some fairly graphic sex talk.

His favorite theme: How "hot" it would be if she worked for him at the pizza shop. He would pull her into his office, making her co-workers think she was in trouble for something. Then, with only a thin door separating their naked bodies from the other (mostly teen-age) employees, they would have sex over and over again on his desk.

He talks about how sexy it would be to keep his other employees from knowing what was really going on. This grooms her to think about sex with him as a thrilling secret.

While he's texting these sex stories, Clawson also mixes in a lot of flattery. He writes that it would be obvious what was going on be-tween them at the pizza shop because JENCOWGRL is "so pretty."

When he first propositions her, JENCOWGRL doesn't answer quickly enough and he starts to retreat. We'd seen this before, too: Predators jump from topic to topic a lot. In some ways, this mirrors normal teen conversational style; but it also accomplishes a couple of other things. First, it allows the predator to talk about sex and then change the subject if the child seems frightened or nonresponsive; second, it can groom the child to give the predator permission to talk about sex.

How much of this psychology does a 24-year-old pizza shop man-ager realize he's using? It's impossible to know. But Jake Clawson was not an Ivy League graduate; his ability at grooming young girls might have come from trial and error in many text chats. Of course, in many

cases, the expertise comes from experiences that predators had—as victims of sexual abuse in their own childhoods.

Wherever he got it, Clawson had a reptilian proficiency at getting young girls to agree to sex.

MRMONDAYNIGHTWWE: i wanted to see if you
 wanted to meet up today.
MRMONDAYNIGHTWWE: well i guess not ill let
 you go
JENCOWGRL: shit sorry
dont be mad
i am starving and i wish i could get drunk
MRMONDAYNIGHTWWE: why are you starving?
no food in the place?
JENCOWGRL: crap
bet you dont like pizza, huh?
MRMONDAYNIGHTWWE: i have some sausage that
 you can eat
JENCOWGRL: i woke up all horny
 i keep thinkng about that office idea
MRMONDAYNIGHTWWE: you ever met anyone from
 the net?
JENCOWGRL: once
MRMONDAYNIGHTWWE: how many guys have u been
 with?
 altogether
JENCOWGRL: i told you
MRMONDAYNIGHTWWE: noyou didnt
JENCOWGRL: m y ex boyfrned is all, but ive
 messed around w some others
MRMONDAYNIGHTWWE: well do you wanna fuck
 today?

JENCOWGRL: my god
 can you come over here w some beer?
MRMONDAYNIGHTWWE: what will you do if i bring
 sme beer?
JENCOWGRL: i m already all over u
MRMONDAYNIGHTWWE: whats your address?

The Bust

Clawson tells JENCOWGRL that his name is Jake. And he wants to call her when he gets close to her address—to make sure she is still alone.

Our female TV producer answers his call. Clawson says that he has bought the beer and he's driving a white Oldsmobile.

Minutes later, his older, cheap-looking white car pulls up directly in front of the house. He parks on the wrong side of the street, closest to the front door.

Most men usually would avoid such a bold parking maneuver, since it draws attention to them. And attention is the last thing they want when they're hooking up with an underage girl. Clawson may be used to this kind of thing…or he may be anxious to get inside…or he may just be an inattentive driver. Whatever the case, he doesn't seem nervous or ashamed.

As he climbs out of the car with the six pack of beer that he promised his 13-year-old hook-up, Clawson clearly matches most stereotypes of a socially awkward misfit. He's over six feet tall—thin and gangly, rather than imposing. He's dressed casually (and in better-quality clothes than most of the predators we filmed); but there's something odd about the way he dresses.

Although the clothes are nice enough, they seem a bit boyish for an adult in his mid-twenties. They're the kind of clothes a conservative mother might buy for her teenage son.

And, once again, the predator chose his Internet pictures carefully. His online profile picture made him look younger, more attractive and more physically fit. The man carrying the beer toward the front door of the duplex looked more like the stereotypical nerd, with glasses and thinning hair.

Cameras are rolling everywhere. One view, from the bushes in front of the duplex, shows him approaching the porch. The camera peering out the peephole in the door shows him stepping right up to the door to knock.

He knocks on the door—and the female producer answers again.

"Who is it?" she asks through the door.

He answers, "Jake."

This goes more smoothly than some of our other confrontations. Generally, we need to establish a name (even if it's a made-up Internet handle) that will tie the predator on the porch to predator in the text chats. Some people are instinctively cautious about saying their names—even if the names are fake. Clawson doesn't hesitate to use his real name.

The door swings open and a TV crew is in his face.

A second camera crew quickly emerges from a side door, making a sweeping approach toward him to catch his every move.

"Jake, I'm a reporter with Channel 2 News, what are you doing here, man?"

He exhales heavily and his entire frame seems to get smaller, like a flower wilting. "I'm sorry," he says, his voice lowered in resignation.

The reporter asks about his chatting up a sex meeting with a 13-year-old girl, and his answer is the same.

"I'm sorry."

After several apologies, he turns on his heels to leave the porch.

"I see you brought the beer you promised the 13-year-old girl."

The camera pans down to the plastic grocery-store bag shaped snugly around the six-pack of beer.

Sexual Predators

Both camera crews follow Clawson to his car, while the reporter keeps asking questions.

Clawson answers again and again, "I'm sorry.....I'm sorry."

He climbs back into his car much less confidently than he ambled out. His shoulders are slouched over and he pulls the door shut, setting the beer on his lap and starting the car.

With both cameras aimed right at him, but now with his car door and window buffering him, he turns toward the cameras and his mouth opens as if he has come up with something new to say.

But no words come out.

He drives away.

We research his license tags to learn his name is full name and home address. From that information, we're able to confirm where he works—and, in time, learn more about his earlier run-ins and near-misses with the police.

After the broadcast of his chat room antics and his on camera apologies, an e-mail arrived in the newsroom from Jake Matthew Clawson. His real name is displayed along with the MRMONDAYNIGHTWWE e-mail address he used for his text chats with JENCOWGRL.

The e-mail read:

> *Dear Mr. Dean,*
>
> *I was one of the guys that was on your Investigative Report on Internet Predators. Ever since showing up at the house about a week or so ago, it has made me re-evaluate every-thing in my life. Eventhough it took something this drastic for me to change my life, it has definetly worked out for the best. Your report has been very insightful but yet very scary. I am highly embarassed to be in the report with all of those people, but you should consider your report to be a HUGE success. UNfortunately, some of those people that you came in*

contact with are not going to change anything and continue to live their lives the same as always. But you have changed me, and have changed my life, and I would like to thank you for your report.

Best Wishes,

Jake

An Arrogant Gamble

Clawson was also articulate when law enforcement agents knocked on the door of his apartment a few days after his visit to the duplex was broadcast on the local news.

The Texas Rangers were on the case, now. They asked Clawson whether he had met underage girls for sex before the TV news sting. Rather than keeping silent or asking for a lawyer, he started talking.

A lot.

His answers gave the Rangers enough to file criminal charges.

Clawson admitted that he had met two other 13-year-old girls for sex. He even provided their names or their screen names, which allowed Rangers to confirm that the girls actually existed.

In later interviews, both girls admitted to Rangers that they had met Clawson for sex before they'd turned 14.

A grand jury indicted Clawson on two felony counts of Sexual Assault of a Child.

One of our camera crews was there as he was led in handcuffs out of his apartment. But, that time, his tone had changed. "Get that fucking microphone out of my face!" he barked, as he brushed past our crew.

Several months later, state prosecutors offered Clawson a plea bargain for a couple of years in prison. He *rejected* it. In court, his lawyer shook his head when asked to confirm the risky move.

Sexual Predators

Clawson's lawyer knew it was a bad idea; but he was professionally obligated to carry out his client's wishes.

After consulting with the defense lawyer, the stunned prosecutor explained that Clawson believed a straight guilty plea—that's *guilty*—without any plea bargain, would prove to the judge that he'd truly changed his ways. And, therefore, he thought the judge would give him probation instead of a prison sentence.

In legal terms, this strategy is called "pleading true." It works—sometimes—for white collar criminals. Sexual predators rarely...*very* rarely...try it. In fact, none of the lawyers involved in the case had ever heard of an accused sexual predator using the strategy.

Maybe Clawson saw himself as something closer to a white collar criminal than a sexual predator.

Given how much publicity the case had received, the state prosecutor said there was no way he would offer Clawson a plea bargain that would keep him out of prison. Any deal would include at least *some* jail time.

So Clawson had rejected a reasonable deal. He looked the judge right in the eye and, in a soft voice, admitted the crimes.

The judge accepted the guilty pleas and scheduled a sentencing hearing for several weeks later.

Under Texas law, sentencing takes place after a presentence investigation (PSI) has been completed. PSIs are exhaustive searches into the defendant's entire life. Officers of the court interview family members, friends and psychologists to come up with a total picture of the person's life. They look for factors that might argue for more or less jail time.

The judge then looks at every single factor in determining what sentence to impose.

Clawson wore a smart suit and tie to his sentencing hearing. He had to show the judge what an upstanding citizen he could be. His parents and other family also dressed up to show the judge their support for his new, law-abiding lifestyle.

"All rise!"

Judge Denise Collins stepped up to the bench in the Harris County 208th District Court.

Known as a tough judge, she had a history of being especially tough on sex offenders and those who victimize children. Every lawyer who had experience in her courtroom—and even those who'd never handled a case before her—knew Collins had a "tough" reputation.

Clawson's lawyer knew about that reputation. He warned Clawson...but ended up essentially shrugging his shoulders while Clawson took the major gamble of throwing himself on Judge Collins' mercy.

The lawyer said it's impossible to convince some people that taking a plea bargain is the right thing to do.

Collins didn't look like a "hanging judge." She seemed interested, even-tempered...and perhaps even sympathetic to Clawson's claims.

This was what the predator wanted to see.

A Predator's Mindset

Clawson's lawyer first called a psychologist and sex offender counselor, Dr. Jerome Brown—who'd been counseling Clawson since his indictment. Brown testified that Clawson was not a classic pedophile or Internet predator.

Instead, the counselor said Clawson "was willing to have sex with any willing female." He didn't discriminate between one willing female and another. Age didn't enter the equation for Clawson, the counselor testified.

This argument highlighted an important distinction that psychologists make between the two main types of pedophiles. *Preferential pedophiles* are those particularly attracted to sex partners of a certain gender and age. They actively seek children if none is around. *Opportunistic pedophiles* prey on children if the children are easily available. They'll take a child because they can.

Brown went on to reveal some other details that had emerged from his private counseling sessions with Clawson: He had lost his virginity to an adult woman he'd met in a chat room, he was sexually immature for his age and he had met seven or eight other females—in addition to the two children—for sex after Internet chats.

Brown sounded credible.

Then Assistant District Attorney Mark Donnelly began his cross examination.

Donnelly made it clear that Brown had bent or omitted some critical facts in his sympathetic portrait of Clawson.

Drawing on data from the PSI, Donnelly pointed out that at least half of Clawson's "seven or eight other" sex partners from the Internet were also underage.

And Clawson had been stopped or questioned by local police several times because of his suspicious behavior. Several months before Clawson was exposed as a predator, a police officer had approached his car—and found a naked child in it. Clawson was apparently able to talk his way out of the situation, because the officer let them go. A short time later, Clawson was having sex with the naked girl's 13-year-old friend.

The prosecutor pointed out that Clawson could have had yet another child sex partner were it not a TV news sting operation. Several questions later, the counselor admitted that Clawson "would not have stopped it on his own."

Clawson's mother took the stand and said her only child had received numerous threats since being exposed on television. She testified that "he never did deny it" and he admitted he had done wrong.

She said her son had come to realize that one bad action can affect many people.

On cross-examination, the prosecutor asked whether she found it odd that her son had worked delivering pizza (often to teens or children) and held jobs at a local bowling alley and a miniature golf course, all "places that juveniles frequent." She didn't have an answer.

Later, Mother Clawson did admit that she was surprised Jake would chat with underage girls on the Internet after the near-miss encounters he'd had.

Dr. Melinda Kanner (who was not involved in the case but watched the broadcasts and read transcripts with great interest) said getting away with taboo sexual encounters so many times actually made Clawson worse.

"It just builds confidence, not getting caught. I can say that with 100 percent confidence," Kanner said. "It isn't like, 'Whew! I got away with that.' It's 'Hey, now I'm on a streak.' It makes them more aggressive. I think it inflames them…it empowers them. There could be more encounters with greater risk-taking behavior" after a near-miss with the police.

Rare Sight: A Predator on the Witness Stand

After his mother had testified, Jake Clawson took the stand himself. This was his best chance to convince Judge Collins that he shouldn't go to prison.

He mentioned his e-mail to the investigative team that had exposed him. He called the investigation a success because, "if you can change one life, it's a success. Others will not change, but I will."

Clawson said he didn't log onto the computer as much since being caught in the TV news sting. He admitted that he'd started to chat with a 14-year-old at one point—but "I said she was too young."

He looked directly at the judge as he testified:

Before all this, I thought a predator is somebody who lurks in the bushes. I didn't think I was. But then I realized the computer monitor was my bushes. I was saying stuff to them on the computer that I wouldn't say in real life. It was a predatory act.

He said that when he'd been caught by the TV cameras, "it was like a kick in the gut. I knew that I needed to change."

His lawyer asked some easy questions. Why had he told the police about the two underage girls that they didn't even know about? Why give up that information when the Rangers arrived to ask him about being caught in the TV sting?

"I wanted to clear my conscience," he said, looking at Judge Collins again. "I felt like it was in my best interest for them to know."

Then it was the prosecutor's chance to cross-examine the admitted predator.

"You said your computer was your bush. Is it just a coincidence that you had so many jobs that put you around kids?"

Clawson said it was.

"Were you online looking for young virgins?" asked the prosecutor.

Clawson answered, "No sir."

Then the prosecutor thrust a copy of the chat transcript from our TV news sting at Clawson. (Police had gotten a copy of the transcript with a subpoena during their investigation.) "Do you recall asking her if she is a virgin?" asked Donnelly, pointing to the relevant line in the transcript.

Clawson answered: "I think that was just conversation.....It wasn't in a sexual way."

It was just something to ask a 13-year-old.

The prosecutor pointed out the line about Clawson having some "sausage" for JENCOWGRL to eat. Clawson admitted what he called "sexual overtones" in that exchange.

The prosecutor asked Clawson about his "lack of boundaries" that his counselor had discussed. Clawson explained that, to him, this meant if a girl was *any* age—30 or 12—he'd make a pass at her. Age didn't matter. He just had a hunger for more sex.

Donnelly wasn't buying this argument. He asked, "Don't you find it odd that all of these girls are 13 or 14, the same age?"

Clawson stuck to his argument. He insisted again that he wasn't specifically trying to find underage girls.

In his closing statement, Clawson's lawyer said "Jake Clawson is basically a good person." He didn't trick the girls by saying he was a movie producer; he didn't force himself on girls who were unwilling. He just wanted sex with anyone who'd say *yes*.

The prosecutor countered that our TV sting "was able to show his true colors." And, he concluded, "there's one place for people like that, and that's in prison."

Clawson shook his head in disagreement.

The judge didn't hesitate for a moment over the evidence and arguments. She quickly ordered Jake Clawson to rise.

Would his gamble in rejecting the plea bargain pay off? Would he get the leniency he was hoping for from a judge with a sympathetic look on her face?

Judge Collins told Clawson that she appreciated his mother taking the stand for him and that she also appreciated that he'd pledged to turn his life around:

> But I have to make my decision based on the crime that was committed. This is about what you've done. I'm assessing the sentence at 10 years in the Texas Department of Criminal Justice Institutional Division. Bailiff, take him into custody.

Clawson slumped, sobbing. His mother began crying loudly from her seat in the courtroom.

Jake was still crying as he was handcuffed and led away to prison.

A few months later, we approached Jake Clawson for an interview from jail about any lessons he'd learned.

I expected that the man who'd been confident enough to send me an e-mail complimenting my team's work exposing him would have a lot to say about his time in jail.

But he declined to be interviewed.

I was able to get a copy of his prison mug shot, though. He'd shaved his head. And his face had gotten years older in months. No more nicely-dressed nerd—he'd turned into a hardened felon.

Sexual Predators

Jake would be eligible for parole after serving half of his 10-year sentence; but he'd be a registered sex offender for the rest of his life.

In my opinion, the bottom line for parents: Sexual predators don't "learn lessons." The more experienced a predator becomes, the more dangerous he gets.

Canadian sex crimes researcher R. Karl Hanson has performed academic research that suggests certain kinds of sexual predators are more likely to keep on pursuing victims—no matter how often they are exposed or even jailed. Hanson works for the Solicitor General's office (the Canadian equivalent of the U.S. Justice Department) and has conducted a meta-analysis of data taken from more than 23,000 rapists and molesters. He's concluded that the following types of predators are most likely to offend again:

- those with more than three convictions,

- those who attacked strangers,

- those who targeted children (specifically boys) and

- those who never completed treatment programs after their prior offenses.

These predators will be willing to do more than others—even than other *predators*—to get the sexual release that they want.

8 Chat Rooms and Instant Messaging

19mNJ athletic. Wanna chat?

People who know the Internet have known for years that sexual predators stalk chat rooms. One of the earliest academic studies on the subject—a 2001 survey conducted jointly by the Pew Charitable Foundation and the *Journal of the American Medical Association*—found that 89 percent of all unwanted sexual solicitations involving teens online took place in chat rooms or by instant messaging (IM).

Chat rooms have been shut down due to the risk of sexual predators. In 2003, Microsoft shut down its MSNChat service in many countries or made the service subscription-based in order to keep user details and increase accountability. At that time, a spokesperson from MSN's Australian unit (called NineMSN) told local media:

> *We've made that decision because we think it will help protect users from unsolicited information and inappropriate communication, in particular towards children.*

It was an early admission that Internet Service Providers (ISPs) knew about the problem.

More recently, in late 2005, Yahoo closed its user-created chat rooms and discussion lists involving sexual topics because so many

were being used as recruiting tools for predators. (In fact, as was widely reported, my investigative team's news reports caused Yahoo to shut down these user-created chat rooms.)

Even more recently, the Web site MySpace.com has come under heavy scrutiny because its teen-focused platform has become a favorite stalking ground for sexual predators.

These companies—Microsoft, Yahoo and MySpace.com—argue that they are not responsible for crimes or abuse perpetrated by a tiny fraction of the millions of people who use their Web sites or services. And there's some merit to their claims.

Chat rooms and IM are two of the most popular uses of the Internet. People like to exchange information, news and gossip with others who have similar interests or beliefs. They also like to swap quick messages with friends in a more private exchange. So, chat rooms and IM will remain—in some form.

Sexual predators and other criminal sorts try to manipulate chat rooms and IM to their advantage, regardless of which company (or government agency) administers the applications. So, the best way people can respond is to understand how chat rooms and IM work—and use each wisely.

How Chat Rooms Work

Chat rooms are electronic gathering places, available through most major Internet Service Providers. Yahoo members have certain chat rooms available, while America Online and smaller specialty or regional ISPs have their own.

One popular Web portal for teachers and school administrators has its own chat forum and other services, for example.

When people log in to chat rooms, they look at a screen that flows with every comment typed by every person who's logged into that room. Each new comment appears at the bottom of the window, and

then it's displaced and pushed upward when a reaction or new idea is typed by someone else.

If five people type comments in a few short seconds, the text scrolls quickly; it can become a struggle to keep up.

A NASCAR fan may log into an auto racing chat room to see what other fellow racing enthusiasts are saying and how they're saying it. To jump into the fray, he simply types a thought or comment into a smaller square on the screen. With one click on the ENTER button, that comment flashes up into the chat room for everyone else to read and consider around the globe. Anyone else logged into that particular room can read it.

Then, in seconds, the reaction to that comment will light up the screen. It's an instant stimulus that can be quite addicting for some computer users.

Sometimes, the computer comes alive with interaction; and certain users in a particular room can become recognizable personalities.

Where else can someone get instant attention and instant response to any thought he or she may want to present? For many Internet users, chat rooms have replaced in-person social gatherings as their main connection with other people.

With all these personalities gathering in chat rooms, it's easy to relate quickly with some of the characters, while instantly disliking other ones.

The reactions can become emotional.

For kids, those emotions can be just as powerful as schoolhouse spats. Being rejected by a friend online can seem just as devastating as being shunned at school. Even hurtful comments from a complete stranger can send a child into a depression.

Teens will often call in their Internet "friends" or try to get to the bottom of a heated exchange with more online dialogue, even if they're not chatting with a rational person. Children sometimes recall nasty things said by a stranger in an Internet chat months—or years—later when talking with parents or friends.

Conversely, positive feedback from a stranger can be just as powerful. Sexual predators know how to exploit those emotions.

Chatting Out of Control

"The curious nature, the excitement nature, no doubt the fear....it's hard to explain," says Allen, a 48-year-old father who arranged a sex meeting with a Houston child.

When he was caught, he swore it was his first time he ever actually showed up for a meeting with a child.

Nearly every man who gets caught swears it's the first time he has acted on his impulses. Most insist their pursuits have always remained idle computer exploration—until this explosive event.

Allen says he started chatting at home, when his wife was away or in another room. His kids always thought he was handling office work. "(Then) I started accessing it from work....the computer is there all the time. If you're within an area where you don't have to worry about others seeing what's going on....." He shrugs his shoulders and his voice trails off as he says this is what pushed his problem out of control.

He spent several hours a day online at work, trying to convince children to meet him for sex.

Men like Allen can deal with rejection online because it's anonymous; he always lied about his age and his name. The chat rooms kept drawing him; they were unregulated and full of young people.

He would never consider approaching dozens of children, one by one, on a playground or at a skating rink. He would certainly be caught. But the Internet offered him the chance to approach hundreds of young girls with little fear. He figured he would know if he was actually talking to a cop posing as a child.

The chat rooms keep some men like Allen busy every waking hour of the day.

Predators Sneak Into Chats

When prowling in search of children, experienced predators know exactly which chat rooms to scan.

They search their local rooms with titles like "Locals and Friends" or "Chicago Chat", depending on the locale.

They love the "Cheerleading" or computer gaming rooms that are popular with kids. They also scan pop culture rooms or those catering to fans of certain recording artists, movie stars or computer games, because these rooms contain many children.

And the chat rooms geared toward children have become the most dangerous rooms for children.

The scrolling dialogue in the chat room is of little interest to most predators.

They don't care about the name calling, the humorous banter or the inane observations that flash up on the screen every few seconds.

Instead, they're searching the field of their computer screen, where there is a listing of every single user who is logged into that particular room. Some rooms allow 20 users at a time—and some as many as 50. The list in any particular chat room could look like this:

```
MiKee81
QTFace4
Htownhottee
BaBygUrRl93
AshleeEEee
BigScott99TX
KarazSOhot
Crazy59John
GameBoyZ93rule
CuteAssNMass
HolaIMJuan42
Hot99ChiKKee
HeathRRzON
```

This is a list that could contain the name of a predator's next victim.

The online identities (or *handles*) are unique; there can be no duplication on any single Web service. In other words, there cannot be two different ALEX44 screen names on Yahoo's Internet portal and there cannot be two SEXYJENNYs on AOL.

This is why strange phrases and complex upper and lower case combinations of letters are so common, since a chat user can only create a name that is not already taken.

Most of the chat services are free or easily accessible on the most widely used Internet portals. For instance, Yahoo's chat forum is free to anyone who downloads the program, while AOL's has one chat forum that is available free to anyone and a separate group of chat rooms only available to paying AOL members.

The predators who sit at their computers for hours every day know how to spot a child's screen name when it shows up on the attendance list in a chat room. As the predators I interviewed seemed to agree, a *real* kid practically jumps off the screen at them.

Anonymity, Sexuality and Limits

A preteen girl's screen name will often contain the word GIRL or some misspelled variation like GRRL, or Spanish CHICA. It's also popular to incorporate a complimentary term or slang like FOXY or SEXY; something a person would like to be called.

Imagine a young girl yelling a nickname across a school cafeteria, as in "Hey chickie" or "Shut up Lori Bori" and it's likely that such a name will show up on a child's screen name.

It is surprisingly common for children to use their birth year or graduation year in their screen name. A hobby or something they're passionate about would also be a good indicator.

The predator looks for any combination of these ideas, CHICKI94VBALL might be a girl who's into volleyball, who's called "Chickie" by her friends and who was born in 1994. Or the handle might be even easier to read: CHEER15ASHLEY is a youngster by the name of Ashley who envisions being a star cheerleader before she graduates high school in 2015.

Kids see their screen name as an expression of their personalities. Some examples (taken from actual chat rooms my investigative team visited):

QTwitaBootie [*cutie with a booty*]

iMaBaBe [*I'm a babe*]

delishaTrisha

Sexy93Chica

You've probably started to notice that a lot of these handles are flirtatious—or downright sexual. Many are.

As I've mentioned before, adolescents and teens live in an awkward middle-ground between childhood and maturity. Their bodies are changing...and their minds are trying to find the right ways to adapt. They test limits of social behavior. These impulses—combined with the anonymity that the Internet can offer—seems to draw out sexual suggestiveness in teens. Especially in young girls.

In their chats, girls can be crude, flirtatious, vivid and vague. All in a few sentences.

This can be a healthy thing. Most of the time, the jumbled mix allows a girl to experiment with how she likes to communicate.

But—in a few wretched cases—a sexual predator will be reading what the girl writes. And trying to manipulate the jumble by being friendly one moment and graphically sexual the next.

A parent or guardian should help a young girl understand how anonymity on the Internet works...and that predators acting like friends can exploit anonymity much more easily than they can in the real world.

Sexual Predators

The anonymity of the Internet leads to many malicious sex-related tricks. One common trick is chat room hoaxing—especially involving alternate sex interests like bondage, domination or group sex. The hoaxers post their victim's real personal information on the profile of a bogus user name. Then, the hoaxers enter chat rooms dedicated to perverse topics under the bogus name and cast around for IM exchanges. They'll make dates; and people looking for... nontraditional... sex show up at the hoax victim's home or office.

Anonymity online is a complex matter. While most people try to remain anonymous to strangers, they want their friends to recognize their handles immediately when they appears on chat room screens.

"Sometimes, I can't remember who some of my friends are because they have so many screen names," says a 14-year-old schoolgirl who lives in the suburbs north of Houston.

When she logs on, the popular Internet portals will immediately list the various "friends" she has chatted with in the past and tell her whether they are online right now. "I have more than 200 friends listed here but I only chat with a few of them," she says.

When a new screen name pops into the list of visitors in a chat room, a predator will leap into action to make contact with that user—if the screen name looks like a child's. For many, this first approach is a compulsion. They react as if they're in a race, hoping to contact the child before someone else does.

Sometimes, the predators contact a child within 10 seconds of a child's name showing up in a chat room. Without knowing anything other than a childish-seeming screen name has joined the chat room, they bombard the newcomer with greetings:

```
hey cutie
hello. asl
```

ASL or *a/s/l*—perhaps the most common abbreviation in the chat environment—is a quick way to ask a person his or her age, sex and location. The question mark is usually left off. It's implied.

Also, when answering a person, the same format is standard. A person's age is listed first, followed by gender, and lastly location (the nation, state or part of town).

A critical point here: Because the Internet is anonymous, people lie all the time about who they are. It's common for a man to subtract many years from his age to be seem threatening to a child.

A greeting a child might see when she enters a chat room:

```
19mNJ athletic. Wanna chat?
```

This person is claiming to be a 19-year-old male from New Jersey with an athletic build. If the child seems interested, he may admit within a few minutes that he is really 25...and he may, in fact, be even older.

Instant Messaging

Sometimes these exchanges take place in the chat room—where anyone can see them. More often, though, they take place through a separate, more private text channel—or *portal*, in Internet jargon—called instant messaging or IM. (On some systems, the same application is called "private messaging" or "PM").

In the race car chat room, someone may post the message:

```
Anyone see that wipeout on ESPN an hour
ago? IM me.
```

After one or two clicks on the computer, that person and another switch to a one-on-one, real time exchange that's like a private chat room.

Predators will often move around from one chat room to another, contacting any participant whose name or texting style sounds like a

child. The child will have a new window suddenly open on his or her computer screen, usually accompanied by the sound of a bell or chimes. In that window is a greeting typed by the person who wants to initiate a private exchange.

Sometimes, it's simple like:

```
Hi Loren, care to chat?
```

But that kind of bland greeting isn't enough to draw in some kids—and predators know this. A child probably needs a reason to chat with a perfect stranger, so evoking some sort of response can be hard work for a twisted mind.

If a hobby or sport is evident in a screen name, a predator may zone in on that. When my investigative team used an online handle that included the letters VBALL, strangers offered opening lines like:

```
Hey, what position do u play?
Is ur team any good?
How long u been playin volleyball, sweetie?
```

Sometimes, the predator will have to work a little harder. If the child has listed personal interests on his or her user profile (and many do), the predator will mention those in his IM greeting.

A Pew Internet & American Life Project study titled *Teens and Technology* estimated that 16 million teens regularly use instant messaging. That's two-thirds of all teenagers in the United States!

For many kids, logging on to an instant messaging portal is their first activity when they get home from school.

While visiting with a Houston-area mother, I watched her 15-year-old daughter walk in the front door and set down her backpack after school. She took three steps and sat down at the computer— logging on to Yahoo, AOL and MySpace.com at the same time. She checked on messages and contacted friends, her fingers flying. She

moved from one portal to another, having conversations on all three. Had the power been out, her routine would have been shattered.

By logging in directly to the IM portal, users don't have to enter a public chat room where their screen name becomes visible to others. Instead, their screen names will pop up as being "Online Now" to friends and other people they've chatted with privately in the past.

They talk about mundane things that happened at school or they'll gossip the way they would on a phone call. For many teens, phone calls are more tightly regulated by parents or babysitters. IM is more private. There's no chance of a voice being overheard if a girl is simply typing words into a computer.

Peaks and Valleys

Multi-tasking is a big part of chat room culture.

Unlike on cell phones, kids can carry on 10 or 12 text chats at once. If there's a lull in one, the child can switch to another. Each time a new message appears during a chat, the box or window on the computer screen changes color. If four windows turn orange instead of yellow, four people have typed messages that are waiting for answers.

In chat rooms, it's not uncommon for the scrolling dialogue to stop occasionally, even if the room is full. This means that if 25 screen names are listed in the room, they are *all* busy doing something else—often engaged in private IM exchanges.

The Pew study found that 48 percent of American teens use instant messaging every day; and 30 percent use it several times a day. On a typical day, a quarter of the teens say they IM for one to two hours each day; 11 percent are on for more than two hours.

Many parents say it's dizzying to see their children with a dozen different little boxes and hundreds of words filling computer screens.

For the children, though, the full screens mean constant stimulus. It's like being at a party with a room full of people—and being able to talk to each one privately about different topics.

Sexual Predators

For the predator, the peaks and valleys in a given chat room or on an IM exchange with "sweetie" or "cutie" require patience. Sometimes, more patience than an anxious 40-year-old man can muster. Law enforcement investigators agree that one reliable indicator of a sexual predator is multiple, impatient or begging posts:

```
cutie, r u there
jen please answer me!!!
wher r u Katie?
```

User Profiles

I've mentioned "user profiles" several times. These deserve some detailed attention.

Almost all Internet Service Providers, IM portals and other applications request that people who use them provide personal information for other users to see. So, in most chat rooms, one user can click through to the profile of any other user at any time.

The information in the profile is usually based on standard questionnaires filled out by every user when his or her e-mail account, IM account or chat room handle is first set up. The questionnaires are often a strange mix of the vague and the very personal. They'll ask questions about marital status, age or hometown, favorite books, quotes or Web sites, favorite music—but they'll sometimes leave out things like name and address.

And, again, people lie often on their profiles. In fact, some Internet users (and these aren't necessarily sexual predators) create several different "personas" whose profiles are completely different from—even the opposite of—each other.

```
panch163's profile
{No photo selected}
 Last Update: 04/07/06
```

```
My Email: Private
Basics
Yahoo! ID: panch163
Real Name: Ted
Nickname:
Location: houston
Age: 43
Marital Status: Married
Sex: Male
Occupation:
Favorite Quotes:
```

Some users provide no information whatsoever in their profile, but others are so thorough that you'd think they were answering a mandatory government census—they offer every detail in their lives.

Young people tend to be more detailed in their profiles than older people are. But a *smart* young person avoids lengthy details.

Why? Because it's so easy for a visitor to a chat room to click on another user's screen name to gain access to that profile information.

Predators will often click on the profile of any new user in a chat room, hoping to find some detail that indicates the new arrival is young and "curious" or "looking."

If the child lists her favorite quote from a recent movie, the predator may try to strike up an IM exchange about particulars of that movie. Anything to provoke a reaction…to get the child to respond to the IM greeting.

Once he gets that first reaction, grooming the prey is simply a matter of keeping the child's interest.

So, a chat room can be as competitive as any singles bar. When trying to lure a potential sex partner into an IM chat, the opening line is important—but there's also a cat-and-mouse dynamic to getting and keeping the child's interest.

In one chat, a guy who calls himself PLAY4ALL searches for the interests of a "girl" my investigative team named AMBER92VBALL— whose profile said she was 13. The predator probes for the child's interests and boundaries; and, when he finds information he understands, he moves in with a proposition:

```
PLAY4ALL: 29/m/sw houston here. Is that cool?
    do you mind talking? u mite be looking
    for guys ur age i guess.
AMBER 92VBALL: uh, no.
PLAY4ALL: so wht u upto? wht do u do for
    fun?
AMBER92VBALL: clubbin if i get an id.
PLAY4ALL: really
    cool.
    how abt this. lets hang out for a while. i
    am bored too.
AMBER92VBALL: k
PLAY4ALL: i am 6ft tall, light complexion.
    we will just hang out and then do whateva
    u wanna do.
AMBER92VBALL: what r u lookin for?
PLAY4ALL: just to hangout. how abt u?
AMBER92VBALL: nevr mind.
PLAY4ALL: what;s wrong. do u want to then?
AMBER92VBALL: tell me what u want to do. i
    gotta know more.
PLAY4ALL: well we can go get ice cream.
or movies. whats on ur mind.
do u wanna have sex?
```

There's the abrupt switch that I've mentioned before. If AMBER29VBALL reacts badly to the unexpected proposition,

PLAY4ALL will retreat—apologizing profusely and relying on harsh self-criticism and flattery of the girl to soften the shock.

Not all chats move this fast. Many predators focus on safe topics, to seem understanding and friendly. Also, they'll offer a steady flow compliments or flattery and show interest in topics the child likes. These exchanges are where grooming starts.

But, even when the process is gradual, it can still surprise outside observers with its bursts of speed.

"It happens very fast. And the escalation can happen very fast," according to Houston Psychologist Barbara Levinson. She counsels paroled sex offenders newly released from Texas prisons.

"They get them to be their friends and then they get into very sexually explicit talk. And that's also part of the grooming. There are men on the Internet that have done this over and over again and haven't gotten caught," Levinson says.

These men aren't stupid. They know how to approach a child and they know how to interest a child and *keep* him or her interested. They know the self-esteem issues many kids face; and they know the other societal pressures that frustrate children and teens.

Homosexual predators can be especially ruthless in exploiting the additional anxieties that teens who are gay—or who think they might be gay—feel.

But straight predators aren't any kinder. A predator will tell a young girl she's special or pretty or smarter than others her age. (The naivete that some girls show in responding to these lines is heartbreaking.) He'll appeal to her vanity, selfishness or insecurity. Then, he'll start to isolate her—at least psychologically, and in regard to their secret "friendship." Then, he'll press for a face-to-face meeting.

Sexual Predators

9 Some Kids Invite Predators In

"The fact that I don't know you, that's kind of wierd."

Two grown men sitting in the gym bleachers had their sights on one of the girls playing in a junior high basketball game. From the court, the girl didn't even notice the two men. But *they* noticed *her*.

The 15-year-old focused on the opposing team. She wore jersey #52 and was clearly one of the best players in the game. She stole the ball and dribbled the length of the court to fire off a shot at her basket. She didn't look into the stands at all. No parents or family were at the games, so why bother?

When she had the ball, some of her teammates called out her name. "Caitlyn!" "Cait, I'm open!"

The men in the bleachers guessed that Caitlyn weighed about 110 pounds. She had an athletic frame—not too skinny, not too curvy. Her black hair was probably shoulder length; but it was tied up in tight braids for the game. When she was playing, she had an infectious smile.

The men knew other things about Caitlyn. They knew what music she liked…what parts of school she hated. They knew these things—

and knew to come to this basketball game—because of things Caitlyn had posted on a "social networking" Web site marketed to teens.

Personal Page Web Sites

Millions of teenagers—and even younger children—express themselves and send messages back and forth on Internet Web sites like MySpace.com, Xanga, LiveJournal, and Facebook.com.

The popularity of these Web sites has coined new words. The pictures posted on MySpace.com are so often taken by people holding a camera at arm's length and photographing themselves that any such picture—online or off—is called a "MySpace picture."

If a couple snaps their own pictures on a beach vacation, then get home and pass the photos around the table with friends they're likely to hear a few jokes about snapping MySpace pictures—even if no computer was ever involved.

Kids, on the other hand, are usually alone when they snap their MySpace pictures. And they're usually alone for most of what goes on in these social networking Web sites.

So, they're *already* isolated—and that much closer to being groomed by a sexual predator.

All of the major social networking Web sites share some common features:

- posting personal information is easy and free (at least for the most basic pages);

- a basic profile page allows the user to list personal information—like name, age, school, religion, sports, favorite music or books and other interests;

- the profile page will include one main photograph—and come with the option of posting many other photos;

- creating a page allows the user to trade messages, similar to e-mails, within the service;

- creating a page also gives the user access to some chat rooms;

- the most popular chat rooms are focused on common interests—such as music (HipHop, rock, country, jazz, etc.), geographic location, sports, etc. In these chat rooms, links will display pictures and names of all active participants;

- search functions, which allow a user to find another user's profile page; and

- browse functions, which allow a user to search of a zip code, city or age group for other users online at a given time.

Most of these Web sites are designed to create a sense of community among people who—in some cases—never meet. The language and rhetoric of the systems encourage users to think of other users as "friends." Profile pages will sometimes include lists of "friends" with whom the user chats often. In some cases, these are real friends from the physical world; in others they are "virtual" friends from...anywhere.

More importantly, a stranger who accesses one user's profile page can identify and send messages to an entire group of friends in a particular social circle. This access helps experienced predators find out all kinds of information about underage users.

Even if a particular child is careful not to post details about where she lives or goes to school, a dedicated predator can click through to her friends' pages and piece together these details.

Handing Predators Everything They Need

Back to the basketball game.

Caitlyn had set up a personal Web page for her friends from school. She meant the information to go to them—not expecting strangers to care about the details of her rather ordinary life.

Making the page for her friends, she gave the whole world enough information to look at her and find her. She gave her school, her date of birth, her hobbies, the fact that her favorite food was ice cream and the schedule for her basketball team's season—including the *location and time* of every game.

Toward the end of the game, Caitlyn was worn out from lots of running and shooting. Her coach gave her a break and, as was the habit at this gym, she sat down a row behind the coach and some of her teammates.

One of the strangers in the bleachers decided this was a good time to do something. He walked down, as if heading to the concessions stand, then crossed to the other side of the court and sat down near Caitlyn.

"Hello, are you Caitlyn?"

The girl hesitated and then answered, "uh huh."

"I saw your page on MySpace and I wanted to come meet you. You said you like basketball and I just watched you play," he said.

Her eyes grew wide with alarm. She was a little confused because she was tired from the game...but this was definitely *weird*.

The stranger tried to keep her from getting up, so he repeated, "I just wanted to come meet you."

Some of Caitlyn's teammates overhead this and surrounded Caitlyn. Then as a group, they moved away from the stranger.

Fortunately for Caitlyn and her family, I was the stranger who approached her. The second man in the bleachers was my partner, a photojournalist with a TV camera trained on the encounter the whole time.

Our exercise was to look for personal information on social network Web sites that would tell us where and when to contact an underage girl—and hunt down as many as possible in the Houston area. We found dozens...and most of their profiles told us where and when to find them.

At the National Center for Missing & Exploited Children, John Shehan in the Exploited Children Unit calls this sort of confrontation "an absolute worse case situation." But he went on to explain:

> We've had these online predators that are trolling through these online journals and blogs. They're establishing when the child's going to be home alone, when the parents are still at work, and they're showing up at these children's homes, without ever even talking to the child beforehand.

Any predator who was looking for a girl with Caitlyn's particular features could click from page to page until he found such a child. Then, he could use the information the child posted with her profile to find her in the physical world. It's easy to do.

In early 2006, MySpace.com reported having nearly 68 million member pages established on its system. With numbers like that, it's become a photo directory of sorts for the wired world.

A Texas medical supply business owner recently sold some office supplies to a woman in an online auction. In follow-up e-mails, the woman identified herself as a waitress at Hooter's restaurant—a chain known for highlighting its waitress' physical features.

The businessman was curious about what the woman looked like, so he typed her name into a search on MySpace.com. Immediately, he came up with the profile this waitress had created for herself. It confirmed her Hooters employment and where she lived. It showed her picture, her friends' pictures and lots of other information about her.

A spokesman at Myspace.com, which is now owned by Rupert Murdoch's News Corporation, says no one under 16 is allowed to post a site. But kids evade the site's perfunctory controls by lying about their age. Some list their age as "99 years old" so the automated filters won't catch them and block them from joining.

Spokesman Bennet Ratcliff has been quoted widely, saying that Myspace.com "immediately" removes anyone found to be lying about his or her age. Such lies violate the site's terms of service.

How does the site find out someone is lying? That's not clear. But, when it does find out, it usually does so *after* trouble has occurred.

The site insists that it's getting better about preventive measures. Myspace.com allows users to set their profiles to "Private"—which means messages will only be received from another user if he or she asks for permission first. This setting also blocks strangers from viewing a private profile without permission.

Tricking His Way In to a Child's Life

Of course, a predators can try to con his way into to a child's invitation-only circle.

A predator can draw in a child by simply modifying his searching or "browsing" techniques on a social Web site.

If he's looking for a young boy with a certain appearance, he can steer around the usual "browsing" feature and instead go hunting within pages that are not set to "Private." If he looks at plenty of young boys' pages, he'll stumble across the boy that looks just right for his tastes.

If a user named Jonathan has a picture that catches his eye, but Jonathan's profile is set to "Private," the predator starts by clicking through to all of the friends listed on Jonathan's page—a user's friends list isn't usually protected by the privacy option. If one of Jonathan's friends doesn't have a private profile, the predator can look for details that might allow him to convince Jonathan that he's a friend.

If the predator clicks into the page belonging to Jonathan's friend Scott, he may read that most of the friends are huge fans of the Chicago Bears or music by rap star 50 Cent. The predator can then create a new identity with a screen name such as BEARSFAN50.

The next time Jonathan logs on, he might find a "friend request" from BEARSFAN50, who texts something like "scott says u like fiddy & da bears." If Jonathan isn't careful, he'll click to allow BEARSFAN50 to access his site—and the grooming begins.

Once the predator is in, he has access to all of Jonathan's pictures and information, and he can also send messages to Jonathan.

Determined predators will try these tricks—and more—to make the first contact.

Some kids may immediately "ignore" or shut out someone if they see it's a stranger; but curiosity about the common interests will often keep the young victim interested long enough for a predator to get in.

And most predators will say *anything* to keep a child's interest.

College Kids as Targets

After my partner and I had gone to Caitlyn's basketball game, we moved on to meet a college girl whose spunk and attitude, along with a cute picture, leapt off her page on the social networking Web site Facebook.com.

Also front and center was her busty profile photo. In the picture, her eyes sparkled at a bar table and her long, dark hair draped down to a pair of beer bottles.

Taylor, a philosophy major at University of Houston, remembered the mood she'd been in when she filled out her personal profile on Facebook.com:

> *Sometimes you're sassy and sometimes you're philosophical, it just depends on your mood. It's kind of liberating to have Facebook because I have a lot of friends who are shier and they can put things about themselves that can express themselves. And it's a great way to meet people too.*

Old friends from high school had found her because of her page.

Her profile listed her real name, her middle name, her major and her high school.

Also little epigrams like, "Truth & love are my law and worship" and "i double-fist sauvignon blanc on sunday at the houston polo club."

She listed her part-time employer—a high-end clothing store; that helped us locate her.

At first, my photographer—using a hidden camera—approached her. He said that he'd read her page online and wanted to meet her. She was clearly taken aback by his unexpected introduction.

After a few moments, he explained that he was part of our investigative team, working on a story about social-networking sites. She agreed to give us an interview. Her main reaction:

> It's kind of creepy. I really only thought college age kids, kids who go to school with me, friends of mine at other schools would look at it. And you expect that from people my age. It kind of freaks me out that that's not the case here, that someone else has accessed it. I wouldn't want that information just all over the place.

But "all over the place" is an understatement.

While Facebook.com requires a valid college e-mail address in order to create a personalized page, our investigative team was able to create a profile rather easily—just like any predator could. In our case, we simply asked a friend with a college e-mail address to help us validate our new page.

Simple trickery can work around most of the protections that social networking Web sites put in place. And this shouldn't be surprising; the sites are measured by how many members they have. They don't *want* to make joining too difficult.

Crimes that Start Online

About the time that we were contacting Caitlyn and Taylor, we clicked over to another young woman's profile on MySpace.com and read a profile belonging to BITTER, a 17-year-old from Vienna, Virginia.

Her profile picture showed a girl walking alone and looking to the ground.

On her profile page, BITTER wrote:

Who I'd like to meet: "Someone who is kind"
General: "I want to be out and enjoying
 myself with interesting people."
About me: "I just graduated from high school
 and now I'm off to Richmond. I'm looking
 forward to meeting people that are in
 Rihcmond. I know a few people down there.
 But I love to meet new people. Feel free
 to message me whenever to chat!"
Last Login: 09/04/2005

The day after this last login, BITTER disappeared.

Her real name was Taylor Marie Behl, a freshman at Virginia Commonwealth University.

Her case received national television coverage until her body was found a month later near an abandoned farmhouse. A 38-year-old unemployed "amateur photographer" who'd "met" her on MySpace.com was arrested and charged with her murder.

What One Small Town Is Doing

South of Houston, the boating community of League City had three different sex crimes tied to social networking Web sites in a single month in early 2006.

"It usually starts out almost like any real life introduction," Sgt. Dan Krieger of the League City Police Department said. "You meet somebody, you start getting comfortable with them, then you start engaging in more serious conversation. In these cases, the serious conversation was sexual."

In one of the cases, parents discovered an adult had been messaging their 14-year-old daughter on MySpace.com—so the parents called police. Detectives assumed the girl's identity on the Web site and continued to trade text messages with the 38-year-old man.

Online, the predator referred to himself with the handle DADDY.

In early 2006, undercover officers arranged a meeting for sex with DADDY and then promptly arrested him.

The second case involved another 14-year-old League City girl who'd already had sex with a man at his apartment after "meeting" him on the same Internet Web site. Sgt. Krieger said the man found his victim through "standard window shopping" among many different young girls' profiles.

Krieger said:

> I think by having the profile up there with such specific search terms or searchability, somebody that likes 14-year-old blondes can very easily find them. And they're out there looking. I'm sure there's no shortage of people out there.

His officers arrested this predator, too.

The final case in that busy January involved a 15-year-old girl who vanished from her home, prompting an "Amber Alert"—a missing child bulletin in the local media.

The girl was eventually spotted in a neighborhood not far from her home. Police and television helicopters swirled around the house as officers moved in and arrested a 26-year-old man. He was charged with meeting the 15-year-old girl on MySpace.com and then bringing her to his home for sex.

The child had posted her real name, her age and her school on her personal page. Sgt. Krieger summed up the problems this poses: "Putting that type of information out there could potentially lead any attacker right to their front door."

How Predators Approach the Kids

When a child sets up a personal page, some social networking sites tally and display how many people have clicked on the site to view it. These numbers become bragging points for some users.

A vain 14-year-old girl might brag to her friends that 60 people visited her page in a month—meaning that 60 people could have read her views on life, her favorite bands or favorite movies. And many of those could have been adults looking for sex with children.

John Shehan with the National Center for Missing & Exploited Children says:

> *Obviously, we talk about these child predators. They are predators but to the kids they don't seem like predators. They're going to talk about how school is so tough, or they're disappointed with their parents or they're having problems with their friends. Well, these predators are going to come in and tell them exactly what they want to hear. They're going to be that new best friend. They're going to try and make that connection and groom the child into believing that they are the best thing out there.*

That's exactly what happened when my investigative team set up the profile of a 13-year-old girl on one of the social networking sites. Our profile page displayed a real 13-year-old girl's picture, and it listed her hobbies and her observation in pink letters: "Cowboy butts drive me nuts!"

Within a few days, a "window shopper" had found something he liked.

He sent the girl a message:

```
Subject: hey
Body: hello, my name is Jacob. I live in
    southwest houston and i think you are
    really pretty and thought i would say hi.
    so hi! well what do you do for fun? and
    how old are you. if there is anything you
    want to know, just ask.
Jacob
```

The "girl" answered that she was 13 and she thought JACOB's picture was cute. She asked about his age—because his profile said he was 17 years old but his picture looked older.

He immediately tried to make their age difference seem like a small matter. As we'd seen before, this was a bold statement followed by a rhetorical retreat.

Subject:RE: RE: hey
Body: Hey, thanks for the compliment. Truth
 be told my profile, well that is incor-
 rect. I guess I put the wrong year when I
 signed in.
 I'm really 23. Im probably too old but to
 me age is just a number but id still like
 to get to know you better you seem really
 sweet really cute. so if you want to know
 more about me just e-mail me.
Jacob

A few messages later, he was calling her "sweetie" and signing off with the phrase "Luv ya, Jacob." He was also suggesting—rather urgently—that they meet in person.

"Parents need to know that there are real predators out there that really are trying to contact children," Sgt. Krieger warned. "They need to be candid with their children so their children aren't naive as to the dangers that are out there."

"That's the perfect grounds for predators," said Houston mother Diane Gonzales. She found out an adult had been contacting her 14-year-old daughter. Her son also had a page on the same social networking Web site, so she was doubly concerned.

"They go in there and scan everything and they can see these 14-year-old girls looking for somebody to love them and that's what happened here," she said.

The man first claimed that he was 17—but soon admitted he was 20. He wanted to meet Diane's daughter at a nearby mall.

Diane tried to convince her daughter that this man was trouble:

She said, "Oh no, mom, he just needs a friend. He's just a nice guy. He needs somebody to talk to." I said "No! And, if he's admitting to being 20, he's probably older!"

Diane unplugged her girl's computer for a while because her mind was racing with how close the daughter came to meeting a stranger from the Web. Diane describes her feelings:

Very violated and very insecure. When {my daughter} is alone before I get home from work, there's at least an hour that she's alone. What is she doing?

She contacted the adult and told him to stay away from her girl. She said, "I'm really feeling like this guy's a predator. Who knows what kind of person he is? He could have taken her and killed her."

10 Web Cameras and Other Devices

You sure are hot.
Are you wearing anything under that blue
and white shirt?

A computer-based Web camera seemed like a useful tool for one Texas family—until the mother and daughter realized that a predator (interested in the daughter) had taken control of theirs. He could see into their home without their knowledge, watching them as they went about their private lives.

The family was conventional in many ways. The father was a successful contractor. The mother held various part-time jobs—but her real passion was investing. She traded commodities online. Together, they had two children: a 20-year-old son who was tall with scraggly brown hair and a 15-year-old daughter, Jessica.

Jessica had long black hair and loved to ride her horses—every day after school and on weekends.

Her family's lifestyle was *country*; they lived in a ranch-style home on four acres of land. They spent a lot of their free time outside.

They didn't think of themselves as very high-tech. The mother did spend an hour or two each weekday managing her investments

online. But she didn't spend a lot of time surfing the Web. The kids used her computer for e-mailing friends and some Web surfing...but neither spent hours online, like other kids they knew.

Their computer had come with a Web camera. It was about the size of a billiard ball with a lens in front and sat on top of the computer's monitor. It plugged into a multiuse jack in the back of the computer, called the Universal Serial Bus (USB) Port. They'd set the camera up but hadn't used it much.

A Web camera's intended use is brilliant. It takes pictures—either still pictures or movies, depending on the software you use—and can send them in various ways to other people on the Internet. Web cam pictures can be attached to e-mails...or uploaded to Web sites. Movies can also be attached to e-mails, stored on Web sites or shown in real time (the real-time use is sometimes called "streaming" or a "live feed"). These live feeds can be sent over a standard Internet connection; and they can be set up as two-way exchanges, allowing users to have a video conference.

"Video conference" sounds like a business application; but it's more commonly used for one-on-one personal exchanges. This is especially common in chat rooms, where people sometimes expect to look at the others with whom they're swapping typed messages.

Kids like to chat and watch other kids; family members separated by work or school like to see what's going on at home.

In the chat rooms, some ISPs will announce (or note with special icons) how many users have Web cams. This allows users to see who else has a camera...and move to a private video call if they choose.

Predators work these services. Kids in chat rooms are constantly bombarded with text requests like:

```
SILLYGUY44 has invited you to view his
Web camera, would you like to accept?
```

If a child has never heard of this person, he or she can click on DECLINE and that should be the end of it. But some don't.

And there are lots of traps. A child logging on to a chat room connected to a kids' Web site may see a dozen or more requests pop up on the screen in just a few minutes. Some of these requests are from other kids who want to chat; but some are from predators.

It's disturbing how many predators hang around children's Web sites. The people who run the sites watch for users who act suspiciously. But predators can be very cagey about pretending to be kids themselves.

In a chat room devoted to popular computer games, a teenage boy may be intrigued if he's contacted by someone who has a screen name that alludes to his favorite game. The name would suggest another boy with similar interests...and the message might talk about trading tips on high scores and "talking" by Web camera.

The National Center for Missing and Exploited Children says these chat rooms are becoming some of the most dangerous on the Internet because predators know the rooms are full of young people who could be their next victims.

How Predators Abuse Web Cam Technology

Back to the Texas family.

Jessica was the one person in the family who had used the Web camera to chat with friends a few times. But she wasn't a heavy user—of the Web camera or the computer in general. It was more like a footnote to her chats with friends.

Like most kids, Jessica primarily chatted with school friends; so, she was relaxed about the Web cam—leaving it turned on and pointed at her. Friends who were chatting with her could look at her at any time, if their computer chat programs were configured that way.

One afternoon, Jessica was chatting more busily than usual. At one point, she had seven different windows open with seven different IM chats going on—with seven different girls from school.

Suddenly, her screen went black. Maybe she was chatting too much and the computer had crashed.... Then, the screen lit up like she'd never seen. An eerie greeting was printed in huge letters, nearly filling her entire computer screen. They scrolled from right to left like a stock ticker.

`Hi, Jessica.`

She hit the space bar, hoping that might stop whatever was happening.

It didn't.

She leaned forward in her chair to hit the escape button. Then the message on her screen changed:

```
You can't stop me by hitting escape
If you keep pissing me off, bad things
will happen
```

She was focused intently on the computer screen and trying to figure out what was happening. The room was silent. Then, a sudden noise nearly sent her jumping out of her chair.

The noise was the mechanical clicking sound of the computer's disc drive tray opening up less than a foot away from her elbow. The tray was now extended from her computer tower, ready for a new disc to be inserted. But Jessica hadn't done that!

She waited a few seconds and then reached up with her right hand to hit the "close" button. In that split second, the drive suddenly closed before she could hit the button!

She jerked her hand back and the tray opened again with that mechanical sound. Then it closed again, even though she wasn't touching anything on her computer.

She noticed a new message scrolling across the computer screen:

`Annoying isn't it?`

Frightening a Child by Remote

The person typing the message might have been sitting at a computer next door, or he could be typing from a terminal on another continent. He could see her; and he loved the expression on Jessica's face as he controlled the computer in her home.

If he saw her reaching for the disc drive again, he'd be ready to type another message to let her know he was looking at her.

As he watched her, his fingers were typing away furiously. He'd zing off a couple of lines and then hit the ENTER button. He'd type a few more and hit ENTER again. He'd enter line after line.

```
Nope!
Try Again!
That didn't work either.
Give up yet?
```

For Jessica, it was a bizarre feeling—as if someone was in the room with her. It was not only words on a screen, but this person was actually making things around her move on his command.

She was trying to figure out how to stop this...but she still didn't understand exactly what was going on.

Then, her 20-year-old brother shuffled in and handed Jessica the phone. He didn't say anything and she didn't tell him what was going on with the computer. She just took the phone.

Her friend Michelle was on the line—and was furious.

Michelle wanted to know why Jessica had started saying such nasty things to her in their IM chat. And, why had Jessica told their other friend Stacey that the whole group of friends thought Michelle was a loser and a slut?

Jessica had no idea what Michelle was talking about. She'd never said anything like that. She told Michelle something weird was going on. Michelle said the nasty messages been happening just in the past 15 minutes. She asked if anyone else had access to Jessica's computer.

Jessica said she didn't think so.... But she was distracted. Her computer screen had just gone back to normal. She clicked through to the IM chats that she'd been having before it started acting up.

Instead of seeing the last sentences she'd typed to her friends, she saw chats that were completely foreign to her. But they showed the awful things Michelle had described—looking like Jessica had typed them. All of the chats had all turned ugly the same way.

She told Michelle she'd have to call her back. Somebody else was typing these things and she had to figure it out.

Then, as she tried to type something to one of her friends to tell her someone else was posting under he name, her screen suddenly went black again.

```
Jessica, your friends all suck
I want to be your friend
Damn, you're hot. I love when your hair
is down like that instead of up in a
towel. Are you wearing anything under that
blue and white shirt?
```

This time, the messages all scrolled from bottom to top, almost like a TV TelePrompTer.

Her disc drive jolted open again and then closed again.

Now, Jessica was starting to get scared. This person knew she liked to wear a towel around her hair after a shower at night. And he knew what she was wearing right now!

She walked out of the room to get her mother from the kitchen. Her mom walked into the computer room and everything appeared normal.

The chat screens were up again; the scrolling messages from the stranger were gone.

Jessica opened one of the chat dialogues to show her mom the mean things that appear to have been typed by her. Then, responses from her friends, usually shocked or confused questions like:

`Jess, why are you being such a bitch?`

Although she used the computer to trade commodity investments, Jessica's mother really wasn't very tech savvy. The angry texts looked more like typical teenage antics than the work of a hacker.

"What do you mean you didn't write that? If you didn't, then who did?" the mother asked.

Jessica said she doesn't know, but "he acts like he knows me or something.

He's a pervert."

Then, she described how he seemed to know what she was wearing and said she was cute.

The mother walked out of the room and dismissively said Jessica should just turn the computer off if it happened again.

Jessica turned back toward the computer now that her mother was gone from the room, and instantly the disc drive opened again.

Words scrolled across her screen, from top to bottom this time:

`DON'T CALL ME A PERVERT!!!!!!!!!!!`
`I do know you, Jessica. I could come over`
`tonight and we could fuck. If you keep`
`telling your mom it will spoil all the`
`fun.`

Not only did this guy know what she was wearing, and how her hair was done, but he knew where she lived—and he knew what she had just said to her mother in their own home!

Jessica unplugged the computer.

Malicious Software for Dummies

The predator who was harassing Jessica used some relatively basic, easy-to-find software to hack into her family's computer.

Law enforcement agents and computer experts call it "malware" or malicious software.

The most common way that a computer is infected with malware is that a hacker (or predator) creates an e-mail with an attached program that gives the sender access to a remote computer.

Opening the infected e-mail or the attachment loads the program on to the recipient's computer. In most cases, the malware program stays hidden in the infected computer until either a predetermined time or the sender chooses to activate it.

In the meantime, most malware programs will attach themselves to every e-mail sent out from the infected computer—giving the sender access to dozens or hundreds of other machines.

In this way, malware programs are like computer viruses.

While it may wipe out a hard drive or clean out a person's e-mail files, the *main* characteristic of a virus is that it reproduces itself.

Many malware programs give the sender complete control of the recipient's computer. In Jessica's case, the predator had used a new program (one of a group of programs called "Trojan Horses") that the U.S. Secret Service had just been briefed on a few weeks earlier.

Trojan Horses get their name from the fact that they fool a computer user into giving a stranger remote control of the user's system. These malware programs insert software that allows the stranger to enter, read and use all of the data and programs on the infected computer. They can give the stranger access to personal information—including passwords, bank account numbers, phone numbers and physical addresses.

Attacks on Other Devices

The people who write malicious software are constantly in search of new computer tools to exploit. Some attack the Web camera, some attack e-mail accounts, others attack Personal Digital Assistants (PDA's). Still others zone in on instant messaging programs.

Malware programs are also beginning to infect cell phones. The cellular telephone industry is downplaying this threat, saying security precautions are tougher and phone-use patterns in the U.S. make large-scale hacking less likely than in other countries.

But the ingenuity of malware is only partly technological; a big part of its effectiveness comes from what experts call "social engineering"—that is, the ability of the crooks to convince victims to accept their programs.

With cell phones in Asia, the malware may be disguised as a hot new ringtone that kids want to download. If a teen receives a call or a text message, saying a favorite musical act has released a ringtone based on a hit song, he is likely to press "Send" or begin the steps to download that ringtone. In fact, he's just downloaded a virus that may drain his call minutes or allow a stranger to make long distance calls on his account.

With computers, malware is usually launched by one of two methods, so parents should warn kids to avoid anything that remotely resembles:

1) A link to an unfamiliar Web site

This is less of a threat on mainstream Web sites or those of established companies. But if a person is visting a Web site with adult content, for example, the screen may display a titillating image and then offer more if the Web site visitor clicks on a certain link. In reality, clicking on that link allows the malware to invade the computer.

No one should ever click on a link on an unfamiliar Web site. It's the equivalent of turning on a power switch. Clicking empowers the malicious program. There is usually no way of telling that a link is trouble before clicking on it. Also, the trouble may take a while to start—hours, days or months after the infection.

Just because a person clicks on that adult link and gets the "more" he was promised, doesn't mean he's home free. The malicious program may be "sleeping" or waiting for a particular time or a particular activity on the computer before truly taking over.

2) An e-mail attachment from an unknown person

No one should ever open an attachment unless it's from a trusted source; and someone should an attachment if it was expected. If a friend says vacation pictures are on the way, and then an e-mail shows up with that friend with the subject: "Vacation Pics," it's probably safe.

However, an e-mail may have the exact same title "Vacation Pics" and come from the exact same friend, but—if it's not expected—it could be trouble.

Malware crooks know that they need to trick people to open their e-mails, and they're able to manipulate the e-mail lists of friends when they infect a computer. If an e-mail appears out of the blue, especially from a friend that hasn't been heard from in a while, it could be trouble. Call to confirm it was really sent by the friend, if you have any doubts.

A person whose computer is infected may have no idea that dozens or even thousands of e-mails are going out from his computer.

In general: If in doubt, delete e-mails.

A Computer Novice Needs Help

Jessica's mother went online to invest on the Chicago Board of Trade; but she was a relative novice beyond that narrow application. So, when Jessica said she thought someone was eavesdropping inside their home—and even spying on what she was wearing—her mother decided it was time to call in some help.

She contacted my investigative team because she'd seen our taped confrontations with sexual predators in the Houston area. We agreed to bring our computer experts—and cameras—out to their house to track down the stranger who'd been harassing Jessica.

We also contacted the local office of the U.S. Secret Service, because its agents had spoken with us about their interest in these crimes during our previous investigations.

The Secret Service agents were particularly interested in the case. They'd been briefed recently on Trojan Horse programs like this one; but they hadn't had the chance to catch a live user in the act yet.

They arrived at the family's ranch in five unmarked sedans with tinted windows; and a group of agents who looked like they should be running beside the President's limousine carried in large briefcases full of forensic equipment.

The Feds cracked open the family's computer and plugged their own devices into the box. Two of their laptop computers lit up with forensic programs beginning to run. They quickly located the likely source of the harassment—and it didn't have anything to do with Jessica's chats and her mother's commodities trading.

Jessica's *brother* had given the remote predator access to their home.

Her brother—like other young men his age—used his time on the computer to look at Internet pornography. Jessica and their mother had suspected this; but, since they each had a separate screen identity, they figured one user's activities couldn't affect the rest of the family.

They were wrong.

When the experts logged onto the computer under the brother's name, they found folders filled with pornographic pictures and videos. He'd been downloading all sorts of material—and had downloaded the Trojan Horse along the way.

The program had planted itself stealthily. Jessica's brother had no idea that he'd caused the family's problem.

Who's In Control of This Computer?

This particular Trojan Horse allowed the stranger to take control of any Web camera attached to the computer—and also listen in through the microphone that many computers have built into their central processing units. Normally, a user has to push a button or enter a command to turn on a Web camera or microphone; but the malware on Jessica's machine allowed a stranger to activate both.

In fact, *any* computer function could be manipulated remotely by the stranger. In Jessica's case, the predator harassing her had simply chosen opening and closing the disc drive from a menu of computer functions.

It was surprisingly easy for someone to install this Trojan Horse. As is the case with many variations of malware, it didn't require a genius hacker. The program was available on many Web sites that cater to hackers and other online criminals.

Any sexual predator with Web access can log on to these sites and choose viruses or Trojan Horse programs that will give him remote access...or do other kinds of damage to infected computers.

(True *hackers* often prefer to damage a victim's computer than control it; controlling a victim's computer is more likely to result in criminal prosecution. Sexual predators, on the other hand, want the control and have already rationalized the legal risks they're taking.)

The hard part is getting someone to accept the malware. If a predator sends out 20 infected e-mails, he may have a hard time getting one reply. So, as we've seen before, the predators play a numbers game; they send out as many e-mails as they can, hoping that a handful of people accept.

The malware program that Jessica's harasser chose was extremely predator-friendly; it automatically notified its sender when someone had accepted. Of course, it didn't tell the victim anything. The predator could activate the Web cam and microphone and eavesdrop silently...before deciding whether or how to use his control.

He also had access to Jessica's mother's investment account information. He could make trades and move money—if he chose to (though apparently he hadn't). This is why Trojan Horses are such a threat to people who keep sensitive financial data on their computers.

A Tough Trail to Follow

After their fast start identifying the Trojan Horse, the Secret Service agents got bogged down in their efforts to trace its origins.

One agent took Jessica into another room to interview her. Her story would be part of the case against the predator, should they be able to track him down.

But then the pace of activity slowed.

The agents started flashing looks at one another and whispering things under their breath. They no longer appeared comfortable and in control. They were repeating a number of steps and restarting computer programs, but then shook their heads.

They told Jessica and her mother that they couldn't copy the hard drive of their computer as they had been hoping to do. The process is called "mirroring the hard drive;" it's a basic law enforcement procedure. The entire contents of the computer—including deleted files and electronic footprints of every single function that's ever been performed—are copied onto a different computer.

It's a basic step, yet this experienced team couldn't make it happen.

The agents asked Jessica's mother if they could take the computer to their forensic lab. They explained that most of the computers they dealt with had been seized in raids; they didn't do many forensic searches in the field.

The agents promised to have the computer back four days later. They'd work on it over a long weekend.

Jessica's parents agreed.

The agents packed everything up and headed out the gravel driveway in their identical unmarked cars. They certainly acted impressively—with an almost military decisiveness.

What followed next wasn't so impressive, though.

Jessica's family didn't get the computer back for *five weeks*. And, even then, the agents found nothing that they could use to track down her harasser.

They'd hoped to find an "electronic footprint" showing how the Trojan Horse had been installed—and more electronic footprints from the time that the computer had been under the control of the predator. But they couldn't find the footprints.

They guessed that the predator had used some additional program to erase any traces of who he was or where he was. Or the program he'd used had been designed to vanish once disabled.

The Secret Service agents had removed the Trojan Horse, so the predator would no longer be able to control the computer remotely.

Why did these agents have so much trouble?

One thought: Law enforcement agencies focus their forensic efforts intensely in a few directions. They're very good at finding data files that have been erased...or locating e-mails sent by people they've already identified as targets of an investigation.

But, beyond that, their effectiveness becomes a hit-or-miss proposition.

Anyone who experiences a sexual predator's online advances or harassment should avoid any assumptions (based on TV crime shows) about what police can do. A few keystrokes generally won't yield enough evidence to convict the bad guy. Sexual harassment is hard to prove in the real world—and it's even more difficult to prove in the virtual world.

The truth is that most law enforcement agencies have been slow to keep up with the computer age, a big reason that so many computer crimes get little attention from those who carry badges. And

another reason: various police agencies often get in disputes over who has jurisdiction over Internet crimes—since it's usually unclear exactly "where" the crime took place.

Finding which agency is best positioned to investigate can be a chore; and then convincing that agency to show interest can be another.

My advice, based on several years of trying to get Internet sex predators prosecuted: Start with the local offices of federal agencies— the Secret Service or the FBI. I'd do it again, even though the Secret Service wasn't able to catch Jessica's harasser.

The Feds run CyberTipLine, which is a clearinghouse for handling online crimes (including sex crimes). The staff there can find the right agency for a situation and get it handled as quickly as possible.

Make sure to mention what evidence you've retained or what computer security software may help in their investigation.

Tips for Helping the Investigators

If you have kids who go online, there are some things that you can do—before any sexual predators come lurking—to improve your chances of catching one if he does.

The common theme to this advice is to make sure valuable evidence is not destroyed.

1) Extend the *archive life* on chats.

 Many chat programs allow archives to be kept for all chats. Click on general options and look for an option titled "chat archives" and then set it to store messages for 60 or up to 99 days. Then click "Accept."

 This option will take up more of the computer's available memory; but the archive keeps more evidence on your hard drive, in case a bad person chats with your kids.

2) Install a firewall and log connections

 There are some great firewalls available for free online. Find a reputable and reliable program that blocks all unwanted attempts to contact your computer. Make sure it will block outgoing attempts by your computer to connect to someone else. Set your options so that logs are kept of all activity. If a Trojan Horse does launch, this tool can log exactly where it's trying to send information.

3) Consider a comprehensive computer watchdog program.

 There are several good off-the-shelf programs available. Spector Pro is thorough and user friendly—and usually retails for around $100; NetNanny is another that is widely used. Both programs allow parents to retain and check every single word that's typed or received on a computer. They document which Web sites users (kids) visit and what's sent and received in chats. They even save pictures of the computer screen every 30 seconds to 30 minutes. These programs can be configured to send e-mail notices to parents at work when particular things happen—or Web sites are visited—online; they can also send the notices if certain key words are typed on the computer.

These steps will give police or other investigators more to work with if a predator or harasser invades *your* home computer.

11 The Internet Warps Kids' Perspectives

I thought I had achieved online what eluded me in real life: I was popular. Everyone wanted to know my thoughts. Everyone wanted to give me things.

In previous chapters, I've discussed the mechanical details of how sexual predators use chat rooms, IM, Web cams and other Internet applications to find and groom victims.

In this chapter, I'd like to spend some time considering the broader question of how the Internet shapes—or misshapes—kids' notions of friends and strangers, trust and trust*worthiness*...safety and danger.

The mechanical details of technology are important to understand (at least generally); but understanding them doesn't guarantee anyone's safety. Why? Because the details are always changing. As this book goes to press, law enforcement agencies and public policy groups are just starting to focus on Internet chat rooms as sexual predators' favorite hunting grounds.

In fact, chat rooms already have a lot of competition for Internet users' attention. Web cameras, live video feeds and the generation of new Web sites dedicated to their use appeal to many young people.

There are thousands people constantly trolling popular Web cam video sites, looking for young and curious people.

In this chapter, I want to consider what those young and curious people think—and expect—when they engage strangers in flirtatious or graphically sexual online exchanges. Why are they willing to put themselves at risk? Why don't they show the simple common sense that would seem to keep them out of dangerous situations?

It may be because a precocious 13-year-old who doesn't know a world without a multimedia Internet may be smart as hell about data packets but warped about basic issues of *risk*. He may quote trendy movies but may not know not to take candy from strangers.

How One Boy Slipped Down the Slope

In April 2006, the Energy and Commerce Committee in the United States Congress heard firsthand how damaging that warped perspective can be.

Justin Berry, who looked much younger than his 19 years, testified that—when he was just 13—he'd received a free Web camera when his family signed on with a new Internet Service Provider.

He was 13 but he looked even younger. And that had been a problem for the Bakersfield, California boy. "I hoped my Web cam would improve my social life" and maybe help him find a girlfriend, he told the committee.

He posted some pictures on a social networking Web site called Spotlife.com and—within minutes—he'd been contacted by several grown men who noticed the icon that indicated he had a Web cam.

"One of these men approached me online with a proposal. He would pay me $50 if I took off my shirt for a few minutes while sitting in front of my Web cam," Berry testified.

The man sent Berry instructions for setting up a PayPal account, so the boy could collect the money. (PayPal is the most popular of

several commonly used Internet payment services. It's owned by the Internet giant eBay.)

Berry thought the deal sounded harmless; he didn't understand that accepting money to take off his clothes was the first slip down a slope toward worse treatment. As he'd later tell Congress, "I now understand that, by removing my shirt, I had signaled that I could be manipulated."

More men started paying him to pose in various states of undress. And they were willing to pay. The PayPal transactions filled his "starter" savings account to amounts the 13-year-old had never imagined possible.

He started receiving other gifts in the mail. As he testified:

I was swamped with videos, CDs and computer equipment—including better Web cams. All free from my new friends. Looking back today, my thoughts seem foolish. But at 13, I believed these people were my friends. They were kind. They complimented me. They wanted to know about my day. And they were endlessly patient in listening to me. All I had to do in exchange was strip while alone in my room.

The word of mouth spread and, in time, Berry had more than 1,000 men who paid him money to strip in front of the Web cam. They paid him more to masturbate. (His mother and step-father didn't use computers much, so Berry was able to set up and maintain his operation—mostly in his bedroom.)

In a haze of bad decisions, Berry had gone from making a few bucks to producing home-made pornography. And he wasn't old enough to drive.

He described his mindset at the time:

The compliments were endless, the gifts and payments terrific. I thought I had achieved online what eluded me in real life: I was popular. Everyone wanted to know my thoughts. Everyone wanted to give me things.

Sexual Predators

On several occasions, Berry's Internet "friends" set up elaborate fake computer camps and other activities—and the boy managed to convince his mother to let him "attend." In fact, these trips were sex-for-money junkets; the men molested and sodomized Berry in exchange for cash and gifts. At a later trial, he would testify that one of these men "said I was gay and said just try it. It confused me; it messed me up so bad, so bad that to this day I have problems."

Some of these predators also ran pornography Web site businesses. One offered to build a site for Berry that would allow members to pay a monthly fee to watch his homemade sex shows. They built the site—and money started coming in steadily. Berry had become a true sex professional:

> *How could I get myself into that situation? How could I not see it? ...this is one issue I wish to stress. Web cams and instant messaging give predators power over children. The predators become part of the child's life. Whatever warnings the child may have heard about meeting strangers, these people are no longer strangers.*

About the time Berry turned 16, some clips and pictures from his Web site were distributed on the wider Internet. And some of *these* ended up in the hands of his schoolmates. His schoolmates harassed and bullied him—and his teachers turned a deaf ear to his complaints.

So, Berry asked his mother to let him visit his father (they'd been divorced for years), who was living in Mexico.

After Berry had been staying with his father for a few weeks, his father asked how a teenager always had so much money. Berry confessed he'd been running an online porn site. His father didn't object or punish the boy. "He offered to help," Berry said on one TV talk show. "He said, `Well, how can we maximize the earning potential here?'"

His father hired prostitutes to film having sex with Berry, who complied...but didn't stay in Mexico very much longer.

Chapter 11: The Internet Warps Kids' Perspectives

Back in Bakersfield, Berry started having problems with his increasingly suspicious mother. He was using marijuana and cocaine. He bought a car for cash—which raised some eyebrows. She started taking away his computer hardware.

So, one of Berry's business partners rented an apartment nearby, where the boy could film his Web cam porn. Later, Berry would say:

> *I had become exactly what my members viewed me to be,*
> *what their degrading conversations convinced me I was: a*
> *piece of meat, for sale to the highest bidder.*

By the time he turned 18, Berry was immersed in the world of pornography and prostitution—and recruited minors to perform on his Web sites. He'd crossed over from child victim to adult predator.

"My experience is not as isolated as you might hope," Berry testified to the House committee:

> *This is not, as so many want to believe, the story of a few bad*
> *kids whose parents paid no attention. There are hundreds of*
> *kids in the United States alone who are right now wrapped*
> *up in this horror.*

After several failed attempts, he finally quit the sex business for good in late 2005. He turned over extensive billing and financial records to the U.S. Justice Department. But he told Congress exactly what my investigative crew had already discovered—that law enforcement was not able and, in some cases, not *willing* to prosecute underage sex cases. "I believed that the government would protect the children being abused. I believed they would act quickly," Berry testified. "I was wrong."

So, he started going public with his experiences. He was the subject of a lengthy profile in the *New York Times*. He appeared on the *Oprah Winfrey Show* and the *Today* show. This, in turn, resulted in some backlash—especially from the gay community. Several advocacy groups complained that Berry unfairly equated homosexuality with sexual abuse of children. One Internet commentator wrote:

> *Justin Berry was an opportunist and manipulator. Any teen-*
> *ager you speak to who has a Web cam would never get inde-*
> *cent with strangers and if they are asked to would quite*
> *simply block them.*

There may be some validity to this skepticism. In the wake of Berry's media tour, some mainstream media outlets were looking into supposed inconsistencies in his stories.

Feeding a Massive Underground Market

But even if there are some holes in Justin Berry's stories, his description of the childish vanity and egotism of some teens who are drawn in by sexual predators rings true to the experiences my investigative team has had.

And there's no doubt that pedophilia is profitable.

According to congressional staffers who helped arrange Justin Berry's testimony, mainstream music downloads generated $3 billion revenues worldwide during 2004—but sales of child sexual abuse images generated revenues of *$20 billion* that same year.

Some of the people raking in that money hold day jobs but claim to be "Internet entrepreneurs" or "Web site hosts" on the side. They rarely brag about peddling child porn; instead, they claim they're paid to display fetish videos, modeling photos or quasi-sexual images involving role playing. Anything to sound legal and plausible.

But my investigative team found that some of the people dipping into that $20 billion cash flow get their "fresh" images by tricking children to pose for Web cameras.

Unlike Berry, many of these children never get the promised cash.

A bright 13-year-old girl who had seen our predator stings on the news recognized that she was being scammed online. This seventh grader wasn't allowed in chat rooms—and yet she still got a private message that seemed all wrong.

Chapter 11: The Internet Warps Kids' Perspectives

While chatting with friends about school, she got a message that greeted her by name:

```
Hi Amber, you could make $200 for model-
ing.
```

The message assured her the company was legitimate—and that it paid girls in a secret way, so that their parents didn't have to know.

Amber wanted to be a model; her older sister had been a runway model for some local clothes stores and fashion shows. Amber had the looks—and, like many attractive teens, she knew it. She was also slightly rebellious: She'd posted a profile picture that her mother felt was too sexy to be appropriate.

Plus, the money was good. Amber was thrilled to be promised $200 for simple modeling. She felt like she had to beg and plead with her parents for $20 anytime she wanted to go to the mall with her friends.

Despite all these reasons for saying "yes," something about the offer just didn't seem right. Amber asked what she'd have to do for the money.

The person who'd sent the first message replied that the company would pay for topless pictures of girls age 12 and up.

Amber knew she was too young to pose topless for any legitimate media company. So, she called the television station and asked for my investigative team—while she was still online with the recruiter.

She wanted to see if the person on the other end of her chat could be caught by our TV crew—just like the older men she'd seen running from the cameras on the evening news. She kept her chat with the recruiter going while we worked out the details.

Her mother agreed, so we sent over a crew and set up to record every keystroke. I sat down in Amber's chair and took over the chat. Amber's screen name wrote back that she'd thought about it and was interested in earning the cash.

Danger Outside the Chat Room

How can a young girl—who's not allowed in chat rooms or networking Web sites—be found by a complete stranger? The answer is surprisingly simple: IM.

On most ISPs' instant message services, any registered member can click a few buttons to access a browsing feature that asks what topics are of interest to that user.

(Amber used AOL's Instant Message service, called AIM. That service's browsing feature was called "Find a Buddy.")

A user can specify that he wants to chat with others who like a particular hip-hop singer or who like cheerleading...or who like modeling.

About the time of Amber's chat, if you clicked on the term "modeling" in AIM's Find a Buddy service, your screen would fill up with the names of other AIM users. Some of them listed ages and most of them listed cities or states.

Amber's mysterious recruiter—or anyone else who took the 30 seconds required to register with AIM—could troll around for teenage girls in Texas or they could contact all of the girls who were interested in modeling. One more click and the stranger could send a child an instant message.

Amber's mother made her leave the room as our investigative team started trading messages with the recruiter.

"Aw, come on mom! I just want to watch!" she pleaded.

Her mother didn't budge. Our TV crew was completely assuming her daughter's identity now so the mom expected the language to degenerate with words her daughter shouldn't see.

But the curious youngster would be needed again soon.

The chat messages were coming from a screen handle LANZARINC (as in Lanzar, Incorporated). The instructions for doing business with LANZARINC were so specific and complex, it was a wonder than an actual underage girl could follow them.

First, LANZARINC required a fully clothed picture of Amber be sent directly to its computer by an AOL feature called Direct Connect. This feature connects two computers, so that files or pictures can be shared only with each other.

With the mother's permission, we took a still Web cam picture of Amber—who'd come back into the room—connected with LANZARINC and sent the picture.

Next, LANZARINC said it had to verify that this was really the person on the other end of the chat. So, it required us to send a picture of Amber making a "thumbs up" sign.

We snapped that special picture and sent it, as requested.

This was really an ingenious way to verify the girl's identity. A sting operation working with a stock picture (which was, in fact, what we *usually* did) wouldn't be able to generate a matching image including some specific gesture invented on the fly.

At the same time, this bit of ingeniousness seemed a little odd. It certainly didn't establish the child's identity in any legal sense. If a legitimate company wanted to establish that a model was who she claimed to be, the exercise was really useless.

The whole exercise was designed more to prove who the girl *wasn't*—namely, the police—than to prove who she *was*.

LANZARINC started pressing hard to get the topless pictures.

All of the sudden, after swapping IM posts for a quite a while, the person on the other end of the chat seemed to be in a hurry. And some of the texts sounded like they came from a script. Like the way a telemarketer in a boiler room speaks, these short text messages were too wordy and precise to have been typed on the fly.

Real-time text messages are usually full of abbreviations and typos; these weren't.

We asked:

```
How do I know you're for real? What if I
send you pictures and you don't pay me?
```

LANZARINC answered:

```
The money is 100% guaranteed, trust me,
anyone dumb enough to go through this
much trouble to see boobs would need help,
especially when there's 40 million free
pictures on the net.
```

We asked how it could possibly be guaranteed. LANZARINC has a fast answer:

```
Legally, we are required to pay you by law.
```

We tried to push the envelope, offering pictures of our 13-year-old girl perhaps kissing a friend or doing some other naughty poses. LANZARINC's answer was: absolutely not. Those kinds of pictures could only be sent after the protocol had been followed and, right now, that wasn't in order.

The person did promise more money if we took off more clothes or performed some acts. But that would have to be later.

We tried to stall for time and draw out more information from LANZARINC—but the person on the other end started getting impatient. He took on the tone of an employee who was paid by the picture and growing more and more frustrated.

Before finally giving up on Amber, since we weren't going to send the topless pictures he desired, LANZARINC did provide enough information that we'd be able to dig deeper into the scam.

In answering one of our questions about getting paid, LANZARINC provided a company Web site and the name of the company owner. Those pieces of information, in turn, allowed us to look up a street address and e-mail address on Network Solutions' "WHOIS?" service.

We traced LANZARINC to a Phoenix, Arizona address. Within 24 hours, the man who owned the company was surprised to get a knock at the door from an investigative news reporter.

He said that his Web site name was being used by crooks to trick girls all over the U.S. into posing nude. He claimed it was a common scam that affects many "legitimate" adult Web sites—like his.

But his story was pretty dubious. His "legitimate" Web site included pictures of seemingly underage girls in compromising poses; but he insisted that they were all over 18 and that he had verified their identities and signed contracts with them.

But he wouldn't allow us to verify any of his claims independently.

The man did provide us with a stack of e-mails he'd gotten from other girls who were angry that they hadn't been paid. One girl wrote that she had sent in the pictures they'd asked for and that she was expecting her fees—adding up to $1,000.

She'd been promised the same sneaky payment method that Amber had been promised: A *Seventeen* magazine would be delivered to her and the cash would be in an envelope inside the magazine—so that her parents would never find out she'd modeled nude.

The frustrated teenager wrote him that she sent eight different nude poses and was promised payment. She wrote:

```
I did send this person everything he wanted
then after that he disappeared. I haven't
seen him online or anything.
```

She didn't know where those pictures might be circulating.

Parental Controls: A False Sense of Security

When confronted and questioned about making thousands of real screen names available so that any stranger can contact a child, an AOL spokesperson simply said that the AIM service is intended for adults—so there are not as many protections in place.

AOL advertises so many different parental controls and security features on its regular Internet service, one might think those mea-

sures are in place on the AIM service; but the spokesperson confirmed that that wasn't the case.

The lesson for parents here is not to be fooled by a false sense of security. You may have the advertised protections and parental controls in your regular AOL service but, if your child is using AIM, you should check that separate AIM profile to see what is being made available to everyone.

(And I don't mean to single AOL out for criticism here; most ISPs allow similar loopholes in the security of their IM services.)

This comes as quite a shock to many parents who figure their kids are safe because they are not allowed in chat rooms.

Almost a year after the near-miss with LANZARINC, my investigative team encountered a similar operation while posing as a child in a Yahoo chat room.

Again, an impatient chatter sent an unsolicited IM. This one claimed to be a "Model Finding Models" business.

Our research quickly showed that the person was lying about what city—and possibly even what state—he was in. I write "he" even though the person claimed to be a *female* model who was trying to land lucrative modeling gigs for aspiring young girls.

Yet, as "she" grew more frustrated with our questions and hesitation, her writing still got terse and angry-sounding. In short, it sounded like most of the male sexual predators we'd encountered online.

We alerted the Feds to this latest scam; but, once again, no action was taken. And we saw the same name trolling for new victims a few months later in the chat rooms.

With millions of children online regularly, this was one well-thought-out way of exploiting them. The promise of cash and secrecy is very alluring.

And, if a child became aware that his or her nude picture was circulating on a subscription website, he or she would be unlikely to tell a parent or the police. A child can't sue and, even if pressure were

brought to bear, the Web site operator would likely claim he bought the picture from someone else.

Given how huge the kiddie porn market is and how widespread our investigation found the modeling scam to be, parents should make this a standard warning for kids before they go online.

Just as parents should warn about text chatting with strangers, they should warn that no legitimate "modeling" enterprise would ever conduct business with secret cash payments hidden in magazines.

If kids are taught early that this is always dangerous, they can avoid becoming victims whose bad choices are circulated—for eternity—on the Internet.

But the most important thing parents need to keep in mind is how fragile and needy a teen's ego can be.

The details of how Justin Berry slipped into online porn…and prostitution and drug abuse…aren't as important as his blinding vanity and disabling insecurity. The fact that he so willingly traded degradation for "feeling popular" suggests that his perspective was terribly warped.

As he has admitted, his warped perspective could have cost him his life.

A parent should do everything he or she can to break through this vanity and let each child know that popularity is fleeting at best— and shouldn't be bartered for sex or personal integrity.

Amber sensed this—even though she'd never gotten a specific warning from her mother.

Unfortunately, some kids aren't as bright as Amber.

Sexual Predators

12 Corporate Sponsorship of Child-Sex Chat Rooms

We were completely unaware that our advertisements were associated with these chat rooms in any way and we've worked with Yahoo to immediately remove them from the site.

In some Internet chat rooms, the one and only topic is sex involving children—even infants and toddlers. By any standard, it's pretty nauseating stuff. It's tough to find anyone who defends these chats, even on free speech or "tolerance" grounds.

A handful of psychiatrists and sex educators defend sex-focused chat rooms as tools some repressed people can use to work out their hang-ups by "role playing" in fantasy settings. But even they back away from fantasies involving sex with children.

Still, the chat rooms and sex-focused Web sites remain.

In the early 1990s, the North American Man-Boy Love Association (NAMbLA) made headlines for its defense of homosexual relations between adults and children. Several Catholic priests implicated in widely-publicized molestation cases during the early 2000s seem to have been involved in the group.

NAMbLA's Web site still exists (www.nambla.org). It doesn't link to any chat rooms; instead, it focuses on legal discussions of predators "persecuted" by various law enforcement agencies. The Web site states, carefully:

> NAMbLA does not provide encouragement, referrals or assistance for people seeking sexual contacts. NAMbLA does not engage in any activities that violate the law, nor do we advocate that anyone else should do so.

As you might guess, the NAMbLA site offers little detailed contact information—one phone number, physical mailing addresses (post office boxes) in New York and San Francisco. This anonymity is unusual for a political advocacy site...but normal for a sex site.

Anonymity on the Web sites and in chat rooms is the Internet equivalent of the plain brown wrappers that used to cover dirty magazines.

So, you can imagine the surprise our investigative team caused when we discovered some *major* corporate names emblazoned on those plain brown wrappers.

In early 2005, we reported that a number of chat rooms frequented by sexual predators were actually being sponsored by ads for the owners of some of America's most recognizable corporate and brand names.

The names on some of these chat rooms included:

5-13 Kiddies who love sex
Girls 8-14 horny for older guys
Younger Girls 4 Older Guys
Girls 13 & Under for Older Guys
Preteen girls peeking at cocks
Girls 5-13 for Older Men
9-17 Wantin Sex

Chapter 12: Corporate Sponsorship of Child-Sex Chat Rooms

```
Under 13 girls for much older men
6-11 year old girls into old men
```

The Basics of Internet Advertising

Why would any company pay to have its brand associated with these reviled chat rooms? Because it was inattentive about its Internet advertising.

The companies weren't selecting "Under 13 girls for much older men" for their Internet ads; they were paying chat services—in this case, Yahoo—to place ads in thousands of chat rooms. A few filthy ones happened to fall into the mix.

The Internet advertisements that ISPs sell most successfully are called *banner ads*. These ads appear across the top (or, sometimes, the bottom or side) of each page within a Web site or chat room. Other ads are called *pop-ups* and have to clicked on or closed before a user can see a particular Web page—or a chat room.

Where do these ads appear? Older people tend to read news and information pages of Web sites; younger people care more about chatting. Since advertisers like to reach younger (and more impressionable) people, most prefer to put their ads in chat rooms.

ISPs like Yahoo set up their most popular chat rooms, focusing on topics like sports, movies, TV shows, music, health, etc. These rooms are among the busiest and most used places on the Internet. The service providers promote them to corporate advertisers as great places to run ads and other promotions. And they often are.

Traditionally, service providers had also allowed everyday users to set up chat rooms of their own. These "User Created Rooms" were much less popular and nowhere near as busy. They were essentially unregulated; in fact, the users setting them up didn't even have to provide valid information about themselves.

Most of the Yahoo child sex chat rooms had been set up and given their obscene names by anonymous users of Yahoo's Internet services.

Yahoo and other Internet Service Providers pointed out—rightly—that they merely hosted the User Created Rooms, giving people an electronic gathering place to discuss their areas of interest. On the Yahoo portal, a disclaimer appeared before User Created Rooms (and not just sexually-explicit ones) could be accessed:

```
Warning: You are trying to access room
lists created by users. These rooms may
contain topics that might be offensive to
some users.
```

Indeed they might.

Bombarded with Obscene Propositions

If a curious kid popped into the child sex rooms, he or she would be instantly bombarded with IM filth.

When our investigative reporting team posed as a child in these rooms, we'd be bombarded with IM requests. We were propositioned for sex meetings, asked to view Web cam feeds of men masturbating and even asked about running away from home with grown men. Usually within seconds of entering the room.

```
Are u a virgin?
Wanna see me cum?
Hi sexy, are u horny?
Would you ever have sex for money?
Im naked on my cam right now
Wuld u let me watch u play with urself?
```

It was constant. During school hours, the critical hours after school but before parents get home, in the evening, overnight...the sea of pedophiles never slept.

And these people had to click corporate ads in order to enter the chat rooms where they looked for their prey.

Even more common in these rooms were the Web cam sex acts being offered to children. Our investigators—using a profile that claimed to be a teenage girl—received hundreds of requests:

```
User PEDO4814 has invited you to view
his/her Web camera, would you like to
accept?
```

If we clicked YES, we would see a live image of a person—almost *always* a middle-aged male—handling his genitals or in various stages of masturbation.

The important point here is that these middle-aged men thought…or wanted to believe…that they were exposing themselves to children.

Turning a Blind Eye

The Internet service providers turned a blind eye to the filth because—they insisted—what went on in the User Created Rooms was happening among consenting adults.

A spokesman for America Online told us that children had no place in his company's chat forums. Also, he stressed that AOL's Instant Messenger service was intended for adults only—and that this point was clearly stated in the terms-of-service agreement all users were required to accept.

In response to our questions, Yahoo issued a statement about the child sex chat rooms on its site:

> *Yahoo! condemns the abuse of the Internet's tools and services for illegal activities. The use of Yahoo! products and services for illegal activity is expressly prohibited by our Terms of Service. Yahoo! strongly supports law enforcement's efforts to combat illegal activity on the Internet and works cooperatively with law enforcement to aid in their investigations.*

Fair enough…if a little vague. But why sell ads in these places?

Yahoo was making lots of money, cashing checks from some of the largest consumer products companies in America that paid for ads appearing in child sex chat rooms full of masturbating perverts.

Again, a user had to click on an advertisement before he or she could enter most chat rooms—including User Created Rooms.

Most casual Internet users didn't know about any of this; and they were angry when they found out.

"If Yahoo knows this and is not doing more about it, then I'm appalled," said Kathy Casey, a Houston mother of two teenagers. We interviewed Casey and several other parents to gauge their reactions to the corporate ads in sex chat rooms. Those reactions weren't good for advertisers.

Casey could barely contain her anger, when we showed her some of what was going on. She'd been allowing her son and daughter on to chat rooms, thinking they were safe. "These are predators," says Casey. "They are preying upon our children. They are going to where children are and this is unacceptable!"

Foolish Advertisers

The room titled "6-11 year old girls into old men" was sponsored for a time by Brawny paper towels—with an ad campaign titled "Innocent Escapes."

It was as if someone at Yahoo had a wicked sense of irony.

Before entering the child sex chat room, a user would have to click on the "Innocent Escapes" banner featuring Brawny's mascot.

Robyn Keagan, a spokeswoman for Brawny's parent company, Georgia Pacific, said the company had no idea its ads were appearing in the child sex chat rooms. She said the company was "shocked and appalled" to find out; it quickly pulled all of its ads from the entire Yahoo system while it tried to revisit its Internet ad-buying guidelines.

Chapter 12: Corporate Sponsorship of Child-Sex Chat Rooms

Keagan said Georgia Pacific had paid Yahoo to tailor its ads to the female, aged 25 to 54 demographic, but "they did not adhere to the contract." She said Yahoo had even admitted that it failed to place the Brawny ads as agreed.

Yahoo declined to comment on Georgia Pacific's assertion.

This kind of confusion was a problem for any company trying to advertise online, Keagan explained to us. The company writes a check to advertise on a major Internet site—but it assumes that the site has the same control over its content that a magazine or TV channel does.

It doesn't. The Internet doesn't work that way.

The appeal of online media for users is that they have direct input—and, in some cases, even control—over the content they see. The graphic sex chat rooms are a logical extension of this appeal. And that's a logical extension that advertisers didn't consider.

Georgia Pacific's Keagan concluded that, in the future, "if we purchase again on Yahoo we have been assured that we won't be in those arenas."

When a Pepsi spokesman was told that Diet Pepsi ads were appearing in child sex rooms, he said, "We sure as hell didn't know."

Then Pepsi issued a statement:

> *Thanks for bringing this matter to our attention. We were completely unaware that our advertisements were associated with these chat rooms in any way and we've worked with Yahoo to immediately remove them from the site.*

Countrywide Mortgage Co. also removed its ads in response to our queries. The big lender's statement read, in part:

> *Countrywide has a strict advertising and media buying policy, which expressly prohibits our ads from appearing on inappropriate Web sites. Once this had been brought to our attention, we took immediate action to remove Countrywide ads from the Yahoo sites in question. In addition, we took measures to ensure that a situation like this could not occur again.*

We are committed to helping families and would never know-
ingly permit our name to be associated with immoral or un-
ethical subject matter.

Some family groups wanted Yahoo punished—financially—for hosting the child sex chat rooms. But there wasn't much legal basis for any such fines.

The Communications Decency Act passed by Congress in 1996 was meant to regulate online obscenity; but the law allowed Internet Service Providers to avoid any liability for merely hosting a chat room in which third parties placed illegal content.

As long as individual users created the child sex chat rooms—and Yahoo merely maintained them—Yahoo couldn't be held legally liable for the content.

The World Wide Web Changes Overnight

But the marketplace forced Yahoo's hand as effectively—perhaps more effectively—than any law or group of laws could have.

So many corporate advertisers pulled their money out...and so many family groups complained so vehemently...that Yahoo decided to pull the plug on *all* of its User Created Rooms. The company made this decision in June 2005, within two weeks of our investigative team's first broadcast report about corporate ads on child sex chat rooms.

Some First Amendment groups complained that Yahoo's termination of User Created Rooms was a free speech concern. Among the chat rooms killed by Yahoo were many legitimate and clean ones, serving small groups of people with common (non-predatory) interests.

"Their answer is to just strip them all, strip all these chat rooms off. It makes no sense," said Rod Mitchell of Spring, Texas. He'd hosted a User Created Room focused on networking and job searches

for people involved in independent films. "It isn't fair to people who have depended on these chat rooms for work. It's throwing out the baby with the bath water."

Some of the other "babies" were chat rooms dealing with religion, computer games and sports.

But the Internet's fragile economy relies heavily on advertising dollars; and Yahoo wasn't about to endanger its best revenue stream for the sake of some masturbating exhibitionists and niche groups. Brawny towels wanted women chatting about Oprah Winfrey and *Desperate Housewives*; Pepsi Cola wanted chat rooms full of kids swapping gossip about Jessica Simpson and *American Idol*. Yahoo was determined to deliver the advertisers what they wanted.

The predators would have to find somewhere else to cruise.

Within hours of Yahoo's decision, if someone clicked on the directory that usually listed all the various choices among User Created Rooms they'd reach a blank screen.

Yahoo would not answer—for the record—our questions about its user created chat rooms or its decision to remove them. However, posted on its chat service was this message:

```
The ability to publish user-created chat
rooms in the public Yahoo! Chat directory
is currently unavailable. We are working
on improvements to this service to en-
hance the user experience and compliance
with our Terms of Service.
```

These problems are likely to continue, in different forms. So-called "user-created content" remains one of the hottest growth areas for Internet Web sites; and true user-created content is difficult to manage as an advertising-friendly media environment.

Yahoo promised that it would add more safeguards to its chat rooms. Soon, a new warning advised anyone entering Yahoo's remain-

ing chat rooms that his or her IP address was being logged. In fact, Yahoo had always had the ability to log the IP addresses; but the warning was meant to discourage anyone who might want to start talking dirty in any of the remaining chat rooms.

Predators Follow the Teen Traffic

Yahoo's move left a large void on the Internet; but it didn't stop child sex Web sites. Most of the meet-for-sex rooms for specific cities were gone; and these rooms were the busiest places for men seeking children during our team's investigations in 2004 and 2005.

Those rooms cropped up in other places and on other Web site...but they didn't have the volume of people clicking through that the Yahoo rooms had had.

So, the predators went where they kids were.

For many, that meant MySpace.com.

For others, it meant prowling other chat rooms created by Yahoo, AOL or other ISPs. Sometimes, this meant minding their online behavior more carefully since some of these rooms were monitored by corporate administrators.

Instead of a custom-made chat room named for some sex act, predators lurked on more mainstream rooms that would obviously draw children. Chat rooms focused on computer gaming or cheerleading became the launching pads for the same IM propositions that our team had seen on the User Created Rooms.

The intensity of the IMs was definitely not as strong as it had been in the sex rooms; but the predators were still out there.

And a group of Web sites cropped up—outside of Yahoo, AOL and other big ISPs—that were dedicated to guiding predators into the chat rooms that still existed and offered the best chances of finding victims. Sometimes these lead users to "hidden" (or simply harder-to-find) chat rooms that still deal with sex in graphic detail.

Chapter 12: Corporate Sponsorship of Child-Sex Chat Rooms

Advancing technology is a fact of life in the Internet age. The corporate advertisers who ended up paying to have their logos and brands posted in sex chat rooms didn't understand the media they were buying. The ones who got burned and embarrassed won't make that mistake again. But they might stumble over other new technologies (advertising on cell phones and PDAs is one recent variation).

The shocking thing is that sexual predators are so far ahead of Madison Avenue ad geniuses.

As long as that remains true, big companies may continue to be embarrassed by their Internet advertising miscues. Of course, for them it's just a matter of money.

For curious children, the stakes are much higher.

Sexual Predators

13 How the Law Responds

This will be a very thorough investigation.

In a scene that sounds like something from a bad TV movie, a Houston-area father of three discovered a sexual predator in his home.

The father—a computer technician who made his living (ironically) installing security systems for corporate clients—had taken a day off to play a character role at the Texas Renaissance Festival. He'd enjoyed dressing the part and amateur acting for years, so his teenage daughter thought she knew how long he'd be gone.

But he finished earlier than expected and headed home, where his daughter was watching his two younger children.

When he walked in the front door, he sensed something was wrong—though he wasn't sure exactly what. The little ones were okay; but the teenager wasn't around. He headed up to her bedroom. The door was closed.

When he opened it, he could tell she'd been doing something suspicious. His daughter seemed nervous...and she spoke in an unusual tone of voice. He figured that she was hiding something.

He looked around—and then opened the closet. Hiding inside was a naked man in his late twenties.

The father was so shocked that he didn't know what to say. He shouted that the man had a few seconds to get out.

Or he'd be dead.

Then, instinctively, the father headed downstairs to get the pistol that he kept in his bedroom.

Coming out of the bedroom with his firearm, the father ran into the predator—literally.

He slammed the stranger up against a wall...and, with his pistol in his hand, realized he didn't want to *kill* the predator. He just wanted to make sure the man didn't hurt his children.

The father told the predator he was calling the police.

As soon as the father took his arm off of the predator, the predator slithered out the front door and rushed out to his car.

In a later interview, the father summed up his biggest worry:

> *I could have come home and I could have had three dead children, and would have known absolutely nothing about what had caused it.*

Eventually, the father got in touch with the Texas Rangers, who had worked with my investigative team on our original undercover investigations.

The Rangers headed to the home to interview the underage girl and her father.

Listening to his daughter, the father quickly realized the mistake he'd made by not putting better security software on his family's computer. He ruefully admitted the irony, like the old story of the shoemaker's children who had no shoes.

Although the father felt ashamed that he hadn't done more to prevent the predator from sneaking into his home, his call helped the Rangers a lot. They'd been investigating a different sexual predator; and the daughter—who'd had sex with several older men—would give them some important evidence for *that* investigation.

Profile of a Victim

The daughter—a slender teen with long black hair and pronounced dark eyes—had never been in trouble before, according to her father.

Her name was Charlotte. And she'd started home schooling a few years earlier because her family wasn't comfortable with the junior high she'd be attending in their suburban subdivision. They'd heard horror stories of girls getting pregnant and drugs flowing freely.

But home schooling came with its own risks. It left her alone at home during most days. There was some upside: She was more available to watch her two younger siblings. But there was also some downside: Her father had little idea how she spent her time when he was away from home.

Charlotte said she'd been finding sex partners on the Internet for more than a year. Because of her home-schooling, she didn't have any "normal" way to meet boys her own age. But she said this really didn't bother her so much. She'd always been attracted to older men; and they were *everywhere* on the Internet.

She knew that having sex with these older men meant they'd have to be willing to risk going to jail. She was flattered by their willingness to take that kind of risk; and the danger made it all more thrilling.

When her dad asked her to start naming names, she started with an orthodontist she'd seen on television being chased by cameras. Charlotte said he had been over for sex a couple of times after chatting with her on the Internet.

In a later interview with our investigative team, Charlotte described her memories of being with the orthodontist: "He was saying, you know, that I was...it's almost like I'm a little too old for him."

She said that when the orthodontist arrived for that first sexual encounter, they went straight to her bedroom and talked for only a few minutes before "it went straight down to sex."

"He was just ensuring me that he didn't want me to be clingy, this was just a sexual relationship, you know, nothing where I'm thinking we're dating or anything. We were both on the same page," she said in a matter-of-fact tone.

She said she knew he was married and what he did for a living before she had sex with him.

A Critical Piece to the Puzzle

Sgt. David Rainwater of the Texas Rangers had already opened a file on the orthodontist after the television sting. The orthodontist had left an impression because Rainwater's partner had an 11-year-old daughter getting braces at one of his clinics.

Charlotte's testimony gave Rainwater some powerful evidence...as well as several new cases to pursue.

On the job, Rainwater wore a white straw cowboy hat, dark slacks, a white button-down shirt and the round badge on his chest—just like most Texas Rangers. His sidearm holster was aged leather, not the black utility holsters most police carry. He was laid back, confident and thorough.

"This will be a very thorough investigation," Rainwater promised. Anyone who heard him would believe that.

He interviewed Charlotte about specific dates and screen names in the chat rooms. He confiscated the family's computer, with the father's approval. The U.S. Secret Service would help him to dig for the evidence he needed to confirm her chats with the various men; but Rainwater would make sure the Rangers stayed involved.

In her sworn statement, Charlotte formally declared that she had had sex with the orthodontist on two occasions. She also named three other men: An ex-convict who had a lengthy criminal record and had spent time in prison for stealing a computer, a local father of two young girls who was separated from his wife and a local television sports reporter.

The Rangers knocked on the TV sports reporter's door and got a quick confession. The reporter admitted to meeting Charlotte for sex after "getting to know her" in the online chat rooms.

The ex-con, named Michael Corrigan, admitted the same thing. He was sent to prison for another eight years for having sex with Charlotte. Technically, he pleaded guilty to "Sexual Assault of a Child" (Texas' version of what other states call *statutory rape*).

The other two men would plead not guilty to similar charges, after Rainwater's investigation resulted in their arrests and indictments.

The Pattern in Online Sex

At one point, Charlotte had said, "Isn't it strange how they all do the same things?"

Three years after her father had walked in on her and one of her sex partners, the girl had become an adult. She was still involved as a witness in some legal proceedings; the cases of the two men who were fighting the charges were still winding their ways through the Texas court system.

In a follow-up interview with my investigative team, Charlotte offered some observations from her experiences meeting men in chat rooms and then having sex with them. While she was hesitant to offer advice, her recollections do offer some warnings signs about how predators operate. She said:

- The predators all complimented her appearance and flattered her in ways designed to appeal to her ego.

- They all asked about the likelihood of parents coming home and catching them.

- They all asked how many other men she'd had sex with.

- They all parked their cars down the street, away from her house.

- Most brought condoms.

- Most asked, at some point, whether she was a cop.

Even as a young girl, she thought the questions about her being a cop were strange. And, frankly, they are.

In our investigations, many predators would ask "Are you a cop or in any way working with law enforcement?" As I've mentioned before, they seem to think that an undercover police officer must admit who she is if asked.

Again: That's *not* true. An undercover agent can deny being an undercover agent.

Charlotte said most of the predators would arrive for their first meeting and sit on the bed with her for a few minutes. Usually, they'd swap some pretty generic small talk—like people meeting in a bar or at a social event.

The orthodontist stood out in her memory, though; he asked her repeatedly if she was sure her parents wouldn't come home.

After a few minutes of chit-chat, they'd usually start kissing and undressing. The rest would go in a blur…and then the predators would be in a hurry to get out. She remembered that all of the encounters went fast—some would be over in a few minutes.

Legal Battles

The orthodontist fought Charlotte's allegations aggressively. Through various pre-trial hearings and other early court appearances, he pronounced his innocence and pleaded *Not Guilty*.

He had retained a new lawyer—a criminal defense specialist who'd won several high-profile cases in the Houston area.

At one bail hearing, the orthodontist's wife took the witness stand to convince the judge to lower bail and let her husband out of jail. Also an orthodontist, she had long blonde hair and a petite figure.

Some men in the courthouse hallways whispered they couldn't believe someone would cheat on such an attractive woman. But child sex is something far more complicated than simple adultery.

The orthodontist's wife looked stoically around the courtroom as she described the financial ruin that had resulted from the charges against her husband.

The wife said that legal bills and lost business at the family practice had left her with no assets and that the family's million-dollar home was on the brink of foreclosure.

The judge agreed to lower the orthodontist's bail slightly; the reduction was enough for the family to post a bond and get the man out of jail.

Outside the courthouse, the orthodontist's lawyer argued that Charlotte was lying to get attention:

> It's easy to accuse in this country, very easy to point your finger. It's easy to make up a story. It's easy to get the attention of the media by making up a story, but {my client} is innocent. We look forward to our day in court.... I don't know her psychiatric makeup. All I know is she's lying and what she's saying is not true regarding {my client}, so we're looking forward to the truth coming out. Right now, we haven't had a day in court.

The lawyer said that he looked forward to digging into Charlotte's background as trial approached because he had discovered some curious things about her.

Charlotte got a little uneasy when the lawyer's comments aired on TV. What "curious things" could he have found out about her?

She said she had nothing to hide.

But she wondered if he'd dug into her past far enough to find out that she'd been sexually abused by a family member when she was six. That abuse lasted quite a while—and had been detailed at great length in a divorce case that anyone could read at the courthouse.

Aside from that, Charlotte figured that the lawyer would focus on making a jury believe she was lying. She had no proof that she'd had sex with the orthodontist. (Now, she said, she wished she'd kept something out of his wallet. Or maybe one of the condoms she'd been so careful to throw out after their trysts.)

Charlotte's father was also part of the proceedings. At one hearing, her father took the witness stand and was prepared to face a grilling. But the orthodontist's lawyer only asked him a couple of questions. First and foremost: "Has your daughter ever lied to you?"

Of course, in all of her childhood, there'd been a lie or two, he answered.

Watching her father and the lawyer, Charlotte thought she knew what the question meant: When she took the stand, the lawyer would work hard to make the jury see her as a lying tramp.

She lied every day to cover up the sex meetings she was having with adults, so why wouldn't she lie here on the witness stand?

But Charlotte knew how she'd reply. She wasn't the one who caused the charges to be filed. That was the Texas Rangers…and maybe her father. She didn't care whether any of her four sex partners went to prison or not. She wasn't mad at them.

Charlotte had the wisdom of hindsight now. "The thing I regret the most is being more selfish," she said:

> I didn't think about my younger siblings, you know. I was really putting them in danger, and I didn't realize it at the time. What I regret the most. I was just thinking of myself and wasn't thinking of them or their future.

Her father had a better perspective, too. He said:

> Normally you think of your home as being safe and secure, and now I don't think my home is safe and secure. I really have no idea how many people have had access to my house, who know what's inside my house, know how many children I have, who know intimate details that you wouldn't

*give that information to anyone except friends of yours. And
it really concerns me. It highly concerns me.*

This whole ordeal has changed how this computer technician will
handle computers in the house as his two younger children are grow-
ing up. His advice to other parents?

*Do not leave your children alone with the computer. Don't
act like it's a babysitter. Make sure it's in plain and open
view. Make sure that you have some type of spyware protec-
tion or software that can track what they're doing.*

Can't Stay Away from Online Sex

All four of Charlotte's sex partners eventually posted bail while
their cases proceeded. As I've mentioned, two of them would plead
guilty and end up back behind bars.

In order to be granted bail, Christopher Lance Cobb (the TV
sports reporter) had to promise that he wouldn't enter any more chat
rooms and that he wouldn't log onto any sexually suggestive Web sites.

He promised. Then, with the threat of more jail time hanging
over his head, he broke both promises.

Charlotte was surfing the Web a few weeks later and found Cobb
listed in a romance chat room. There was a picture of him sitting at a
TV anchor desk; there was a profile that included his love of walks on
the beach and romance—and there was a list of young females who
had been chatting with him.

This particular Web site allowed anyone who'd chatted with Cobb
to post her own picture on the page along with each message. Several
of the girls looked like teenagers.

Some of the girls posted provocative messages, saying they couldn't
wait to meet him; others spelled out their attraction to him in graphic
terms. A few even mentioned having already met him in real life; in
the chat room, that seemed to mean they'd had sex.

Sexual Predators

When prosecutors learned what Charlotte had found, probation officers were sent to Cobb's home to search his computer. They headed back to the judge to report what they'd found.

The judge called a hearing.

In court, the TV sportscaster admitted he had violated his conditions of bail by chatting on not one, but three different sexually suggestive Web sites. He admitted that one of the young females had sent him nude pictures and had spoken of meeting him for sex. He admitted that he couldn't verify if any of the girls were really of legal age.

The judge immediately ordered him arrested again.

Later, Cobb agreed to a plea bargain. After spending a couple of months in jail, he pleaded guilty in exchange for probation. He had to register as a sex offender (which is seen as *worse* than jail to most sexual predators). He also couldn't touch a computer during his probation.

Michael Corrigan—the ex-con—got out on bail for a short time. But he showed up at one of his pre-trial hearings visibly drunk.

When his named was called, Corrigan stumbled into some courtroom benches and then staggered toward the judge. The constable's deputy on bailiff duty reported to the judge that the defendant smelled of alcohol.

Corrigan was immediately ordered to take a urine test on the spot. This proved a bit difficult. As deputies guarded the small bathroom near the courtroom, Corrigan whined that he just "didn't have to go."

After 15 minutes, the judge didn't have to wait any longer—he revoked Corrigan's bond and locked him up again.

Several weeks later, Corrigan pleaded guilty and accepted a trip back to state prison for eight years. With good behavior, he might be out in half that time.

14 A Child's Diary of Being Attacked

It's just really scary how your children can trust someone outside,
someone they've never even met, more than they trust you.

Terri—a fit and active suburban mother—felt panic and a chill racing down her spine when she looked at the diary of her daughter, who'd just turned 14.

Her daughter described sneaking out of the house at 12:30 in the morning to meet a stranger she'd been chatting with on the Internet. She described how he drove her to a business where he unlocked the gates and a door and then forced her to have sex with him on an office couch. The man actually pushed her to the floor as she was telling him to stop. He remained completely silent as he forced her into several different sex acts.

After staring at the pages in disbelief for...she wasn't sure how long, Terri ran downstairs to ask her daughter when this had happened.

The girl broke into tears before saying a word.

She had been caught violating her parents' trust. But Terri noticed that the tears seemed to be relief that, finally, someone else knew what the girl had been living through.

"It wasn't just that she had met this guy, this unknown person outside from us," Terri said later. "It was also that it was in the middle of the night and we didn't know that's where she had gone. And the fear of...."

Her voice stopped. She sighed as she considered the worst but didn't say it. Racing through her mind were thoughts of her daughter being tortured and killed.

"We would never have even known who this was," she said. "It's just really scary how your children can trust someone outside, someone they've never even met, more than they trust you."

Terri's daughter, April, was a tall and thin girl with fair skin, freckles and long blonde hair that fell straight down her back.

April's troubles started when she made the choice to sneak out through a doggy door in her family home near Katy, Texas to meet a man she'd chatted with online. "I was on the computer and I really wasn't paying attention to him," she said. But the man—who called himself "Eddie"—was determined. He kept trying to get her attention with jokes and instant messages; when she finally responded to him, he locked onto her.

Their computer chats progressed into phone calls—that took place after her parents had gone to sleep. "Eddie" was pressing the whole time for April to sneak out and meet him.

April insisted that she agreed to meet him for innocent purposes. "He said we were just going to get something to eat or something and talk. But he brought me to his car shop and that's when I figured out something was wrong," she said.

Terri asked April to repeat the story. And then, like a prosecutor cross-examining a witness in court, Terri started picking apart the details.

There was a good reason for this. April's story seemed a little fuzzy in places, making it appear as though she was trying to conceal some of her dealings with the online predator. Maybe she was ashamed

that she had allowed so much to happen; maybe she was trying to obscure how much flirting she'd done.

At that moment, Terri didn't care so much about the details of April's flirting. She was afraid that April's story wasn't enough to help the police find the predator.

She asked April for the guy's real name. April said she didn't know that—all she had was a screen name and "Eddie."

Terri figured that wasn't enough information for police to track down the attacker, so she sat down at April's computer and started her own brand of detective work. She'd seen recent TV news reports— including my investigative team's segments—that involved reporters posing as children online. So, she did the same.

Parental Detective Work

Terri logged onto the AOL Instant Messenger service as a different 14-year-old girl with a different screen name: BLONDESRULE069.

She typed an e-mail to the screen name that April had mentioned.

```
Hey U.
I don't know if you remember me, but last
time we chatted things got pretty hot and
I would love to chat with you again. IM me
when you get this.
```

The bait had been placed.

Terri wanted to lead police right to the predator, "to find out who he was so we had something to report. So we had some place for police to go and say *this is the guy*."

Not everyone in the house was so clear-headed. Her husband Rick had come home from work—and learned in a few minutes the facts

that Terri had spent several hour piecing together from their daughter. Like Terri, Rick was stunned at first. Then he was angry. He wanted to kill "Eddie" himself and face the consequences.

After speaking with April, Rick paced back and forth in the computer room while Terri set the trap. "I think at first it was anger," he said, later. "I wanted to set it up, consider having her meet him again and take care of it myself."

But their labors would take a while to bear fruit. "Eddie" didn't respond immediately.

A few nights later, his screen name took the bait from BLONDESRULE069.

"Eddie" answered that he didn't remember her, but he'd love to chat. Then he asked her to describe herself. Terri described the kind of girl that would really interest him: small, blonde, a cheerleader.

Within minutes he's telling her he'd love to hook up with her. He even uses the exact same words that he used in his chats with April: "We could meet at the end of your street so no one will see us."

"It kinda gave me a worse feeling," Terri recalled, later. "I found out how easy it was to meet him, within 20 minutes I could have met with him."

Instead, she wanted confirmation.

She asked him for a picture—and he sent one to her without hesitation. Terri called April into the room and April confirmed that it was the man who had attacked her.

Terri's online detective work was paying off.

Rick did some detective work of his own. He loaded April up into the car to locate the business where the attack happened. April remembered that it was near her middle school; but she didn't know which street.

They drove up and down several streets until she told her dad to stop.

April started crying.

The business was an auto repair shop with the repair bay doors flung open and mechanics mulling over various cars. And parked in the lot was the same fancy, nearly-unique orange sports car that had picked April up at the end of her street the night she'd been raped.

Rick jotted down the license tag number and the name of the business.

Now April's parents had plenty of information to hand over to the police. But they called me first. I made sure that Terri and Rick handed over their information to the police; within a few days, we broadcast a story that highlighted the family's detective work…with their identities concealed to protect the teenage rape victim.

The Police Investigation Stalls

After the story ran, the local sheriff's deputies called the family to say they wanted April to come down and look at a photo lineup—to see if she could positively identify her rapist.

A photo lineup is a common police procedure at the beginning stage of an investigation. In the movies, the actual robber or killer is walked into a room with a bunch of similar looking people and from behind a mirror, the victim yells, "That's him!"

But, early in a real criminal investigation—when there's not yet enough evidence to file charges—it's more common for police to request the drivers license photo for their main suspect. Then, the photos of other similar looking people will be shuffled in to see if the victim can pick out the criminal.

In this photo spread, one of the drivers license photos belonged to the owner of that nearly-unique, orange sports car.

April looked at the pictures carefully.

The room was quiet, with detectives seeming to hold their breath.

She couldn't do it.

April wasn't sure whether her attacker was among the pictures.

The officers tried not to seem disappointed. But, without a firm ID from the girl, the investigation was stalled.

Terri and Rick couldn't understand what was happening. Weeks passed and they grew angrier every day. They wondered why the detectives hadn't visited the auto shop where the rape happened. Why hadn't they seized the predator's computer?

Many parents and victims of Internet sex crimes (and *all* crimes, for that matter) are frustrated with how the investigative process really works...or doesn't seem to work.

Terri said, "Nobody ever got out from behind their desk. How much more do you have to give them?"

Detectives reminded the family this was not a one-hour drama on TV. Real detective work is more complex and takes more time.

Lt. Ruben Diaz, head of the Harris County Sheriff's Department juvenile sex crimes unit said, "Things were getting done, but just not to their expedient satisfaction."

Rick argued with the detectives and told them they should be able to lock up the man who'd raped his daughter. Rick practically shouted that if he walked across the street and punched his neighbor, they'd be knocking on his door within hours to haul him to jail. So why would they gloss over all the evidence the family had handed them...and let a violent criminal remain on the streets?

Diaz said other leads were being followed and his detectives were trying other methods to identify the alleged rapist—since the victim couldn't positively identify him.

After several more weeks, April starting to get phone calls from "Eddie." He wanted to see her again. He left messages on her cell phone. One time, she accidentally answered the call and heard his voice; she told him she was having dinner, so she'd have to call him back.

Now April was scared again.

Rick said he was afraid to send his daughter off to the neighborhood pool, fearing "Eddie" could be right around the corner where he

had picked her up. He wasn't going to live like this. Something had to be done, even if it meant jeopardizing any criminal case. Or putting his family in more danger.

Police say this is never a good idea.

"We definitely don't recommend people do their own investigating because they don't know the entire story all of the time," said Diaz. "What if they come up with a suspect who is a very violent suspect? There are just too many things that can go wrong."

But Rick and Terri were willing to take that chance. Rick said it was "because the danger's still there, and that would make me as negligent at my job as I felt they were at theirs."

The parents got online again, creating a third screen name in an effort to draw their daughter's rapist out for another meeting. They planned to call 911 when he arrived.

Then, they figured, police would get the positive identification from April that they didn't get from her photo lineup encounter. The girl would be there in the flesh to point at the man and tell deputies that is definitely her attacker.

Once again, the parents typed a message to the same screen name that April had chatted with on the night of her attack—and the same screen name that Terri had chatted with after that as BLONDESRULE069.

Once again, he took the bait and was ready to arrange a sex meeting with an underage girl.

Terri decided April should do the chatting this time so it would seem more realistic. April would use the abbreviations and the lingo that all teens use and the guy would simply figure he'd found another potential teenage sex partner.

This time, they were posing as LORIN, a cute blonde 95-pound eighth grader.

LORIN told "Eddie" that she had found him on her buddy list but she didn't remember when she had chatted with him.

Sexual Predators

On America Online's AIM service, the buddy list consists of screen names that you can add by yourself when you learn a friend's screen name, or you can automatically add a name when you chat with someone. This makes it easy to send future Private Messages to them, sometimes with a single click.

For someone who chats with many different people, it's no stretch to find a name on your buddy list that you can't quite remember adding. Was it the guy I was talking about Astros with...or the girl I chatted with about the Dixie Chicks?

LORIN sounded like someone who was trying to jog her memory. She sent several messages:

```
Do you remember me?
What's your name?
Are you there?
```

Then Eddie is back, and he's puzzled:

```
WHO IS THIS??
```

April wove a plausible story about why LORIN would be so anxious to chat with him. In short, she was sexually curious and ready to try something—right now. It worked like a charm.

Within minutes of starting the chat, "Eddie" was suggesting a meeting with this young blonde.

Then, he reverted to his standard mode of operation. He suggested they meet at the end of her street so no one would see them; and he provided her the same cell phone number that April had called on the night of the attack. It was the same phone number that "Eddie" had used to call her cell phone several times weeks after the attack, causing her dad to become more and more enraged.

Then, Terri jumped out of her chair and yelled "Oh my God!" at what "Eddie" typed next.

He typed that he could take LORIN to a business that he had the keys to; and he named the neighborhood where the attack on April had occurred. It was a repeat of the night her child was raped!

They called me and, within an hour, I was in their house and had taken over chatting with "Eddie." My hope was to draw out specific sex talk that would be incriminating and to arrange another meeting for the family.

"Eddie" chatted that he wanted LORIN to perform oral sex on him, and that he wanted to kiss her and teach her things. (LORIN had said that she was a virgin.) But, before he'd chat any more, he wanted to hear her voice on the phone to make sure she was for real.

Rick dialed his cell phone and handed it to April. He paced back and forth the whole time she was on the phone. But he didn't have to worry; April did very well. She spoke to "Eddie" in a calm, low voice like a girl who hadn't a care in the world. They agreed to meet behind a convenience store, less than five minutes from the family's home.

The entire family loaded into their SUV and headed to the meet—with my investigative team following behind. It was after 1 a.m.

Rick and Terri pulled into a parking lot near the meeting location. Our camera was rolling as that same nearly-unique, orange sports car arrived at the convenience store as agreed.

As soon as it arrived, we called the police. Within minutes, sheriff's cars pulled up—and we pointed out the sports car driving away.

The deputies pulled over the car and ordered the man out.

The family's SUV screeched up—less than six feet away from "Eddie"—while officers were deciding how to deal with the man. April got a good look at him.

She started to cry and told her dad that was "Eddie"—the man who'd attacked her. For sure.

Rick jumped out of the SUV and rushed toward the patrol car. He pointed his finger and screamed, "You raped my daughter you motherfucker!"

The deputies on the scene told Rick to get out of the street and—if he wanted to stay close—to park in a nearby parking lot.

In the next few moments, more police cars flooded the scene. A call must have gone out. The detectives were called in and quickly realized why April had been unable to pick the rapist out of the photo lineup earlier.

"Unfortunately, the drivers license photo and the actual suspect: they don't match. He doesn't look anything like his driver's license photo," said Diaz.

Detectives had followed standard procedure, using "Eddie's" most recent driver's license photo—but that had been taken before he'd shaved his head and gained some weight. It had also been before he'd started wearing glasses.

Just as the family was hoping, April's positive ID of the man on the spot was enough for charges to be filed. Prosecutors accepted charges of Sexual Assault of a Child and "Eddie" was finally booked into jail.

Diaz admitted the arrest might have never happened without the family's push; but he still said families should never consider such a move. "It kind of worked itself out," he said. "But you never know if involvement like this could jeopardize the total outcome of the case."

Eddie went to court and pleaded not guilty. If he was convicted at trail, it could mean 20 years in prison.

Several months later, Terri said April was trying to put it all behind her. But "I think she still may think she got away with something because she made it home safely. Even though something horrible happened to her, she didn't get hurt....physically....forever."

Some kids aren't so lucky.

15 Child Pornography... and Legal Bureaucracy

He told me the only reason he became a schoolteacher is because children arouse him.

Some images strike you as wrong immediately, on an instinctual level. A child carelessly playing with a gun. A toddler padding into freeway traffic. They are dangerous combinations.

Scott MacKenzie—a Dallas lawyer and father of a four-year-old daughter—found himself looking at another dangerous combination on his home computer late one night. It was a primary school teacher's lesson plans...and a cache of hardcore child pornography.

But what could he do?

MacKenzie has an unusual hobby, especially for a lawyer. He's an Internet snoop. He spends his nights surfing the Web—looking for sites, servers, intranets, local area networks and other places that aren't well secured. When he finds one, he goes in.

Some people might consider MacKenzie a hacker. He doesn't like the term. He only uses common "file sharing" programs widely available to anyone. He doesn't do anything to change computer settings; and he doesn't do anything malicious to the computers he gets into. He just looks. And sometimes he copies things.

He hadn't been looking for *this*.

The teacher's computer listed file names for lesson plans, his resume and grades; all of this was scattered on the screen with an array of twisted and perverted names for thousands of pictures of child pornography. Lesson plans mixed with sex crimes against children!

"I've seen a lot on the Internet," MacKenzie said, later. "I've seen stuff on the Internet that I've found disturbing. But I've never seen anything like this in my life."

MacKenzie figured the teacher had more than 100,000 hardcore images of child sex on his computer. This gave MacKenzie a mission: "I was enraged and I had to find out who this guy was."

While some lawyers would liken his mission to a burglar spotting something illegal and reporting to police about what he'd seen, MacKenzie had no qualms about the teacher's right to privacy.

When asked how he would handle defending a case where the crucial evidence was discovered by a stranger peeking into someone's computer, MacKenzie answered almost immediately:

> *What if I had a case like this? I'd shove him under a bus. I couldn't stomach it. It was like a garage sale, not a burglar. He was holding this material out there to view. I had an obligation to do something.*

Child Pornography and Other Factors

The millions of tawdry pictures on the Internet originate in different ways.

Legal pornography, involving adults, is a mammoth business. Three studies from 2001 agreed that, each year, the top five porn sites on the Internet received nearly twice the number of visitors as the top five news sites.

Many men who are arrested for arranging sex meetings with children are also found to have child pornography stored on their com-

puters. And, in some cases, the child *pornography* charges stick better than the child *sex* charges.

As a result, predators are getting smarter about hiding their dirty pictures. Many have started storing their filth on cell phones, PDAs or other small electronic devices.

"Innovative technology has made electronic recordings and photographs more portable and accessible," said Texas Attorney General Greg Abbott. His cyber crimes unit had arrested nearly 100 men for trying to entice children into sex meetings; and, in 2006, federal funding allowed his cyber sleuths to go after even more.

Abbott boasted a 100 percent conviction rate for men who thought they were chatting about sex with a child.

In early 2006, his investigators handcuffed Ron James Guzman, a 50-year-old grain elevator manager from the Texas town of San Marcos. As Guzman was being booked, officers confiscated his iPod—the popular portable music player.

But Guzman's iPod didn't contain music from U2 or a favorite country act. It contained hundreds of videos and photos of children engaged in sex acts.

After Guzman's arrest, Abbott said, "Unfortunately, sexual predators are taking advantage of these new developments in order to exploit children. Collecting and distributing child pornography is a crime."

Psychological studies find that people who view child pornography often have a "collector's fetish." They will trade and share and store images and videos, limited only by the memory of the computer they're using. (And sometimes not even limited by that—some "collectors" will have several computers or separate hard drives dedicated to their images.)

Child pornography circles are tightly connected; law enforcement agents often recognize an image or group of images in a new case from previous investigations.

And—while the connection between "regular" pornography and sex crimes is disputed by psychologists—police say they see a definite link between child porn and child sexual abuse. Some men (and, again, most of the people who collect child porn *are* men) stick to looking at pictures and video in private; but a disturbing number "progress" to seeking out meetings with children.

But even those who haven't yet progressed to physical contact can be dangerous.

Pornographic File-sharing

Scott MacKenzie—the Internet snoop—knows this.

In his mid-30s, MacKenzie has a slight growth of a beard and the soft expression of a caring person—but he's obviously well read and articulate. There's little doubt that juries find him sympathetic and believable.

But MacKenzie's not just comfortable in a court room, he feels most at home...at home, hanging around with his four-year-old daughter.

His hobby is the hard part to square with the rest of his life. MacKenzie started by using various file-sharing programs to search for little-known games, music or software applications available on the Internet. These file-sharing programs—called peer-to-peer (P2P) systems—are an edgy part of the online world; some people consider them piracy tools, used by people who steal copyrighted material.

Napster (in its original version) and Morphius are the probably the two best-known P2P systems. Millions of people use them.

For music, a P2P user simply types the name of a song; in seconds—or fractions of a second—millions of other users' computers are searched for that song. Then, with one click, the user can download that song onto his computer. The same process goes for photographs, office software, games and so on.

Chapter 15: Child Pornography...and Legal Bureaucracy

Most people who use P2P systems only pay attention to the files that they're swapping. In fact, the systems can give users a lot more access to other people's computers than most realize. If a P2P user chooses his settings carelessly, he can open his whole computer to the whole Internet. And a surprising number of people do exactly that.

When MacKenzie was setting up the P2P software on his own computer, he was able to choose what sorts of files he would share with others. He could agree to offer only his games or only his music, while choosing to bar any visitor from viewing other files.

MacKenzie was intrigued by these complex options and guessed— rightly—that many users wouldn't understand what they were doing when they chose their settings.

His original interest was in regional versions of well-known computer applications—for example, he was impressed by how many high-quality photo editing programs there were that few people had ever heard of.

This work was a little more sophisticated than the standard P2P user's focus on swapping Green Day songs.

Because he looked, MacKenzie saw more than a Green Day fan ever would. With a few clicks, he could gather a list of hundreds of screen names on his computer. Next to the names were cities where the users lived, as well as numbers indicating how much memory each computer had and—finally—a list of what sorts of files each user like to trade.

The list looked like this:

```
GAMEDUDE4 Houston 60 Gigabytes X-Box
COWBOY99 Amarillo 80 Gigabytes Animation/
art
QUILTMAKR Corpus Christi 40 Gigabytes Pho-
tos
```

But it would go on for hundreds of pages.

MacKenzie usually looked for the larger memory numbers, because computers with more memory on their hard drives would typically have more interesting programs to peruse. The amazing thing was that so many of these people simply left the "virtual door" into their computers wide open.

MacKenzie would click on the entries with those hefty-memory computers all the time. He'd get a listing of all the various sorts of files they would agree to share. He could then go shopping for movies, computer programs, games, or music.

But MacKenzie wasn't thinking about copyrights this time.

AALVARADO Houston 140 gigabytes Pics

At the time, 140 gigabytes was a large amount of memory for a home computer. MacKenzie figured that AALVARADO must be a serious user...and would probably have interesting software. He checked what was available on AALVARADO's computer.

MacKenzie would later conclude something law enforcement agents know: personal computers with *really* large hard drives sometimes belong to people who collect pornographic pictures and video clips—*pics* in Internet jargon.

At this point, though, MacKenzie didn't really know what "pics" meant. He clicked onto AALVARADO's hard drive to see what programs might interest him.

Instead, he felt the nervous realization of finding something really bad. The files were labeled in a way that left little to the imagination. He realized he'd found a giant collection of child pornography.

"What I saw was beyond description," he said. "I was rattled. I'd never seen such a thing."

And this AALVARDO had left his illegal material unsecured...on a computer with a P2P system that let anyone in.

Chapter 15: Child Pornography...and Legal Bureaucracy

MacKenzie confirmed his suspicions by clicking on several of the images that the porn collector had stored. Most were in the common JPEG format.

```
Joshbackyard.jpg
Brianbendsover.jpg
Timmyshower.jpg
Jennysfirst.jpg
```

On his computer were pictures of boys and girls, appearing to be five or six years old, involved in sex acts with grown men...and even younger children pictured in suggestive poses or these small children doing sexual things to one another.

Most were young boys.

ALVARADO appeared to be what sex-crime experts call a "preferential offender." He was interested mainly in pre-pubescent boys.

As nauseating as the prospect was, MacKenzie copied some of these files—and made sure each was time-stamped and identified clearly for future reference.

But the lawyer in MacKenzie knew that, even though the child porn was illegal, the pictures alone might not be enough. He wanted to find out more about who AALVARADO was.

MacKenzie backed out of the picture folder and looked for other available files. It didn't take long to find a smoking gun...in fact, several smoking guns.

When AALVARDO had set up his P2P file-sharing system, he'd had opened his "My Documents" file for anyone to access.

If you use any Windows/PC system, you'll recognize the "My Documents" folder as a catch-all that can hold anything from drafts of letters you're writing to images you've scanned. Many programs save files to the "My Documents" folder by default—unless the user instructs otherwise.

ALVARADO's "My Documents" file had a resume in it. MacKenzie clicked on it and saw the man was a grade school teacher.

The name at the top of the resume was Alfredo Alvarado, who listed his then-current job at an elementary school in the Aldine Independent School District (a large district just north of Houston). Other files in the folder contained kids' test scores, their names and their family information.

MacKenzie sat back his chair; he was stunned. How could this be? How come someone else hadn't discovered this before?

He copied and catalogued the evidence…but he realized he had to do something. Right away.

MacKenzie's forehead actually felt hot. He was a little nervous and a lot angry.

The Police Department's Initial Response

MacKenzie knew his way around criminal prosecutions. So, he'd put together a powerful file of electronic evidence. He knew that police investigators followed their own systems and schedules; but he also knew that his information was really strong. He expected the police to agree and arrest AALVARADO.

Instead, he would get a front row view of the major problems that plague law enforcement in prosecuting child sex crimes.

MacKenzie started by calling his local police department. After transferring MacKenzie through several different levels of bureaucracy, the Dallas Police Department tells him only the FBI could investigate such a thing.

So, MacKenzie called the Dallas FBI office and described the whole ordeal to the first person who would listen. The special agent on the phone had never heard of child porn being discovered in such a way; he told MacKenzie to call the Houston Police, who'd have jurisdiction.

MacKenzie called Houston Police—which, at that time, didn't have a cyber crimes detail. He waited through more rounds of call transferring. Finally, one officer told him—with complete certainty in her voice—that only the FBI could handle such a case.

He'd made a full circle, with no law enforcement agency seeming open to receiving his well-assembled evidence. And AALVARADO would be back in the classroom the next day!

He wondered if any of the children being violated in the pictures was in "Mister Alvarado's" second grade class.

He went online and looked for someone in the Houston area who'd dealt with sex predators.

His frustrated e-mail was waiting for me the next morning.

Maybe all of the different law enforcement agencies wouldn't be able to ignore his evidence if it showed up on the evening news. "When there's a camera in peoples' faces, they respond," he wrote in his e-mail. "If the media is asking questions, they will have to respond."

And he was right.

Child Porn: A Hot Potato No Cop Wants

MacKenzie's experience—and his frustration—is common. There's no single law enforcement agency that handles Internet crimes, and many victims have a lot of trouble simply getting an investigation started.

Most local police agencies will routinely refer people to the FBI; but, in reality, there are several different federal agencies that focus on specific aspects of Web-based crime.

In early 2006, the situation got a little better when one unlikely—and somewhat low-profile—agency started taking the lead in prosecuting child porn cases at its Cyber Crimes Center (C3) in Fairfax, Virginia. The agency is the Immigration & Customs Enforcement Service (known by its acronym ICE, it's the agency formerly known as the U.S. Customs Service).

Sexual Predators

Before C3 was created, at least three different federal agencies dealt with child porn and predators. Customs would typically handle child pornography cases; the Secret Service would investigate child enticement cases if state lines had been crossed; and FBI would handle cases in which children would meet predators off the Internet.

If a phone call did not specifically fit into an agency's specific, narrow focus, the caller would often get bounced around for days or weeks before anyone even listened to the story.

MacKenzie felt he couldn't wait that long. He actually e-mailed several news outlets around the country—but most passed, because the information fell outside the realm of a typical news story (the same way it fell outside the comfort zone of the various police agencies).

I called him back right away.

When I heard MacKenzie's voice for the first time, urgency and frustration seemed to drip from his words.

He said he wanted to show everyone just how sick the pictures were, so he was going to send some pictures in an e-mail to the television station.

"Hold it right there!" I told him.

After years of covering child pornography cases, my investigative team knew that it's a federal crime in the U.S. to *possess* child pornography. It also a crime to send it…and a separate crime to receive it.

"I just sent it," he said.

Sure enough, the e-mail was up on a shared computer screen in the TV newsroom. It had attachments that included the teacher's resume and five different pictures of child pornography.

MacKenzie had just committed a crime. "I don't care what the cost is to me personally. I want this guy stopped," he barked at us.

Breaking through the Gridlock

This was uncharted territory—for federal agents and for my investigative team.

Chapter 15: Child Pornography...and Legal Bureaucracy

The FBI probably wouldn't be allowed to do what MacKenzie had done in gathering the evidence, even though the pics had been on a hard drive open to the Internet public. The Feds' position was that they'd need probable cause and a court order—like any search warrant situation—to "look around" inside someone's computer. MacKenzie, as a private citizen, had more leeway; and, now that he'd found the illegal pics by accident, a judge would sign a warrant.

But the Feds would want that warrant before they moved—so, in the newsroom, we had to tread lightly.

And merely having this e-mail up on the screen was making everyone on the team nervous.

I called a contact at the FBI's Houston office and explained what had come in the e-mail. I also offered some background on MacKenzie, so that the Houston Feds would understand what my source had gone through.

The FBI's response was quick and decisive.

The agents didn't care about MacKenzie or my investigative team possessing the pictures. They understood this was a situation of an honest citizen trying to do the right thing.

They *absolutely* wanted the e-mail forwarded to them so they could confirm the facts and get the teacher out of the class room as quickly as possible.

In fact, the FBI arranged a special communication from the United States Attorney for the Southern District of Texas assuring us that neither we nor our source would be prosecuted for having the child porn.

We forwarded the e-mail to the FBI Innocent Images Task Force within a few hours.

The following morning, Alfredo Alvarado was in jail.

He bowed his head as the TV cameras got in front of him when he was taken out of the FBI agent's car and walked in for booking.

Sexual Predators

Our team was on the scene. And, with cameras rolling, I asked Alvarado if he had anything to say to the parents who trusted him with their children.

He didn't say a word.

As we checked further into this man, we found he had quit the Aldine School District and joined the Houston School District the previous year. The resume on his computer hadn't been updated to show the change.

And, in a small detail that made the story resonate even more with me, he was teaching at an elementary school named after a recently-deceased television news anchor in Houston.

Or he *had been*. Alvarado was fired upon being indicted.

At one pre-trial hearing, an FBI agent testified that Alvarado had admitted to him that "the only reason he became a schoolteacher is because children arouse him."

Locking up Alvarado was only part of the case; the children in his pics needed to be identified. FBI Special Agent Bob Dogium said, "What we need to do is get a handle on who may be in those pictures and then notify the family or the parents."

Agents spent a considerable amount of time trying to identify the children. Some of the pics seemed to be many years old. Others were from outside of the U.S. And the agents recognized some of the pictures from other cases.

This happens a lot. Some child porn images are extremely popular and widely circulated. FBI agents often find the exact same pictures in four out of five computers they search for child pornography.

Alvarado's collection was so large that many of the images were new to the Feds. Fortunately, nothing suggested that the children in Alvarado's pics had come from his classes.

But that didn't help Alvarado much in court.

He ended up pleading guilty, admitting to the stack of federal child pornography crimes in a lengthy indictment. The judge asked

Alvarado the standard questions—like whether he'd been coerced or promised anything in exchange for his guilty plea.

The judge ended her questions with, "Are you pleading guilty because you are, indeed, guilty of these crimes?"

Alvarado answered, "Yes, your honor."

He was sent to federal prison for more than 15 years.

In the federal justice system, the Sentencing Reform Act of 1984 made all sentences revolve around specific formulas and criteria. A crime of violence such as bank robbery or assaulting a federal agent would mean a certain number of points in the equation.

Congress decided that people who peddle or even view child pornography are victimizing countless unnamed children, so the crime of possessing, receiving or distributing child porn was put into the same sentencing class as violent crimes. Congress didn't want to see probation as an option—so, judges have little or no discretion to give probation.

Plus, there is no parole from federal prison.

Most importantly, Alvarado would never teach again.

After Alvarado's guilty plea, MacKenzie sent an e-mail to the TV station:

> *This is the most amazing and disturbing thing I have ever been a part of. I am so thankful to you for pursuing this matter, if you had not rattled some cages, I doubt the Feds would be giving this the attention it deserves.*

How the Feds Are Responding

The FBI and the National Center for Missing & Exploited Children are trying to keep others from getting the same runaround when they stumble upon such criminals.

They now publicize the Cyber Tip Line (at www.cybertipline.com) as the main clearinghouse for all complaints involving children and

the Internet. It's a useful place to turn—especially if you're getting the bureaucratic runaround from local law enforcement.

Each complaint is evaluated and sent off to the proper agency and field office to fully investigate it. Many tips don't involve an actual crime. Others are vague or they don't give agents enough evidence to arrest someone; but organizers insist every single complaint is given attention.

When the FBI case agent wrote her application for a search warrant, spelling out her evidence to arrest Alvarado, she revealed that the National Center for Missing & Exploited Children had indeed gotten the same information from MacKenzie.

It just hadn't yet acted on the information before MacKenzie pushed the issue by contacting me.

MacKenzie concluded his e-mail by saying he hoped others won't have as much trouble reporting such a child sex crime as he did. And he said he thinks about how many pedophiles are out in the world. "My stomach hurts to think there are more of them out there. How many of them are teachers?"

16 Protecting Kids from Themselves

Don't listen to them. They're just jeal-
ous.

The biggest obstacle to protecting children online may be the
children themselves.

Risk-taking is in their natures, just as it was in most parents'
nature at that age. Learning how to deal with life's risks is an
important...perhaps *the* important...aspect of being an adolescent.
The anonymity of the Internet helps teens experiment with the risky
nature of adult life—and of their own identities.

This isn't necessarily a bad thing.

Dozens of surveys and psychological studies agree that teens turn
to the Internet to satisfy their curiosity about sex because, online, they
don't have to worry about being laughed at if what they say or assume
is wrong.

Plus—and this point is important to teens—there's no fear of
sexually transmitted diseases or pregnancy when they explore online.

So, teens may have relatively innocent reasons for wanting to pro-
tect their privacy. A kid trying to hide something on his computer
screen doesn't—by itself—mean that he's involved with a perverted
adult. It's entirely possible that he's trying to hide a nervous conversa-

tion with a possible girlfriend or some gossip about a rival. In other words, the same things teens have been hiding from their parents since...there have *been* teens and parents.

The problem emerges when a child moves from the Internet to the real world.

The Internet is called a "virtual reality" for a reason—it's not real. But, to inexperienced children, the intensity that they experience in this artificial world can seem real. Increasingly, in the future, maturity may be defined as the ability to distinguish the "false reality" of cyberspace from the "real reality" of the physical world.

Kids are becoming computer savvy at younger ages all the time. But learning to use a computer mouse and navigate a Web site is the easy part of using the Internet; learning to keep their real lives—their names, addresses and sex lives—separate from the games and information online is the important part.

Parents have to balance many things as their children become teens, on the way to becoming adults. They have to balance giving a child enough independence to learn from her own mistakes with protecting that child *from* her own mistakes. They have to balance encouraging a child to protect his privacy when he goes online with checking on his behavior to make sure he's not in trouble.

There are no simple formulas for maintaining this balance. But one thing is certain, in the Internet age, kids need to understand that virtual reality is not the same thing as physical reality.

Adolescent Secrets on the Computer

One way kids are fooling today's parents is with multiple screen names and identities.

Some of the most protective parents say they'll suddenly hold spot inspections of sorts, telling kids to open up their MySpace.com pages without any warning. Or a parent will tell a child to log onto Yahoo or whichever e-mail service she uses for a spot check.

These cautious parents feel satisfied that they've checked for any e-mail messages that seem suspicious or sifted through personalized Web page content to make sure there's nothing improper posted.

But kids can be cunning about hiding the risky things they do. They set up multiple accounts—and log on ones that are "parent proof" when the spot inspection takes place.

The same goes for e-mail accounts or other Web profiles that kids know their parents watch. Those will be sanitized, mentioning mundane school stuff; they may even showcase swim lessons or some other activity about which the child knows the parents are proud.

Many of these kids maintain different e-mail accounts that parents don't know exist. Those are the accounts where the signs of sex chats and other dark behavior will appear.

A parent may know that the family computer uses Microsoft Outlook with five e-mail addresses for five family members. This parent may use Outlook's administrator's tools to check the kids' e-mails...or just feel secure knowing that he *could* check them.

But a risk-taking child can get around these controls by opening a free e-mail account—with services like Hotmail and Yahoo mail—that don't fall under Outlook's controls.

And, of course, a risk-taking child can find a "friendly" computer away from home...and away from watchful parents.

Most circles of friends have a favorite spot where the restrictions or intrusions are less severe. That's where they'll do the chatting or the Web surfing they don't want parents to know about.

Even if your child isn't looking for porn or chatting with adults about sex, she may be using this more relaxed computer environment for activities that pave the way for later trouble.

Prevention, Prevention, Prevention

The point here is that even the most watchful parent can't keep her eye on everything her children do online.

Sexual Predators

The surest way to keep kids out of trouble is to train them to *recognize* it. Talk to them about Internet sexual predators before there's been any trouble. Make sure they know:

- that sexual predators exist. They are adults who don't grow up quite right and end up thinking all the time about kids' bodies. Sometimes, they'll hurt little kids in order to touch their bodies;

- that lots of people—and not just predators—make up who they are and what they're doing on the Internet. Many people treat it as a massive game of make-believe...and aren't telling the truth when they write things;

- that no one really knows "friends" he meets on the Internet. Even lots of adults make the mistake of thinking they "really know" someone they've "met" online...and they end up getting ripped off or hurt because of it;

- that everyone a kid "meets" online is a stranger—and that no kid should give his full name, address or phone number to someone on the Internet who asks for it;

- that some sexual predators try to scare kids into doing bad things by saying the kids are already in trouble for what they've done or said. If any "friend" on the Internet says he's going to tell on a kid if she *doesn't* do something, that kid should tell her parents right away.

A behavioral analysis report published in 2001 by the Justice Department's Office of Juvenile Justice & Delinquency Prevention pointed out that children aren't suddenly victimized by trickery while doing their homework on the computer. Instead, pedophiles are striking as kids are being curious, rebellious—sometimes troubled—adolescents.

The report said investigators often find out that kids who are victimized had actually lied during chats more than the predator had lied. Predators—with reptilian cunning—know this, and exploit it by playing on guilty consciences kids may have for lies they may have told online.

Children often aren't very good at understanding gray areas or paradoxes. They may want everything they read or hear to be true...but they need to understand that the Internet isn't a reliable as an oak table.

Kids are Curious—Don't Make Them Ashamed

Children are vulnerable when they're experimenting and exploring their curiosities. And they'll dig deep to quench their thirst for knowledge. If a child is curious about a particular sex act, she usually won't just read one account or look at one picture. She'll probably look for many images of it...until she understands it and tires of what it means.

This curiosity may extend into the chat environment, where a predator can zero in and use the child's curiosity to his advantage. One classic predator's trick is answer a child's questions about a sex act (oral, anal, three-way, etc.) and then threaten to tell an authority figure about the child's "perversion." Once a predator has gotten *that* far into a child's mind, he can usually pressure her into meeting him for sex—in the physical world.

Dr. Melinda Kanner, in her study of deviant behavior, agreed that a child's curiosity can leave a child more vulnerable to a predator's grooming and flattery.

"These kids who give into these online people are not just giving in, they're flattered," she said:

> *We're taught to be flattered by the attention of grownups.*
> *The singular attention of a grownup is so flattering that, at*
> *the very least—and I think the most modest way to think of*

213

> *it—it relaxes their inhibitions. It impairs their judgment.*
> *It's like having two drinks. They don't have to be loser kids*
> *for that to be true.*

Chat Lingo and Abbreviations

Figuring out a child's chat methods is not as complicated as breaking a secret code. Many parents are intimidated, fearing they won't recognize trouble even if they see it.

However, Internet text chatting is much more direct than that.

A key point: Teens rarely use capital letters or punctuation online chats. As a result, an outsider's first inclination might be to assume a group of letters is some secret code—when they are actually a couple of words misspelled and run together. Context is important.

While some kids may have code words or phrases within their circle of friends, the truly universal abbreviations and language are not nearly as tough to understand. The common theme to text chatting is *simplicity*. Most text chat code is really designed to save keystrokes—and, therefore, the time required to post a message.

Parents can find lists of hundreds of chat room abbreviations at various family safety Web sites. But some of these lists make text chat abbreviations seem more intimidating than they really are. To simplify the whole matter, I've included a list that explains the basic chat room abbreviations as part of the glossary at the end of this book.

In fact, most teenagers say the chat rooms are moving away from the heavy use of abbreviations that was common when the things first became popular.

Of course, some teens—and particularly some teen *girls*—do develop and use code words. The challenge here is that small groups of girls may develop their own, practically unique code words.

That uniqueness is part of the appeal.

You can usually tell a code word by how heavily a small group of girls will repeat it in a few text exchanges. In other words, if two girls from the same school keep using the word "lucky" in their chats, there's a fair chance they've invested it with some double meaning. What that meaning is may be a guess to anyone outside a group of four to six girls.

If you need to know the double meaning, the best way to find out is to tell the girls that you know they're using the word as a code—and that they've used it so much now they have to explain.

Most teenage girls' code words are related to sex acts or social situations. But—if you're an inquiring parent—be prepared for the meaning to be more mundane than you expected. Teenage girls often have dozens of ways of calling some other girl a *bitch*.

Warning Signs

Sometimes, a child's circumstances encourage a predator's efforts. Law enforcement agents and child sex experts mention the following situations as warning signs of vulnerability to a predator's advances:

1) An Established Routine

 Many predators stalking chat rooms and social-networking sites know the best way to meet a child alone is to exploit the child's routine. It's not uncommon for predators to suggest ways for a child to get away for significant periods of time. If volleyball practice or soccer practice is every Tuesday after school, a predator may suggest that his curious victim skips practice. He'll offer to meet or pick up the child—and have her back at school before the parents arrive to pick her up from the practice she skipped.

 If you're a parent, make sure your children do not post sports schedules or other activity schedules on the Internet.

2) Flimsy Alibis

Predators inquire about regular outings that don't raise many suspicions for parents. If trips to the mall or a particular friend's house are common, your child may decide that's the way to convince you to let her leave the house.

Checking up by calling a child's cell phone may not suffice. If the child claims to be at the mall with a particular friend, ask to speak to that friend. Make it casual, as opposed to a formal interrogation. Ask for the phone to be handed to the friend and then ask something funny or cute such as whether they're out of money or whether your child will be hungry when he or she gets home.

One lousy alibi doesn't mean a crisis; but, if a child repeatedly isn't where she says she'll be when she says she'll be...consider it a serious warning sign that something dangerous could be developing.

3) Sudden Importance of Non-Relative Adult

If a new adult suddenly appears in a child's life, that adult may be a predator. This adult isn't necessarily a creepy stranger—and it is necessarily a man. It can be a teacher or coach who suddenly shows intense interest a child she'd barely noticed before.

A consistent theme in the series of female teacher/male student predatory affairs that made the news in 2005 and 2006: The female teachers suddenly started spending a lot of time with the boys—giving them rides, calling or sending text messages.

4) Social Tension Among Parents

If the child knows that her parents never speak with a particular friend's parents, she might say a new adult "friend"

is somehow affiliated with those parents. This kind of explanation has an air of credibility but avoids possible verification.

If you're a parent, this suggests something else—don't indulge your ego in feuds with other parents. Try to keep at least civil, open communications with the other families in your neighborhood, church or school. Parents who can call one another to check in on their respective kids are a very effective abuse-prevention system.

5) Inappropriate or Lavish Gifts

The Justice Department behavioral analysis report concluded that predators are "willing to spend a considerable amount of time, money and energy" to win over a child. This means showering gifts or money on them over time. Later, the report said, this may make the child more likely to consider sex as a means of keeping those gifts coming.

So, money can be an issue. Parents should be aware of the source of any gifts to their children. An adult funneling an unusual amount of money toward a child is a serious warning sign—especially if the child tries to hide the gifts or conceal their origins.

6) Unchecked Phones and E-mail Accounts

The Justice Department report also noted that predators have been early adopters of almost every communications technology advance in 1990s and 2000s.

For parents, this means that if you let a child have a cell phone or e-mail account, you need to keep some level of control over her use of it.

Check with your cellular provider to see if text printouts are available with the monthly bill. If you have teenagers,

this service is a good thing to get. Watch out for text messaging clues as well. An occasional spot check of "messages sent" or the "outbox" on a teen's cell phone can tip a parent off to something dangerous in the works.

7) Unmonitored Internet Access

A teen who has an Internet-connected computer in her bedroom is more likely to get into trouble that one who has to use a machine in a common space. In the bedroom, there is always a knock at the door when a parent wants in; it's an island. And not in the good sense. The child has plenty of time to close vulgar chat windows or cover other tracks when a parent knocks. If the computer is out in an open place, there are fewer chances for secret chats.

8) Social Acceptance of Sexual Age Differences

If her girlfriends are consorting with older boys or men on a routine basis, a teenage girl is more likely to experiment with what she sees. The best place to do this is online, where the fear of rejection is minimal. Predators know that children often imitate what they see—so, they work hard to emphasize that no-strings sex with older men is a "normal" experience for a young girl.

9) Traditional Signs of Depression

Sex crime experts also suggest keeping an eye out for traditional signs of depression and emotional disconnection.

A sudden and unexplained disconnection from friends or entire groups of friends sometimes follows the start of a relationship with an adult. An age-appropriate boyfriend or girlfriend (even one who's challenging for other reasons) will rarely cut a teen off from her circle of friends; but a sexual predator will. Isolation is a key part of grooming.

Of course, teens often act disconnected on their own and for reasons that have nothing to do with sexual abuse. But an unhealthy or predatory sexual relationship can cause these classic signs of depression.

10) Excessive or Unusual Numbers of Sick Days

Also, a pattern of sick days from school can be a warning sign. Many men suggested that our curious 13-year-old "girls" simply skip school so that the predator could pick the girl up at her home.

And many of these were quite calculating about how the girls should make the sick day call. In some cases, they said they'd pick the girls up after the attendance or truancy office had called to verify that they were in fact home.

As I've noted before, no one of these factors means absolutely that a sexual predator is around. They are warning signs. Repeated occurrences—or several of these things happening at the same time— probably warrant some affirmative action on a parent or guardian's part.

Hallmarks of a Victim

The children who are drawn to meeting sexual predators tend to have a few common personality traits or characteristics; these hallmarks of a victim can serve as an additional series of warning signs— and they're more closely related to a person that the broader situations I mentioned above. They include:

1) Low self-esteem

The men we found prowling for children zoned in on this trait most ruthlessly. If our pretend child complained about friends making fun of her at school, the predators would respond with close variations on the same words:

```
Don't listen to them. They're just jeal-
ous.
```

Children—boys or girls—drawn to adults sexually often say they didn't get much attention and response from people their own age. But *all* people feel awkward and out of place at some point during their adolescent and teen years.

The difference among child sex victims is that they internalize this natural awkwardness; they believe it means they are worth less than their peers. This creates significant psychological vulnerability.

Predators exploit this with flattery and false assurances.

2) Disconnection from Parents

Predators know that curious children usually hide most of their online activity from their parents. But experienced predators *encourage* this isolation; they'll actively contribute to the divide between their victims and their parents.

This isolation helps the predator in many ways. It narrows the victim's perspective—she's less likely to see her relationship with the predator as twisted if she doesn't get along well with her own family members.

Children who have healthy, open (if not perfect) emotional connections with their family members are less likely to be manipulated by predators.

3) Emotional or Intellectual Immaturity

There's no diplomatic way to state this—some teens are simply not as bright or emotionally developed as others. And weaklings always attract predators.

After one of our news segments on sexual predators, my investigative team received an e-mail from a frightened teenager who needed help with a situation that was making her afraid. She attached a copy of a text chat in which an older male "friend" got angry that she wasn't responding as he was wanted. (From the transcript, it was evident that they hadn't met in person yet.) He texted angrily that he hoped the girl would be raped and killed.

This was a volatile and potentially violent situation. We asked the girl how much personal information she'd already given her "friend." She wouldn't tell us. She repeated that she was afraid—not that the "friend" would harm her...but that if she told her parents about what was going on they'd take away her chat privileges.

We encouraged the young girl to tell her parents what was happening.

4) Bad Grades

A child who is disconnecting from peers because he or she is performing poorly in school is going to seek affection and attention elsewhere. If he's doing really badly in class, he may look for another outlet where he can excel. He may even say he's trying to study online to turn it all around.

In reality, he could be abandoning school in favor of approval by online strangers; and there's plenty of that to go around.

5) Prior Sexual Abuse

In our research, my investigative team found many of the children who were drawn into sex with adults had been sexually abused when they were younger.

Sometimes it was a "near miss" encounter such as an attempted groping or an attempted rape; sometimes it was more than that.

In one case, a teen who was bouncing from one sexual encounter to another with middle-aged men she met on the Internet had been molested and raped by her father...starting at age six. Her mother had gotten her away from the abuse; and the girl had gone through years of psychiatric counseling. But she was clearly still wounded.

Her step-father—a decent man who'd helped the girl and her mother rebuild a stable, middle-class life—acknowledged that the girl couldn't express friendship or affection without some sort of sexual activity. And she was actively seeking this online.

Another child became more curious about sex with adults after she'd been approached sexually by a friend's father. The man tried to have her touch his penis. She didn't—and she told her parents what happened. But the molester avoided prosecution by fleeing to Mexico when the police started looking into the episode.

Even though the girl had escaped any serious harm, she later admitted she started chatting about sex with adult men after the encounter.

A Thin Line Between Normal Life and Abuse

The problem is that the childlike inclination to experiment—which is a natural part of any person's sexual development—can turn deadly online. And it can turn quickly.

If a young boy is struggling with his own sexuality, or homosexuality, he may seek out interactions on the Internet because of the anonymity it affords him. As long as he stays to the Internet, the boy may be able to get reliable information and see things that help him answer his questions.

That boy is also extremely vulnerable to a predator—who may *seem* supportive and helpful. And then start pressing to meet the boy at a nearby convenience store...or threatening to expose the boy to his family or friends.

Federal agents say chats between men and boys progress much more quickly into sex meetings than those that involve young female victims.

While some predators are looking for boys who are aware of their own homosexual inclinations, other predators are seeking a child—of either gender—who's never had any sexual encounter. The exciting and twisted goal is to be the "first" for that child.

A pedophile who prefers little boys will not approach children by saying he's gay and looking for a younger sex object. Instead, he'll befriend the children...and groom them.

Homosexual predators are sometimes quite vague about themselves and their desires. A gay predator may tell a confused boy that he—the predator—has never had a gay thought in his life. That will likely make him seem more supportive...and less threatening.

Then, when they meet, the predator will tell the boy that he—the boy—is so attractive that the predator is willing to try a gay affair.

These encounters have an "ambush" element that's not usually part of heterosexual predatory relationships. When girls hook up with older men after chatting, they don't usually think they're meeting to play cards or go to a movie. Boys, on the other hand, may think they're simply meeting an older friend.

And embarrassment is even a bigger factor in gay sexual assault cases involving children. If a boy isn't sure about his sexuality, meets an older "friend" and ends being molested or sodomized, childish social stigmas attached to homosexuality may prevent him from reporting the attack.

Sexual Predators

The anonymity of the Internet can push adolescents directly toward things that would normally set off warning bells. A child who'd run away screaming from a stranger in an overcoat on the street may actually "run" *toward* that stranger online.

Threats on the Horizon

*The predators will be much faster than law enforcement
to find where the kids are going.*

Law enforcement agencies have a tough time keeping up with the technology that helps sexual predators exploit children.

With picture phones or camera phones exploding in popularity, it's now possible for predators to snap pictures at the swimming pool or in somebody's front yard. In a matter of minutes, the image can be posted on the Internet.

MySpace.com and other social networking Web sites started their move in early 2006 to offer complete access to profiles, messaging capabilities and surfing for pictures from cell phones. MySpace.com executives insist it poses no greater danger because all of the password protection and ability to block messages will exist on cell phones—just as it exists on computers.

Of course, they fail to make the final point: That most people don't use—and aren't even aware of—the security features on their own computers.

225

MySpace.com has grown so quickly that it's turned into a worldwide yearbook of sorts. Unlike chat rooms, where people often use goofy screen names or nicknames, people tend to post their *real* names on MySpace.com, Facebook, Xanga and other sites.

This means that, in the future, a predator shuffling around a shopping mall might overhear a girl's name being uttered. He might log onto one of the social Web sites and search for that name. The child's picture might be available, along with details about her choices in music, her friends and her home life. Her profile might mention her address...or post her volleyball schedule.

A criminal could use that information to get close to her or lure her into a car.

Another problem is the unmasking of otherwise anonymous people. A person could become an easier kidnap target if the predator would, for some reason, start with a name and then log in to match a picture with that name.

But MySpace.com *isn't* the problem.

Keep this in mind: Yahoo's decision in 2005 to terminate its User Created Rooms caused the exodus of kids and predators to MySpace.com. It's very likely that, as MySpace.com improves its security features, there will be another exodus to a newer Web site or platform.

The details of the location aren't important. The general themes and behavior are.

Kids Like to Live on Technology's Edge

Text messaging on cell phones or PDAs is also a source of concern. Teenagers love texting because they can click entire messages to their friends and then receive replies instantly. Plus it's private...and it's a technology that older people have been slow to adopt.

While there are plenty of programs that allow parents to check on their kids' computer activities, text messaging is tougher to monitor.

Predators know this.

Their goal is usually to meet children on the public Internet and then get them to move the dialogue over to one of those more discreet modes of communication.

"Can I Text You?"

Many local police departments have bungled sex crime investigations in the mid-2000s because they are dense about how kids use text messaging and other high-tech tools.

In April 2006, two 16-year-old friends ran away from home north of Houston in the middle of the night. Police say one of the girls left an angry two-page letter for her parents, saying she was old enough to make decisions on her own and she was tired of her life being restricted by "stupid rules."

The police reports were handled as "runaways"—which are a relatively low priority for most police departments.

A sibling received a call from one of the girls from a Houston motel; that caused parents to check the home computer to see what was really going on. They were shocked to find messages being traded on one of the big social Web sites, with men from Louisiana and Delaware—both urging the girls to run away and live with them.

For the police, the sexual predator twists added a new sense of urgency to a standard runaway case; but the parents complained that they couldn't get officers to realize the children might be in jeopardy of being kidnapped or killed—even though some of the online messages from the men were violent and sexually graphic.

In a different direction, streaming video will also change the way predators operate. The big TV networks and cable venues like The Weather Channel are locking in on this technology, offering quick newscasts or weather forecasts that can be viewed like a regular newscast in a handheld computer device the size of a cell phone—or on cell phones themselves.

There is even a new term called "mobisode." This is an episode of an entertainment program downloaded onto a mobile device—usually a cell phone. The term is most commonly applied to content created specifically for mobile venues, as opposed to reruns of a standard television show.

Once this market is set up by the mainstream companies, watch for legal adult pornography to become "on-demand." Soon thereafter, child pornography will be streaming into devices and creating a new demand for mini-movies of indecent acts with children.

It took law enforcement agencies several years to catch up with tracking crimes involving simple cell phone technology; the learning curve for police and federal agents with these new technologies may be even longer.

The new handheld wireless devices will eventually produce their own version of Yahoo's User Created Rooms or MySpace.com.

In other words, watch for regular chat forums to spread onto mobile devices and cell phones. The old dangers will take on a new dimension. And some trendy company no one's heard of yet will become the booming player and a stock market darling.

Predators Already One Step Ahead

That means it's a matter of time until predators will know exactly how to seek out children in the same way they do online, even if the child only intends to communicate with parents and friends.

To make matters worse, the predators will be targeting children when the kids are away from the house. Imagine a predator sending text messages to a child in school or at the mall, when it's easier for the child to get away from adults to meet the predator.

Predators will seize on this in a hurry.

And curious children could be drawn in to chats with predators by spam or other types of unsolicited e-mail.

These surprise messages from strangers could also direct kids to Web sites or chat rooms where a predator would be waiting on them.

On MTV and other cable channels geared toward young people, text messaging and telephone voting are so popular that they seem like they're harmless. MTV urges kids to send text messages to vote for their favorite music videos. Commercials urge kids to send text messages to subscribe to jokes or movie listings. So, a child may become conditioned to think *any* text message that looks like a commercial is legitimate.

Now imagine a predator sending out a message that would only appeal to a child, seeking a text message to vote for a particular movie or fashion. Once the child responds, the predator has a direct link with the child and can start grooming her for sex.

Something They Can't Control

"I knew something like this would happen," said 44-year-old Kirk.

He seemed completely unable to control his urges to meet our 14-year-old "girl" in the chat room. He's 5'6" tall with dark skin and a completely shaved head. He's unemployed.

His screen name ended with MANONTOP and his pornographic profile picture displayed what appeared to be a young blonde child on her back with a dark skinned male having sex with her.

During hours of chatting, he told her "we would be kissing as you are having your orgasms" and he talked about how he's "used to" certain things with the young girls he meets for sex.

Once he had cameras surrounding him, he offered a few typical excuses. But a few minutes later, his frustration and panic yielded slivers of honesty about his compulsion:

> *It was just an accident, man. It's something I don't like to do. I don't like chatting with people in the chat rooms. It's*

*just messed up, talking like that. I'm just sorry. I'm getting
rid of my computer. I need to go ahead with my rehabilita-
tion.*

Go ahead with his rehabilitation? That implied he'd been assigned
rehab previously—and that he may have been in trouble before.

But Kirk's problems weren't about rehab. They were about self-
discipline. If a computer was available, Kirk couldn't stay away from
chats and sex meetings with young girls. His compulsions weren't
checked; technology just made them easier to actualize.

A Plan of Action

For parents, the knee-jerk reaction of banning all technology may
not be the wisest choice for their kids.

If kids are forbidden from using computers at home, they'll be
less tech-savvy. Then, when they're exposed to technology away from
the home, they'll be more vulnerable.

Plus, the backlash of a computer being the forbidden fruit may
cause children to tread into dangerous areas they would normally ig-
nore, all *because* it's a no-no.

Instead, staying in tune with that technology and knowing how
to spot check it may be more effective.

You now have the basics. Prevention requires bending and adapt-
ing these basics to fit technology as it pops onto the scene.

Just as e-mail accounts can be searched for past messages sent and
received, text messages on phones can be. And parents should learn
how to check the cell phone text messages sent or received by their
children. It's just as easy as scanning through the list of phone num-
bers or names saved those phones.

Most cell phones or text devices save inbound and outbound mes-
sages; but, if a parent *announces* that these will be checked, it's easy for

a child to delete them. If you find the phone, check up on those messages without your child's knowledge. You should overlook minor infractions and avoid reading messages that you know are traded with trusted friends. Instead, look for anything outside those bounds.

If you're looking for contact with a predator—but end up grounding your child because of a text message that mentions sneaking out of the house with a known friend—you lose your edge and your effectiveness at protecting your child from a potential kidnapper or rapist. Which is more important?

The same advice should be applied if parents install Spector Pro, NetNanny or any other keystroke-logging or computer security program. These programs allow parents to check into absolutely everything a child does online; but parents should be sparing in which infractions they dwell upon or punish. Otherwise, this tactical tool will be lost as the child finds ways to avoid the home computer that he or she knows is being watched.

Also, check into blocking text messages or phone calls from unknown numbers. The technology is simple so it is likely to grow more common as parents demand it from cellular providers.

Parents should look at all new technology the way people, in past times, would look at new playgrounds being built.

Predators gravitate toward where the kids are. In the past, they would lurk around the parking lots or bushes near the playgrounds in hopes of befriending a child. Today, they'll be found wherever technology takes children.

In the chat rooms, some of the most vile and disgusting content (and propositions) can be found in the rooms geared toward children. When portable devices catch up, the predators will be much faster than law enforcement to find where the kids are going—and those predators will be there waiting.

The major Internet Service Providers have been marketing their family controls and safety precautions just like cable TV has been

offering password protection to make sure parents can lock out some channels from their kids. Today's parents should become familiar with similar parental control features on these new devices. They likely won't be marketed as aggressively at first—but may be available for the asking.

Predators Covering Their Tracks

Police have a tougher road ahead. Wi-Fi—public wireless connections to the Internet in coffee shops, malls or hotels—will make it easier for predators to cover their tracks.

Computer security experts say WiMax (high speed Internet access available *anywhere*) will become just as widely used in the coming years. This wireless technology is already in use in the some locations but, as the price comes down, it will become as common for everyday consumers as cell phones are today.

WiMax will mean an Internet connection is possible on a cell phone or other portable device just about anywhere, using the same technological concept as cell phones. No more searching for Wi-Fi hot spots near coffee shops or libraries. The Internet can be accessed anywhere a WiMax signal reaches, and it will soon blanket the entire nation just as cellular networks do now.

Most computer savvy criminals know that most police investigations are based largely on the "footprints" that most computers leave when they connect to the Internet.

At home or at work, the IP Address is registered on the big ISP servers, so that police can track just about any activity back to a specific fixed location.

When criminals choose instead to log on from these public wireless connections or WiMax, those footprints will be much tougher for police to find.

This makes prevention so much more important.

It all sounds overwhelming, but it's really not.

Just as a parent keeps an eye on the vulnerabilities in his child's life off the computer—a stranger at the swimming pool or a "friend" who just doesn't *seem* right—he needs to trust his intuition about online activities.

It's clearly a matter of reevaluating these new vulnerabilities every time they emerge in the electronic age.

The basic tools are now yours.

But don't wait until tomorrow.

The predators are already looking for those vulnerabilities. They're working to stay ahead of you, in staggering numbers at this very moment, as you close the covers of this book.

Abbreviation Key
& Glossary

Abbreviation Key

The following definitions include the standard words, abbreviations and phrases that kids use to chat with each other—and predators master to chat with kids.

In our several years of contacting and stinging predators, we noticed the following terms and abbreviations seemed to be the ones most often used by adolescents and teens:

ASL (a/s/l). Age Sex Location

BF. Boyfriend

BBW. Big Beautiful Women (Woman)

BOT. Short for *robot*, for an automatically generated message, usually an ad or a trick or spam. It was intended to look like a person in a chat room; but the message is really an advertisement or pitch to click on a porn link or other service.

BRB. Be Right Back

CAM. Web Camera

CYBER. Short for Cyber Sex, used as a verb. "Want to Cyber?" This is typically a fantasy/role playing scenario where the two participants talk as if they were meeting in-person or having sex.

GF. Girlfriend

HOOKING UP. Slang for *having sex*

IM. Instant Message, often used as a verb—as in "IM me"

IRL. In real life, or away from the computer

K. Okay (affirmative)

KOO. Slang for "Cool"

LMAO. Laugh My Ass Off

LMFAO. Same phrase with an expletive added

LOL. Laugh Out Loud

MEET. Usually meaning a sex meeting in the physical world

OMG. Oh My Gosh (Oh My God)

OMFG. Same phrase with an expletive added

PIA. Pain In the Ass

PM. Private Message

POS. Parent Over Shoulder. This is meant to inform the other party in a chat that a parent is nearby so chatting must pause until the coast is clear

SINGLE. Regardless of age, this means without a boyfriend or girlfriend

TTYL. Talk to You Later

TY. Thank You

TXT. Text Message on a Cell Phone away from the computer

TYVM. Thank You Very Much

YW. You're welcome

YVW. You're very welcome

Aside from the basics listed above, most other unfamiliar words a parent may see in a chat room are likely phonetic spelling of words, as opposed to mysterious abbreviations.

L8. Late

2MCH. Too Much

QT. Cutie

HOTR. Hotter (or more attractive)

Or, it could be a word that is shortened by removing some
 vowels, which is also common:

PRTY. Party

SKUL. School

TCHR. Teacher

PRV. Pervert

BTCH. Bitch

SLT. Slut

PRP. Prep or Preppie, a social class among teenagers—some
 times used in a derogatory sense

RNTS. Parents

Glossary

ASL (or a/s/l): A commonly used abbreviation in chats, inquiring the age, sex, and location of a person. It is sometimes used as a greeting, or preceded by a customary greeting like Hello or Hi.

BROWSING: A search function on many social networking Web sites that allows a user to find the personal pages of other users. It can be based on very wide criteria such as an age or a zip code, or a specific criteria such as a particular hobby or area of interest displayed in a user's profile.

BUDDY LIST: On the AOL portal, a collection of screen names of friends or other people you have chatted with. Instead of typing a full name, simply clicking on that person's name on the Buddy List allows an instant message or private message to be sent.

CHAT ROOMS: Electronic bulletin boards where a computer user can log in to post comments or read and respond to other comments. Each room has a name that spells out the area of interest, such as sports, astronomy, dating. Some are general in nature but geographically specific like a "Chicago Friends" chat room.

CHILD ENTICEMENT: A federal offense, the felony crime of arranging a sex meeting with a child and then showing up for that meeting or taking at least one "affirmative step" toward consecrating that meeting.

CUT AND PASTE: A computer keyboard function, mostly used for word processing, that allows words, sentences, or

entire documents to be copied and then duplicated into a new field or separate computer function. Also, a term of Internet jargon that means a lazy way of doing something.

EMOTICONS: Images that are sent within chat dialogues to convey emotion. With a single click, a person can send a smiling face, a frowning face, an angry face, or a rose to accentuate a point in the chat.

FIND A BUDDY: A search feature on AOL's AIM service. It allows users to find other people by checking for certain criteria. A person can search for people of a certain age or at a certain location or by hobbies or other interests. Then, chats can take place between the parties.

FRIEND REQUEST: A function on social networking Web sites in which a person requests permission to access a page that has been locked or set up as private. If such a request is approved, the requestor can gain access to the site and send the person messages.

GROOMING: The process of manipulating a child's mind by flattery or showing false empathy for her feelings or situation. A predator grooms a child by offering praise or displaying that he is "cool" in ways the child's parents aren't.

IGNORE or BLOCK SENDER: Most Internet chat services provide this button to click when contacted by a stranger. Hitting this button allows you to refuse whatever the person is trying to send you and never again be bothered by the person.

INTERNET PROTOCOL ADDRESS: Abbreviated as IP Address, it is a unique serial number for every computer. Most Web sites or connections between computers log every IP address that visits them. Basically, every computer leaves

this fingerprint anywhere it connects on the Internet. Police can confirm that an e-mail was sent from a particular computer with this number.

INTERNET SERVICE PROVIDERS (ISPs): Companies that provide connection and other services for the Internet. Yahoo and AOL are the largest, each offering different services exclusive for their clients.

iPOD: Brand name of a popular digital recording device, used for playback of electronic recordings such as music or videos. Has become a generic term for any device that plays electronic music.

MALWARE: A term used by computer professionals and police for malicious software, such as viruses or Trojan Horse programs installed by an intruder or downloaded by accident.

MIRRORING THE HARD DRIVE: Copying the entire contents of a computer hard drive onto a different computer.

MY DOCUMENTS: A storage location or "folder" on Microsoft Windows computers. It's the default storage location for many types of documents, so it is widely known to be the first place to look for valuable information about a person.

MYSPACE PICTURE: A slang term for a photograph one snaps of oneself by extending an arm and pointing the camera back and snapping a picture. Coined after the social networking Web site where these photos became so widespread on profile pages of users.

PAYPAL: A popular Internet payment system used to pay for goods or services, or collect money. Credit cards can be used to pay someone through this service and the money can be switched directly into a bank account.

PEER TO PEER or P2P SYSTEM: These are file sharing services that allow individual users to sift through the computers of other users or peers. The first, biggest name was the original Napster music sharing service. Even though the music was not hosted on Napster servers, users would find each other through Napster and then decide which songs or files to trade back and forth. Similar P2P networks are common for trading computer programs, games and pornography—both illegal and legal.

PERV: Slang abbreviation for "pervert," often used by people to describe themselves.

PHOTO ALBUM: Most Internet chat services provide this way of sharing numerous pictures with people online. In some cases, the photos are available to anyone who can see a user's profile, but others require an invitation before the pictures can be viewed. Typically, a person will arrange photos that tell about themselves or their interests. However, some people place only lewd pictures they've found online, as an expression of particular acts they fantasize about or want to try.

PICS: Internet slang for pornographic pictures.

PRIVATE MESSAGE or INSTANT MESSAGE: a direct chat dialogue between two computer users that cannot be read by anyone else. The conversations are still called "chats" but they are outside of the chat rooms.

PREFERENTIAL OFFENDER: A criminal who is interested in one specific crime. Usually in the context of pedophiles, this means the person is only interested in one particular gender and one specific age group.

PERSONAL DIGITIAL ASSISTANT or PDA: Hand-held or "palm" sized computer used to store calendars, phone numbers or other reminders. It is hooked up or "synched" with a home or business computer to allow remote access to important data.

PORTAL: a specific service or outlet within a given Internet provider's program.

PROACTIVE STING: A law enforcement tactic whereby police pose as a child in order to catch people who are trying to lure children or expose them to other illegal behavior online. After numerous arrests nationwide, my Houston television investigative team employed these same tactics, beginning in February 2004, in order to expose men who were trying to meet children for sex.

PROFILE: A personal questionnaire intended to give information about a computer user to others who may have similar interests. It is a standard list of questions that would typically be of interest, such as age, marital status, favorite movie or goals in life. Usually allows the posting of a photo.

SCREEN NAME: a unique identity or nickname that acts as a name badge in a chat room. A person chooses his own name, often based on his real name or his hobby or his attitude.

SPAM: Unsolicited or unwanted e-mail.

TROJAN HORSE: A malicious computer program that can transfer control of certain functions or the entire computer to a different computer, often a stranger who has planted the program through an infected e-mail.

TROLLING: The process that predators follow of moving from chat room to chat room (or Web site to Web site), looking for likely victims. A predator may just read the comments other people make in chat rooms...or he may post solicitous or provocative comments, in the hope that a young person will respond.

USER CREATED ROOM: Chat rooms established and assigned names by users, as opposed to those created and named by the big Internet Service Providers. Many of these rooms have graphic names and focus on lewd material or special interest subjects. It allows a gathering place for people who want to talk about or trade whatever subject is depicted in the name.

WEB CAM or WEB CAMERA: Small camera that allows live transmissions of a person's activities as they sit in front of their computer keyboard. The size of a billiard ball, often mounted on top of the computer monitor.

WI-FI: Wireless Internet connections in coffee shops, hotels, libraries and other public places. A computer with a wireless card can simply click and connect to the Internet with no cables or wires.

WIMAX: Wireless technology that allows free access to the Internet over the same transmission wavelengths that make cellular telephone calls so widely accessible. Once this technology takes hold and the price comes down, the Internet will be accessible on portable devices anywhere that a cell phone call can be placed or received—and that's just about everywhere.

Index